Picture This!

Kelly and Velvet:

Hope you enjoy this stroll
through photographic history.

Personal regards, Gary Haynes

oregon IL 9/8/06

Starring UPI.
Ringo Starr wears a UPI eyepatch borrowed from the photographer on the set of *Caveman,* in Durango, Mexico, in 1980.
Photo by Oscar Sabetta.

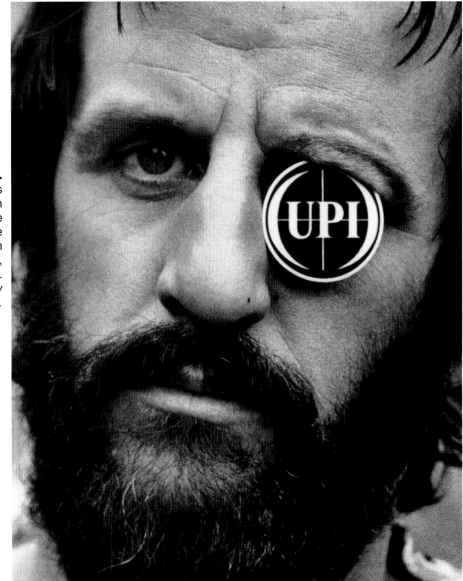

Picture This!

The Inside Story and Classic Photos of UPI Newspictures

GARY HAYNES

Foreword by Walter Cronkite

Bulfinch Press

New York / Boston

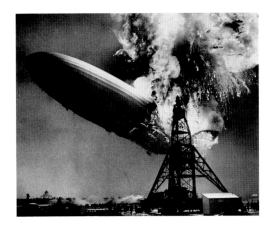

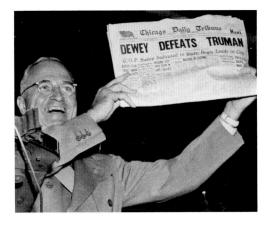

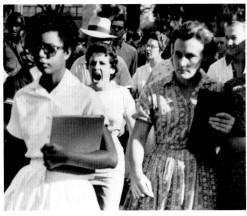

This book is dedicated in memory of Blair and Evelyn, my mom and dad, who encouraged me after I declared, at age nine, that I would become a news photographer. Following a two-year reality check, they gave me my first professional camera on my twelfth birthday.

It is dedicated with boundless love to my children: Stephanie and Philip, the oldest, who endured far too often an absentee dad, and to my youngest, Emily, who endured a dad at home, his camera always aimed her way. And to my stepdaughters, Jane and Katie.

My incomparable wife, Audrey, a fellow journalist, helped keep both me and this project on track with her knowledge, inspiration, and attention to detail.

Two extraordinary women, Gennelle and Paulette, patiently, gracefully, and greatly sacrificed for and contributed to my UPI career, though both eventually grew weary of sharing me with my peripatetic, unpredictable, all-consuming job.

—*Gary Haynes*

Bulfinch Press

Hachette Book Group USA
1271 Avenue of the Americas, New York, NY 10020
Visit our Web site at www.bulfinchpress.com

First Edition: September 2006

Library of Congress Cataloging-in-Publication Data
Haynes, Gary.
 Picture this! : classic photos and the untold story of United Press International newspictures / Gary Haynes ; foreword by Walter Cronkite—1st ed.
 p. cm.
 Includes index.
 ISBN-10: 0-8212-5758-7 (hardcover)
 ISBN-13: 978-0-8212-5758-6 (hardcover)
 1. Photojournalism—History—20th century. 2. United Press International—History. I. Title.

TR820.H395 2006
070.4'9—dc22
 2005029849

Book and jacket design by David Milne
PRINTED IN SINGAPORE

Contents

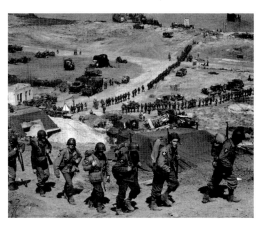

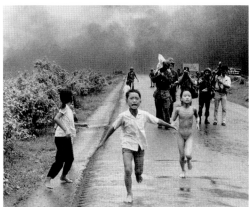

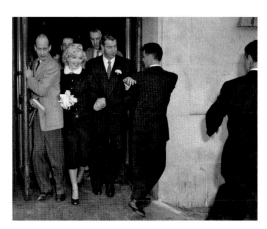

Foreword by Walter Cronkite

Nowadays it seems that almost everyone has tucked into their pocket or purse a midget telephone. And many of the telephones, of course, have as an added feature a tiny camera.

The younger generation may never know, and the older generations may by now have forgotten the cumbersome equipment that news photographers struggled with right through World War II.

The cameramen and the occasional camerawoman may have envied us writing reporters with our simple notepads and pencils, but we honored them for the dangers they faced in covering the breaking news. Whether they were photographing fires and other disasters in peacetime or the ravages of war, we marveled at the risks they took to get the images—or perhaps just that one shot that would live in people's memories long beyond our written words.

We reporters, who often were on the same scenes they were covering, were constant admirers of our cameraman buddies. We could get our story from the firemen, the cops, the soldiers in combat without exposing ourselves to the dangers of collapsing buildings, runaway hoses, or enemy fire, but those dangers were part of the cameramen's daily jobs.

Walter Cronkite

This contrast in our experience was never as obvious as in battle, when we reporters found relative safety in the nearest foxhole. The cameraman had to risk his life by exposing himself to enemy fire long enough to focus and snap the pictures he wanted. Our admiration for them was unstinting. Or almost unstinting. There were occasions when we muttered that they were just a little crazy in that dangerous pursuit of a single photo. In this volume of historic pictures the reader will appreciate the history that they recorded for the enjoyment and education of generations yet to come.

My experience among them was mostly in my eleven years with the United Press. They were the early years in a lifetime in journalism, most of them spent with CBS in radio and television journalism. The broadcasting years were the glamour years. But I still count the experience with newspapers and particularly the United Press as the golden years. There was nothing even in the rivalry between television networks that compared with the ferocity of the battle between the United Press and our archenemy, the Associated Press.

The AP was the senior service; its strength derived from the fact that it was a membership organization to which almost every newspaper belonged. It had been a highly successful monopoly for years before UP came on the scene early in the twentieth century.

The eternal battle to which we Unipressers were dedicated was almost a thrill-a-minute experience. In those days, most big-city newspapers counted on street sales for a large part of their circulation. And those big banner headlines were what sold papers. Sales were boosted if a picture illustrated the story. It was all important to get on the street first with the banner line and the photo if available. So the competition among the UP, AP, and Hearst's less popular International News Service was intense. Hundreds of papers at home and overseas took both the UP and AP services—text and photos—so in the race to get the big news break first we lived the adage "A deadline every minute."

The Associated Press guys were likely to be more experienced and their pay scale was considerably better than ours, which made the competition even more exciting.

When we beat them to a story, the achievement was noted in UP newsrooms around the world with a great cheer normally reserved for a winning football team.

For reasons that I never uncovered, UP newsrooms around the world were called "bureaus." The New York bureau would send a message on the teletypes to all the bureaus so they could exult in any victory over Rox, which was our code name for the Associated Press.

When we were beaten on a story, only the offending bureau got the rocket of official criticism. In the United States these messages were carried in code across UP's leased telegraph circuits. From around the world, they were transmitted by cable. Since photos couldn't be cabled, the cameramen were spared these daily critiques and it seemed to me that as a result they were judged by the home office primarily not on single pictures but on the totality of their work on any given story.

In wartime, when they got back to press headquarters after some time—days or even weeks—with the troops, they would trade stories with their competition. I had a hunch more than once that they were inclined to dramatize their most recent experiences—not only the daring and the dangerous but also a considerable exaggeration of the shots they had sent back to their editors. They were comrades in their profession, and tough and courageous competitors. When we of the writing press were lucky enough to share their yarns, our most frequent reaction was that of thinly disguised admiration.

Occasionally, we would considerably exaggerate the action we had just seen. The photographers would anxiously ask if there were cameras present. Of course we would claim there were, but in the heat of battle we could not tell who among their competitors were actually there. All part of the game played in various ways in peace and war—a game that binds us journalists, in words or pictures, in war or peace.

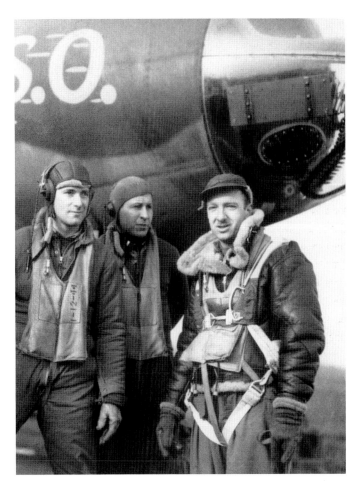

UP correspondent. Walter Cronkite (right) joins fliers of the 303 Bomber Group for a 1943 raid over Germany.

Author's Note

This book celebrates the photographs and photographers of United Press International, who for more than three decades kept their AP counterparts in a state of high dudgeon. Because for 11 of UPI's years I was a UPI photographer and photo editor in six cities, I was a participant in much of the drama. My name appears in the narrative but I have tried to minimize those intrusions. Several of my photographs appear in this book.

UPI picture people—the editors, the staff photographers, and the stringers—poured heart and soul into their work. They proved eager to revisit UPI's glory days to provide new UPI tales and some pleasant photo surprises. I was saddened to learn of the death or serious illness of colleagues with whom I had worked, and played, hard.

My own whirlwind tour with UPI began in Detroit in 1958, when I was 23 years old. Six months later I was "picture bureau manager" in Philadelphia, a bureau consisting only of myself, but locating me at a jumping-off place for space shots, Caribbean misadventures, baseball spring training, occasional news extravaganzas in Washington and New York, and the Nixon-Kennedy campaign. Eighteen months later I became manager of the Atlanta picture bureau, this time with an actual staff, and a base for covering the civil rights movement, baseball spring training, and the space program. I had also become one of UPI's first responders to major events—political nominating conventions, the World Series, and the Tokyo and Mexico City Olympics.

In 1965 UPI brought me to New York. On my first day I rented a house, and the second day I was off to the Dominican Republic to cover LBJ's military expedition there. A month later I was back to New York, meeting the movers and my wife, driving from Atlanta with our two preschool kids. We all spent our first night in the rented house amid moving cartons and by noon the next day, UPI transferred me to Los Angeles as picture bureau manager. The same mover who unloaded our possessions 30 hours earlier was back to load them up again. Next stop was Chicago, as division newspictures manager, directing photo coverage in ten Midwestern states. And finally, in 1969, New York again, when I jumped ship and became first national picture editor at the *New York Times*.

Eventually I was assistant managing editor of the *Philadelphia Inquirer*, where for more than 20 years I worked with two brilliant editors who helped make this book a reality. David Milne, former assistant managing editor, created the design and helped select the pictures. Gene Foreman, former managing editor, rendered the manuscript intelligible. Neither ever worked for UPI, but they both would have fit right in. Like me, Milne and Foreman are retired from active newspapering. Foreman teaches journalism at Penn State University. Milne golfs.

—Gary Haynes, January 2006

Introduction

United Press International still exists, but no longer is it the proud UPI that for more than 30 years caused such high anxiety over at the Associated Press. UPI once had 7,500 customers, 6,000 employees, and 223 bureaus in 100 countries. Today it is but a shadow of its former self, a name, not a comprehensive news service, with fewer than 50 employees. It has been owned since 2000 by News World Communications, publisher of the *Washington Times.*

"Some stories are beyond doubt," Harold Evans wrote in his 1978 landmark book, *Pictures on a Page,* "but the event is not complete without the final photograph. Everest is undeniably climbed, but we want to see the climber at the top." UPI photographers went to extraordinary lengths to get to the top.

Wire service photographers battled each other and the clock. Getting a good picture was often the easy part. The greater challenge might be in getting film somewhere it could be developed, printed, and transmitted ahead of the other guys.

In the decades that UPI Newspictures went toe-to-toe against its larger and richer rival, history played out before the cameras. The beneficiaries of the daily skirmish between the nation's two picture services were the world's newspapers and magazines and TV broadcasters that subscribed to both.

Photographers for both agencies tried to outwit, outsmart, outshoot, and outedit the other, and everybody knew next morning who had done the best job the day before. The photo editors around the world who subscribed to both services made their choice of what they believed to be the best photo of an event, and those choices were tallied seven days a week, like election results, by both UPI and AP headquarters in New York. The photographer with the the most "votes" won—but

that was yesterday, and the race is run every day.

"UPI photographer" was a title shared by the UPI staff and hundreds of nonstaff "stringer" photographers who contributed news and sports and feature photos to the company, many of them on a regular basis. Stringers were sometimes regarded as a necessary evil by UPI's New York staff because they weren't union members, but they were the lifeblood of the company's daily regional and national photo report. Two of UPI's seven Pulitzer Prize–winning photographs were made by stringers.

Speed and a disdain for the AP helped UPI photographers beat the AP, but that is also why today they possess so few prints of their own pictures. In the frenzy to transmit their pictures and then rush both film and prints to New York, most UPI photographers kept no copies for themselves, despite having spent a decade or more shooting thousands of pictures on the world's newsfronts.

With more than 11 million photos in the UPI archive, the photos here are a highly personal sampling that only hints at the breadth and depth of the collection, and the talent that for more than thirty years characterized the photography of United Press International.

Many newspapers wouldn't gamble on 20-year-old photographers, but UPI did. So, by age 30, many of UPI's photographers had traveled with presidents, covered civil rights struggles and been shot at by people who didn't even know them, photographed space launches, and flown around the globe to photograph death and destruction and flood and famine.

Only a fraction of the photos in the archive are clearly credited to the photographer who shot them. Countless hours were spent contacting former UPI colleagues and combing through decades-old UPI logs in an attempt to

match photographer to photograph. In cases where that search succeeded, this may well be the photographer's first personal recognition for photos that appeared when they were first made in newspapers and magazines worldwide, credited only to "UPI."

Sadly, after UPI's cash-starved new owners practically gave away UPI's priceless photo collection to Bettmann in 1984, even the "UPI" credit began to vanish from UPI's pictures. Today they are widely republished, but credited only to "Bettmann" or "Bettmann-Corbis." *Bettmann Moments,* a 1973 book of UPI's pictures with nary a mention of UPI in it, honors the "legacy of Dr. Otto Bettmann," who, after all, never operated a news service and neither created nor assembled UPI's 11.5 million photographs. He simply bought them. Purchasing a Van Gogh does not give you claim to have painted it.

The "word people" of UPI have already splendidly recounted the company's glorious life and—because of cupidity, stupidity, and timidity—its unseemly decline. Three previous books emphasized UPI's "word side" and its formidable newsgathering skills. The book you hold is the first ever devoted exclusively to the "picture side" of the company and a generous sampling of UPI's pictures.

Photographers and photo editors who left the company to work elsewhere, for more pay at AP or to flee UPI's sinking ship in the 1970s, are unanimous: No matter what they have done in the decades since their UPI days, they vividly recall the people, experiences, and assignments of those UPI days as the most exhilarating, satisfying, and professionally rewarding time of their lives.

UPI Photographers Share Joseph Pulitzer's Prizes

At the turn of the century publisher Joseph Pulitzer, whose will endowed the prize bearing his name, filled his *New York World* with photographs. "They call me the father of illustrated journalism," he wrote later. "What folly! I never thought of any such thing. I had a small newspaper which had been dead for years, and I was trying every way to build up its circulation. What could I use for bait? A picture, of course. Next day and every day thereafter, [on] our first page was a picture of a statesman, a blushing bride, a fugitive absconder, or a murderer on occasion—whoever was most prominent in the day's doings. Circulation grew by the thousands!"

An early advocate of training journalists at a university-level school of journalism, he regarded journalism "as a noble profession and one of unequaled importance for its influence upon the minds and morals of the people."

The Pulitzer Prizes (prize administrators say to pronounce it "Pull it, sir") are incentives to excellence, bestowing upon winners prestige and a substantial cash award. Pulitzer even empowered the board to withhold an award in any category when entries didn't meet its standards of excellence. The Pulitzer Prize is one of America's most sought-after accolades in journalism, letters, and music. UPI photographers were awarded seven of them.

UPI PULITZER PRIZES FOR PHOTOGRAPHY
1960 *Andrew Lopez.* Castro firing squad execution. *Page 145*
1961 *Yasushi Nagao.* Assassination of Asanuma. *Page 74*
1966 *Kyoichi Sawada.* A family flees from U.S. bombs. *Page 164*
1968 *Toshio Sakai.* Dreaming of better times. *Page 170*
1972 *David Hume Kennerly.* A lonely and desolate war. *Page 175*
1978 *John H. Blair.* Money borrower seeks revenge. *Page 58*
1980 *Photographer unknown.* Justice and cleansing in Iran. *Page 154*

A History of UPI Newspictures

United Press editor Lucien Carr, whose roommate Jack Kerouac wrote *On the Road* using a roll of teletype paper swiped from a UP office, once said, "UP's great virtue was that we were the little guy [that] could screw the AP."

(That manuscript, 119 feet long with no paragraphs or page breaks, fetched $2,200,000 at a Christie's auction in May 2001, a record price for a literary work. Kerouac had noted in pencil on the manuscript that Carr's dog ate his last few sentences.)

E.W. Scripps (1854–1926) created the first chain of newspapers in the United States and then created his own news service, United Press Association, in 1907 after the Associated Press refused to sell its services to several of his papers. Scripps believed that there should be no restrictions on who could buy news from a news service, and he made UP available to anyone, including his competitors.

The AP was owned by its newspaper members, who could simply decline to serve the competition. Scripps had refused to become a member. A "monopoly pure and simple," he fumed, making it "impossible for any new paper to be started in any of the cities where there were AP members."

"AP" first appeared in 1848 when six New York newspapers formed a cooperative to gather and share telegraph news, but the name Associated Press did not come into general use until the 1860s.

United Press became the only privately owned major news service in the world at a time the world news scene was dominated by the Associated Press in the United States and by the news agencies abroad, which were controlled directly or indirectly by their respective governments: Reuters in Britain, Havas in France, and Wolff in Germany. William Randolph Hearst entered the fray in 1909 when he founded International News Service.

By the early 1900s the U.S. had almost 2,000 newspapers, and there was growing awareness among them that pictures helped sell newspapers, which helped sell advertising.

Large New York papers began to publish separate Sunday sections full of pictures, and in 1919 New York's first tabloid, the *Illustrated Daily News,* advertised itself as "The Picture Paper" and featured pictures over words. By 1924 circulation had reached nearly a million copies a day. Newspapers and magazines had staff photographers, but they also relied on Hearst's International News Photos (INP), Scripps's Acme Newsphotos, and AP, in 1927, to provide photos throughout the U.S. and the world.

The news agencies relied heavily on photos they bought from other sources, and a considerable number of AP's pre-Wirephoto pictures were prints made from 35mm frames from Paramount Pictures' newsreels. No movie theater program was complete in those pre-TV days without a newsreel shown just before the main attraction. The silver screen lit up with the week's heroes and heroines, fads and fashions, disasters and triumphs of the era, a rich trove of material for AP.

UP had no photo service until 1952, when it absorbed Acme, run by Robert Dorman, whom Scripps executive Boyd Lewis described as a "former swashbuckler and gun runner." A Runyonesque character, he had ridden as a reporter with Pancho Villa in Mexico, clung to rickety planes in the Arctic, and bounced across the plains in chartered trains trying to get the best pictures out first. Dorman favored cigars and good bourbon, and kept a bottle handy in the office to entice his staff to stick around after work for late-night poker games. His second in command was Harold Blumenfeld.

Words were being transmitted over phone lines long before anybody came up with reliable and economical machines that could send and receive pictures that way. Early experiments at sending photos by wire were "point to point," a transmitter connected by phone line to a single receiver.

In 1924 Dr. Herbert Ives of Bell Labs demonstrated an experimental "telephotography" machine that a year later AT&T used to send a photo of Calvin Coolidge being sworn in as president to newspapers in three cities simultaneously.

AT&T was publicizing its new commercial "telephotograph" service in eight cities, hoping to attract customers who wanted to send documents and signatures by wire, but it never caught on. Only on rare occasions would Acme or AP send "telephotographs" because even after the hour it took to send one, a recognizable image did not always appear at the receiving end.

One editor complained that wired photos "fail as yet to register recognizable features" though most editors in those early days didn't grasp the fact that even a poor-quality photo transmission brought their readers immediate visual information from distant places that could be obtained no other way.

Admitting in 1928 that "a considerable proportion of the telephotographs have to be retransmitted because of lightning, static, and other troubles," AT&T abandoned its first system altogether in 1933, having invested $2.8 million trying to get it to work.

In the works at Bell Labs, however, was a second-generation "picture sending apparatus" of an entirely different design, using all-new technology, that Bell claimed would transmit pictures faster and deliver copies "indistinguishable from the transmitted original."

But well into the 1930s, the picture agencies still were sending their photos to clients by auto, train, airplane, bicycle, or any means available, a built-in delay of hours and even days.

The news photo services were still in a three-cornered fight through 1934, when AP startled its competitors by announcing what it called a $1,000,000-a-year Wirephoto system. It claimed that soon AP newspictures would be in clients' hands only hours after they were made. No start date was announced.

Not long after AP's announcement, the luxury liner *Morro Castle* flashed an SOS on September 8, 1934, from just six miles off the New Jersey coast. The ship was ablaze, its captain dead of mysterious causes, and a terrible storm raged. The ship's firefighting equipment had been shut off. Eventually, 131 passengers and crew would perish.

Cautious air charter pilots stay grounded in vile weather, but International and Acme knew pilots with daring and courage who would fly—if the payment was generous enough —through just about anything. At dawn in two separate planes, International and Acme photographers flew over the doomed ship and got dramatic pictures. AP had no pictures of the burning vessel and Acme and International wanted to make sure everybody knew it. Soon trade paper ads compared their aerial photos of the burning liner to the file photo AP offered of the ship in port well before the calamity, under a headline that mocked AP: YOU MUST FIRST GET THE PICTURE BEFORE YOU NEED A MILLION DOLLAR TELEPHOTO.

New Year's Day 1935 was literally the dawn of the "picture wire service," and the most significant date yet in news photography's coming of age in the United States. The Associated Press had adopted the AT&T system and inaugurated Wirephoto.

Invited guests were on hand to witness the birth of Wirephoto, which could carry high-fidelity pictures to multiple receivers over a national leased phone network. Solemn engineers tweaked dials and tinkered with an eight-foot panel full of bulbs, wires, and wavering needles.

In 24 newspaper offices across the country other guests watched technicians tinker with switches, generators, and lathe-like receivers. Lights flashed, needles swung, and then a whistle blew. A stentorian voice over a loudspeaker announced: "New York speaking. This will be the first official roll call for Wirephoto."

That first picture showed half-frozen survivors of a plane crash deep in the Adirondack Mountains, and the 24 papers received it simultaneously on a 10,000-mile leased circuit, proof that photographs, not just words, could be delivered by wire.

News photography, at last, was catching up with print. Readers could see what was happening in the world at the same time they read about it. *Editor & Publisher* magazine that year began a regular column devoted to news photography. In his first column Jack Price wrote, "The snobbishness of the scribe towards the photographer is fast disappearing. Photography has a very definite place in modern journalism."

Any of AP's 1,200 members could have Wirephoto if they shared its costs, based on their city's population. In New York in 1936, Wirephoto cost $150,000 a year, and only one of New York's eight daily newspapers, the tabloid *Daily News,* thought it worth the investment. Every paper on the leased photo network could transmit as well as receive photos, enabling them to share their own best pictures with other AP member papers on the "party line" leased tele- phone circuit. By March 1935 Wirephoto was carrying about

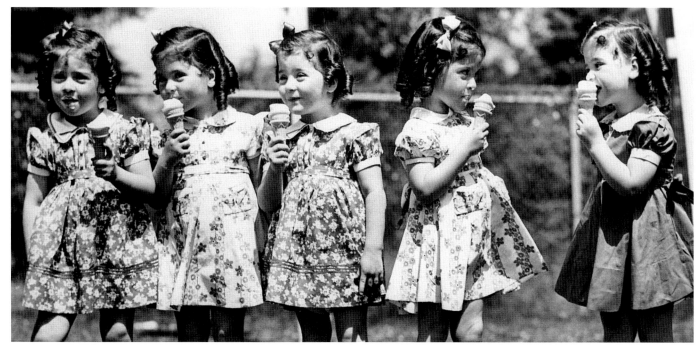

Saving UPI Newspictures? These five girls, the Dionne quintuplets, kept Acme Newspictures viable after AP started transmitting its pictures by phone lines in 1935. Editors craved quint pictures the way the quints craved ice cream, and only Acme could provide them, giving the company time to develop its own transmitters and receivers in 1936.

70 pictures a day.

Conspicuously absent from the new Wirephoto network were Hearst and Scripps Howard newspapers, although fifteen of Hearst's papers and six of Scripps Howard's were AP members. Publisher Roy Howard had lobbied against the Wirephoto project at AP's annual meeting. AP's general manager, Kent Cooper, was the force behind AP's launch of a photo service in 1928, and now he was pushing the newest photo delivery technology on a skeptical AP membership. Both Hearst and Howard huffed that Wirephoto would be a needless extravagance and sure to lead to ruinous competition, all for the sake of "pulling AT&T's $2,800,000 chestnut out of the fire."

The Scripps and Hearst organizations, as well as Wide World, owned by the *New York Times,* had been working on their own photo transmitting and receiving machines since AP's announcement in 1934. International called its version "Soundphoto," Acme was "Telephoto," and Wide World was "Wired Photo."

A January 1936 AP advertisement in *Editor & Publisher* magazine rhapsodized about Wirephoto's first year: "Eighteen thousand pictures, traveling 180 million miles, made it possible for the news-hungry public to see, with the keen eyes of the camera that misses no detail, the what and how and why of everything that was news while it was news. The result of a year of Wirephoto is a new kind of reporter, a newsman trained to see news in terms of pictures which can be delivered an hour from now instead of tomorrow, or next day."

Before its own electronic delivery system was up and running, Acme tried to stay in the game by using airplanes to deliver its pictures. And two things bought the company time. AP's photo reception quality sometimes left much to the imagination. And Acme's Fred Ferguson had scored a coup when he secured exclusive rights to all photographs taken of the Dionne quintuplets, born in 1934, through their fifth birthday.

The five cute, identical girls, the first quints known to have survived from birth, had grabbed the world's attention. They drew more visitors to Canada than Niagara Falls, and offered an upbeat distraction in the depths of the Great Depression. The public loved quint pictures, and only Acme could provide them, so editors retained Acme's photo service while the company perfected its own photo transmitter/receiver equipment.

By the time quint fever abated in 1936, Acme had developed

its own picture machines, more sophisticated and reliable than AP's, and capable of better quality. Photos were transmitted to subscribers on a limited basis, and "Telephoto" was put through a successful test at the 1936 political nominating conventions in Philadelphia and Cleveland.

Three major photo services were still slugging it out in 1948, when Acme, AP, and International assembled crews in Philadelphia for the Democratic National Convention. Harold Blumenfeld, always thinking speed, located Acme's workroom right inside the convention hall, enabling Acme to put pictures in client hands less than 30 minutes after they were taken. AP and INP were slowed because they had located workrooms off-site: AP at the *Evening Bulletin,* a mile and a half away, and Hearst's INP at the University of Pennsylvania, a quarter mile away.

AP and International's response was stopped cold for a while after President Harry Truman arrived at the hall and the Secret Service locked down the building for a time, making it impossible for AP and INP film messengers to even get film out of the hall.

Dick Sarno, head of Hearst's International picture operation, was so impressed with Acme's quick turnaround time that he appeared at Acme's door to ask Blumenfeld if William Randolph Hearst Jr. could come see how they did it. Young Hearst got a guided tour.

In 1951 Scripps president Roy Howard persuaded a reluctant United Press management to make 27-year-old Acme Newspictures a part of UP, to better match pictures and words and more smoothly compete against AP. UP president Hugh Baillie had resisted such a move for years, fearing that establishing a network of picture bureaus would diminish UP's profits. Boyd Lewis later wrote, "The UP, which should have [been competing] on even terms with AP, had declared dividends for its executives for years—by avoiding picture investment."

Mims Thomason was named UP Newspictures general manager and Frank Tremaine, a distinguished reporter and editor, was the assistant GM. "I didn't even own a camera," Tremaine says. "So there we were—two amateurs thrown in on top of a bunch of pros. It took a while for [word] 'Unipressers' around the world to accept pix people as one of them."

The new United Press picture network was not as extensive as AP's, and expanding it across the country became a top priority. A pair of brilliant UP engineers, Jerry Callahan and John Long, came up with Unifax in 1954, a revolutionary machine that needed no operator. Pictures could be viewed as they came in on a continuous roll of inexpensive electrolytic paper. Suddenly UP's picture service was within economic reach of the country's smallest newspapers and television stations. Unifax would soon bring UP pictures into 400 cities, allowing UPI to expand its leased photo network, and fill the great gaps between the East and West Coasts.

Frank Bartholomew, UPI's last reporter-president, took over in 1955, obsessed with bringing Hearst's International News Service (INS) into UP. He put the "I" in UPI in the spring of 1958, when UP and INS merged to become United Press International.

Hearst, who owned King Features Syndicate, received a small share of the merged company. Lawyers on both sides worried about antitrust problems if King competitor United Features Syndicate remained as a part of the newly merged company. So UFS was made a separate Scripps company, which deprived UPI of a persuasive sales tool and the eventual river of gold generated by Charles Schulz's wildly popular *Peanuts,* and other comics.

The new UPI now had 6,000 employees and 5,000 subscribers, 1,000 of them newspapers, though a decline in the number of newspapers in the country had begun. In cities that had two or more papers, the afternoon dailies—a majority of them UPI clients—were often the first to throw in the towel. There was also stiff new competition from "supplemental" news services created by major newspapers, including the *New York Times* and the *Chicago Tribune,* which had begun marketing their own news content to other news organizations at bargain-basement prices.

As a publishers' cooperative, AP could "assess" its members to help pay for extraordinary coverage of such things as wars, the Olympic Games, or national political conventions. But UPI clients paid only a fixed annual rate; they expected UPI to cover extraordinary events but UPI couldn't ask them to help shoulder the extraordinary coverage costs.

UPI sold its services helter-skelter, charging clients what they were willing to pay instead of basing rates on the size of the paper's market. Newspapers typically paid UPI about half what they paid AP in the same cities for the same services. The *Chicago Sun-Times* paid AP $12,500 a week but UPI only $5,000; the *Wall Street Journal* paid AP $36,000 a week but UPI only $19,300. Most papers paid less for UPI's worldwide

news and photo services than the salary they paid just one staff reporter.

Though UPI never faltered as a news powerhouse, it needed management and financial support from Scripps that it didn't get. As UPI's losses grew, Scripps focused on containing the losses instead of exploring new revenue sources. "The only bank we could do business with was Scripps," former UPI president Rod Beaton told an interviewer in 1995. "They had one vision. UPI was to be a fully competitive alternative news service to the Associated Press.

"[Scripps] wanted UPI for their newspapers and for their broadcast stations, period," Beaton said. "Beyond that, they weren't interested. The business was changing rapidly . . . so fast that we couldn't keep up with it. Hell's bells, we should have been the CNN. There wasn't a way in hell we could do that as long as Jack Howard was on our board. Jack represented the broadcast interests of Scripps, and they didn't want us doing that, period. Our ownership limited our opportunities sometimes."

Both Beaton and Charles Scripps, however, ignored entreaties from Bernard Townsend, a Scripps financial vice president, to explore the growing world market for business and financial information. UPI stuck to its basic business as the media landscape shifted and more nimble media companies found ways to profit from the communications revolution—a market that would enrich rival Reuters.

UPI lost $5.3 million in 1978, and Scripps began looking for someone to take the company off their hands. The client list was robust, with 7,079 subscribers worldwide, including 1,134 newspapers and other publications and 3,699 broadcasters in the U.S.

Scripps looked first to the journalism community, but the big players—among them the *New York Times* and the *Times-Mirror* and Knight Ridder chains—all said their shareholders would not want them investing in an ailing enterprise. News organizations that benefited most from the fierce competition between two news services proved unwilling to help keep one of them in business.

E.W. Scripps had established a trust for his four oldest grandchildren, and by 1981 all were in their 60s. If Scripps simply folded UPI, the trust could face as much as $50 million in severance pay, pensions, and other costs. But if they continued to underwrite UPI's heavy losses the trustees could be open to lawsuits by the heirs.

Like washing and waxing a car before a sale so the customer doesn't look too closely under the hood, Scripps even spiffed up UPI's New York headquarters to impress would-be buyers. The news and photo departments were relocated and the first new furniture staffers had seen in years appeared, along with workstation cubicles that made UPI's world headquarters resemble an insurance office. No longer could staffers eat lunch at their desks—but that policy was dropped when staffers actually started leaving their desks for lunch and their phones and the day's business went unattended until their return.

Reuters, a British-owned news agency, ran a limited news-gathering operation in the United States. Sensing a bargain, Reuters expressed interest in UPI, and its executives toured bureaus in the U.S. and abroad, gaining intimate knowledge of UPI operations, before talks collapsed. But Reuters would be back.

By 1982, after four years of trying to find someone to take UPI off their hands, the Scripps family members reached the end of their rope. They even considered giving the company to National Public Radio, which could have meant a UPI tax break for as much as $100 million. NPR nixed the idea. The company's financial troubles seemed irreversible, and "UPI had become such a hot potato," one executive said, "that they were ready to toss it to anyone who would grab it."

Grab it someone did. On June 2, 1982, Scripps president Ed Estlow announced that UPI had been sold to Media News Corp., a new company formed by an unlikely and virtually unknown pair of young entrepreneurs from Tennessee: Doug Ruhe, 37, and Bill Geissler, 35. They owned a small Nashville company that, it turned out, was barely meeting its payroll, an attribute they'd bring with them to UPI.

The two men had no news experience. In time they managed to do to UPI what AP could never have accomplished—pillage the company assets and reduce a proud company to insignificance. Over the next 17 years after UPI was "sold," it would have four chairmen, 13 presidents, a fire sale of assets, ever-shrinking revenues, and a steady defection of clients. And twice it would seek bankruptcy protection.

Ultimately, and contrary to speculation at the time, Scripps didn't get even a token dollar for UPI; it gave UPI away, and sweetened the deal by giving the new owners eight million dollars to pay off debts and shore up the anemic pension fund. "In a sense," Charles Scripps later said, "we filled up the gas tank and sold it that way. So they had some working capital."

Scripps wanted no liability if UPI's creditors forced the company into bankruptcy, and wanted to demonstrate that it had made every effort to give the new owners a reasonable chance at success. "It was not generosity as much as self-interest," a source close to the negotiations said. "The main consideration was that Scripps didn't want to get the business back in six months."

Soon there were hints of money troubles. In 1983 UPI president Bill Small got a call from a friend, a vice president of the *Chicago Tribune,* wondering why UPI hadn't paid the $100 owed for papers delivered to UPI's Chicago bureau. By 1984 money was so tight that the phone company cut off bureau telephones for nonpayment.

Ruhe and Geissler weren't exactly wowing the journalism world. They had owned UPI for a year and a half when they tried to "wing it" in a forum where newspaper experience and doing some homework would have been helpful: their debut before the convention of the American Society of Newspaper Editors.

They did not invite any of their older and wiser UPI veterans onstage to help field questions. Will Jarrett of the *Denver Post* got right to the point: "What can you provide newspaper editors that AP cannot?" Neither Ruhe or Geissler, separately or together, could offer a good answer. The *New York Times* coverage was merciless: "Without exception editors interviewed after the session were convinced that Mr. Ruhe and Mr. Geissler did not know enough about newspapers to make it worthwhile to subscribe to the [UPI] service."

Photo stringers helping UPI cover the 1984 Olympic Games in Los Angeles were surprised when a well-dressed fellow appeared, carrying a briefcase full of money to pay them in cash. Banks were no longer honoring UPI checks. Stringer Wade Byers remembers being told that "the owners were trying to sell UPI and it would send the wrong message if the company collapsed during the Olympic Games."

Other stringers around the country weren't so lucky. They continued to provide pictures that UPI used immediately and submitted bills that UPI didn't pay for weeks or months. Fed up with the long wait, many drifted away to the competition. Staffers had it slightly better: their paychecks still cashed, but UPI was slow to reimburse them for out-of-pocket expenses—cabs, meals, and such. American Express canceled cards issued to executives and bureau chiefs. UPI had come to stand for "UnPaidInvoice."

UPI was so desperate for cash—in many cases just enough to meet the payroll—that Doug Ruhe began selling off irreplaceable parts of UPI at fire-sale prices.

Assets UPI needed to sustain day-to-day operations were sold for less than the annual revenues they produced: the company's stake in UNICOM, a worldwide commodities news service; its right to one-fourth interest in UPITN, a television news film service; the rights to its electronic database; the right to market UPI's stock price reporting service; and its priceless, 11.5-million-image picture library. These transactions provided one-time cash infusions of millions of dollars but divested UPI of vital resources and revenues it needed to survive.

Perhaps the most capricious of all the dealmaking was the 1984 sale of UPI's robust overseas picture operation to rival Reuters for about a third of what it was worth. So formidable was UPI's European photo operation that UPI wouldn't sell the picture service to any client who didn't buy the news report, too.

Only a year before, Ruhe had agreed when his senior staff told him that the foreign newspicture operation was so critical to UPI that it should be sold only as an act of desperation. Reuters had no photo operation of its own, and had predicted in a June 1984 stock-offering prospectus that it might acquire UPI's overseas operation for $7.5 million. Now, keeping the negotiations secret from even his most trusted executives, Ruhe sold the UPI foreign photo operation to Reuters for only $5.7 million, millions less than even Reuters thought they might have to pay just months earlier: $3.3 million in cash and $2.4 million in monthly payments over five years.

The deal gave Reuters 24 functioning photo bureaus and dozens of its best photographers, plus a working distribution system and millions of dollars in long-term client contracts. It enabled Reuters to take a giant leap ahead of Agence France-Press, which at the time was trying to organize its own worldwide photo service.

UPI's European controller Charles Curmi had learned that Reuters might have been prepared to pay far more for UPI, perhaps as much as $10 million. He relayed that information to Ruhe's negotiator Bill Alhauser, who warned him not to rock the boat because UPI was so desperate for cash. The deal done, UPI's executive picture editor, Ted Majeski, was outraged. "If there was a buck in it," he said, "these guys

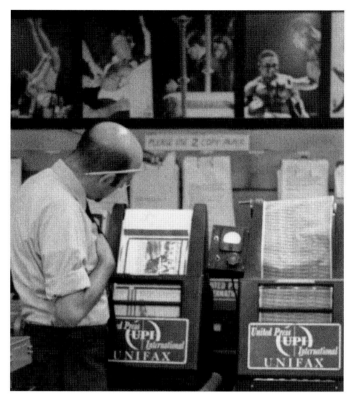

UPI New York. Prizewinning photos adorn the walls and more arrive via Unifax at world headquarters in the *New York Daily News* building on East 42nd Street in 1969.

would cut off and sell your leg and still expect you to run in the Olympics."

UPI would later say that its ledgers weren't sophisticated enough to determine whether the overseas picture operation had been independently profitable. But Mike Hughes, the UPI executive editor and vice president in charge of the international division, had no doubts. The sale to Reuters, he said, was "the most idiotic deal that was ever made." Had Reuters worked 24/7 to organize its own service, Hughes said, "it would have taken [them] three years just to put all the transmitters in place. I'd say a conservative guess is that we saved them $20 million and five years."

UPI, of course, still needed to provide foreign photo coverage for its domestic network. It could no longer direct foreign coverage or tailor it to UPI's needs. Using UPI's former staffers, Reuters would now provide European photos to UPI. And as part of the deal, UPI would furnish American photos to Reuters. In the final moments of negotiation Ruhe even agreed—against the anguished advice of key executives—to let Reuters compete with UPI in the

U.S., selling its own photos to the larger U.S. newspapers.

Majeski was openly contemptuous of Reuters' ability to serve UPI's needs. A major earthquake rocked Mexico City in 1985, and UPI was almost three hours ahead of AP with the story, but Reuters had not yet provided pictures. Majeski arranged a chartered plane and sent a photographer to Mexico City, who got sensational earthquake pictures for UPI clients. Majeski sent Reuters a bill for the charter.

Next on the block was UPI's crown jewel: the picture library. Its 11.5 million images of events and personalities, some so old they were on glass plates, dated back to the Civil War. It is a priceless collection not just because of its size, but because of the "you are there" quality of its once-in-a-lifetime moments recorded by International News Photos (1912-58), Acme Newspictures (1923-52), Pacific and Atlantic Photos (1927-30), and United Press.

The sale of reprint rights to the pictures was earning UPI more than a million dollars a year, using only four salesmen and no marketing program. The business department believed that a new electronic retrieval system and a marketing plan could double or triple that income.

"Who cares about a damn picture library?" Geissler asked. In 1984 he sold it to the Bettmann photo collection—by then owned by Kraus-Thompson of Canada—for only $1.1 million. It was called an "advance royalty payment" in a 20-year deal.

Bettmann gained exclusive control and proceeded to move the photo files UPI needed every day to Bettmann's New York office on 21st Street. UPI lost immediate access to its own archive and had to pay Bettmann $35 every time it needed a copy of one of its own pictures, often several times a day. For a time Bettmann even charged UPI photographers $15 a print whenever they needed a print of one of their own photos to enter in year-end contests. Bettmann split resales of UPI's pictures, keeping 75 percent for itself.

The owners needed cash. They seemed not to understand or care that they were selling a photographic treasure, although it is not difficult to imagine that the photo collection could have gone the way of UPI's word files, which were sent to a warehouse and, after UPI failed to pay the rent, vanished, along with the warehouse. In 1996 a staffer visited the site and found an apartment building where the warehouse used to be.

The fire sale of company assets had raised $10 million but in the process had reduced the company's annual revenues

by at least $7 million a year—to $93 million a year from more than $100 million.

UPI photo editor Ed Hart was assigned as liaison to Bettmann after the move. The Bettmann staff, he recalls, couldn't grasp the meaning of UPI's connection to the files. Bettmann had never been a news service, and the staff was "totally unprepared to handle UPI's requests for copies of its own pictures," Hart says. "It was an adversarial relationship." When the Duchess of Windsor died in 1986 and UPI needed a quick file portrait, it couldn't obtain one for six hours because Bettmann's overnight staffer wouldn't let a UPI staffer come select one. The next day the Bettmann staffer was fired.

In 1995 Bill Gates's Corbis bought and is today preserving the Bettmann archive—UPI's 11.5 million images and the 5 million-plus pictures Bettmann had accumulated since 1933. The undisclosed price was reported by *Newsweek* to be $6 million.

While the company struggled to stay in business and UPI's loyal staff accepted a 25 percent wage cut to help out, Ruhe and Geissler were hiring consultants who did little but collect fees as high as $20,000 a month. The staff would have been scandalized to learn that the owners expecting them to make one sacrifice after another were paying a consultant more every six weeks than they made in a year.

When UPI filed for bankruptcy in 1985, the court learned that UPI had collected employee payroll deductions, but had not forwarded them to the Internal Revenue Service or the employee credit union.

In August 1990 many UPI staffers, including several senior editors, got pink slips. Senior executive Pieter VanBennekom sent a message to all bureaus. He said that he would "miss those who left us, [but that] reshaping the staff is necessary to create the new UPI." By November, saying it was on "life support," UPI imposed a 35 percent cut for remaining non-union employees. Staffers represented by the Wire Service Guild voted to accept the 35 percent wage cuts while, the Guild noted, "UPI tries to seek a buyer to keep the company alive." By 1991 UPI was back in bankruptcy court, listing $22.7 million in assets but $65.2 million in liabilities.

In 1998, Arnaud de Borchgrave, the former editor of the Reverend Sun Myung Moon's *Washington Times,* became UPI's CEO, but by then UPI had lost virtually all its newspaper clients. It had retained some 400 radio clients, but in 1999 sold those contracts, too, to the AP.

By 1999 UPI ceased being a traditional wire service. "It is time to move on," Borchgrave said, and UPI would from that day forth exist only on the Internet. "The world no longer needed two redundant wire services." In May 2000 what remained of UPI was sold to Moon's News World Communications for an undisclosed amount. UPI was down to 157 employees—in Washington, London, Latin America, and Asia—and only a few customers.

Given the fact that Scripps gave the company away, one might wonder why UPI's executives—who possessed the news experience Ruhe and Geissler lacked—didn't try to buy UPI in 1982 when Scripps was paying someone to take the company off their hands. And if Scripps wanted to give the company away, why they didn't sound out UPI's loyal employees.

Buying UPI, Frank Tremaine says, "was totally impractical financially. Even though the price was right, it took oodles of money to operate UPI and none of the top brass, which presumably included me, had the necessary resources. The E.W. Scripps organization had sunk millions into the company to keep UPI afloat for years. They couldn't continue to do that, nor could they finance UPI executives to try to keep it going. Major publishers and broadcasters already had rejected the idea. It just wasn't feasible."

Bob Page said: "My regret, looking back on it, if I had known about leveraged buyouts, I would have put a group together. I said to Rod [Beaton, UPI's president] many times over that if they were going to give it away, which they did to Geissler and Ruhe, they should have given it to you and me. We wouldn't have screwed it up. I mean, we loved the company. They could have given it to all of us."

Today, the only mention of UPI in newspapers is likely to be found in the obituaries, since a considerable number of the nation's journalists over 50 once worked for United Press International.

"UPI never admitted to 'going away,' recalls photo stringer Harrison McClary. "They were still there, but from late 1993 or so anyone crazy enough to transmit [pictures] to them was not getting paid. They closed down most of their bureaus . . . and the people now working for them are not the same people from the old days."

The decline of the once-great company "was like watching a parent die," Ed Hart says. "From the time I was seventeen years old, Acme, UP, and UPI was my family. I spent more hours with those people than I did at home."

UPI vs. AP

Serious photojournalists work to seize the moment, not win awards.

UPI photographers regularly did both. In addition to seven Pulitzer Prizes, they repeatedly won every other award known to news, feature, and sports photography: World Press Photo, the National Press Photographers Association's Pictures of the Year, White House News Photographers Association, George Polk Memorial Awards, and regional and statewide photo competitions.

UPI and AP never published anything. They reported and photographed the news and distributed stories and pictures to customers who did publish. To a far greater degree than their newspaper counterparts, AP and UPI photographers fought the clock and each other to get a picture first "to the wire" knowing that somewhere in the world, almost every minute, a customer was on deadline.

News service photography provided instant gratification. Today you shoot and transmit your best pictures, and tomorrow morning you find out how well you did after a "jury" of editors with access to both UPI and AP services has "voted" by publishing your photo or the other guy's. These contests were closely monitored by both UPI and AP.

A press pass was your all-access ticket—a ticket to experience without experience's costs, an opportunity to meet people you'd otherwise never meet, and to learn that even the most famous and powerful at least pretend to be ordinary mortals when a news photographer's camera is aimed at them.

For more than 30 years news service photographers worked anonymously. UPI routinely put bylines—reporters' names—on stories, but not on pictures until the 1970s, and then only after the *New York Times* and other large newspapers began requesting names so they could credit photographers along with the agencies they worked for.

Perhaps there was no rush to name the photographer, and the photographer wasn't eager to be named, because

for years even the finest photographs given the most prominent newspaper display didn't exactly take a reader's breath away. Until the 1980s, most large newspapers were printed using turn-of-the-century letterpress printing technology using easily smudged oil-based ink; off-white, low-quality newsprint paper; and coarse engraving screens.

The words stayed legible on the page, but the photo-engraving dots that formed the pictures almost always smeared and became fuzzy and indistinct, so that even when newspapers used photographs well—a good crop, a respectable size—murky reproduction often left readers rereading the caption to see what the photo was all about. Not until the 1980s did a majority of newspapers switch to offset presses that reproduce photos with great fidelity on better, whiter paper.

By contrast *LIFE,* one of America's most popular weekly magazines from 1936 through the early 1970s, was filled with photographs reproduced beautifully on oversize 11 x 14-inch pages, using fine engraving screens, high-quality inks, and glossy paper. *LIFE* often published a UPI or AP photo that had been widely reproduced in newspapers, but the quality magazine version appeared to be a different photo altogether.

In large part because their pictures were reproduced clearly enough to be appreciated, and because their name always appeared with their work, magazine photographers achieved near-celebrity status. *LIFE* became a standard by which the public judged photography. Many of today's photo books celebrate "photojournalism" as if it had been the exclusive province of these magazine photographers.

The *Best of LIFE* (1973), for example, opens with a two-page (1960) group shot of 39 justly famous *LIFE* photographers. But 300 pages later, photo credits reveal that scores of the photos among *LIFE*'s "best" were taken by UPI and AP photographers.

During the civil rights struggles in the South in the '60s,

magazines would assign their own staff or pay freelance photographers more for a day's work than UPI photographers made in a week. But those magazines regularly featured photos shot by UPI and AP staff photographers.

Newspaper staff photographers always enjoyed the luxury of working toward just one or two deadlines a day. And, most times, they could return with their pictures to their office, familiar surroundings, and a support staff to process the film and make prints.

But when UPI and AP photographers went toe-to-toe, getting a good picture was often the easy part. Today's digital photo technology makes it a breeze for photographers to stay on the job while they send their pictures and captions to their office, but it wasn't always so simple.

The news service skirmish used to involve lone photographers from each service who had to cover an event, leave the scene at the risk of missing something better, and get somewhere as fast as possible to process, edit, print, caption, and transmit the pictures. The mad dash from an event to darkroom and back might be repeated two or three times on an onerous news day.

More often than not there was no bureau nearby, so a "darkroom" involved a temporary operation that the photographer cobbled together in advance: a room that could be made dark, that had running water, electricity, and a phone. UPI worked out of hotel rooms, friendly local newspapers, public restrooms, and mobile homes parked near pay phones. Even a major Hollywood film studio, Paramount Pictures, once played host to UPI photographers trying to beat AP.

Converting a hotel room into a photo operation had its

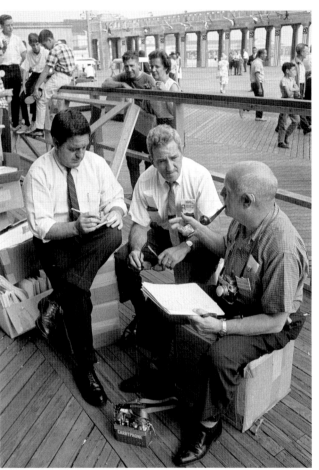

Boardwalk board meeting. Charles McCarty, George Gaylin, and Harold Blumenfeld work out 1964 political convention coverage on the Atlantic City boardwalk.

amusing moments. An upscale New Orleans Hyatt hotel room was transformed into a lab/darkroom with heavy black plastic gaffer-taped floor-to-ceiling over all the windows and door openings, and extension cords draped everywhere—to safelights, a film dryer, and a transmitter. The maid let herself in the first night to turn down the bed and leave chocolates on the pillows. No doubt wondering if Dr. Frankenstein had moved in, for the duration of the stay she remained in the hall and pushed UPI's chocolates under the door.

Even with multiple UPI photographers on a story, there was always a race to speed film from the photographer to the lab. By motorcycle from the first Super Bowl to the Los Angeles bureau. By ski couriers during the 1960 Winter Olympics in Squaw Valley, Calif. And even by United Airlines flight attendants at the 1968 Democratic National Convention in Chicago. UPI's attractive young women film runners in eye-catching outfits were greeted by name and waved through security checkpoints by guards who hassled everybody else.

Foreign assignments often meant that in addition to a bagful of cameras and lenses, the photographer hauled a "portable" darkroom and transmitter. President Lyndon B. Johnson was en route to Australia in 1968 when he stopped in Pago Pago, American Samoa, for a few hours to give a speech while his plane refueled. UPI's Los Angeles staffer transmitted five pictures, the first radiophotos ever transmitted from Pago Pago, using 700 pounds of extra gear lugged from Los Angeles and rigged up inside a U.S. Navy facility.

Competition between news services sometimes got so

intense that one would steal the other's story and rewrite it. AP once caught out UPI with a story from India that quoted a Mr. Siht El Otspueht. UPI's version appeared in the *New York Sun* with the same quote. *Siht El Otspueht*, spelled backward, is "The UP stole this." AP had caught a thief.

Annual national and international photo awards affirmed that AP and UPI photographers were in the top echelon of world news photography—kept on their toes by the presence of the "other guy" that kept them both working harder and shooting smarter. In 1967, AP's Jack Thornell shot a Pulitzer winner right under the nose of one of UPI's best. In 1978, John Blair's shot won UPI a Pulitzer even though AP had two photographers practically rubbing shoulders with him.

But UPI was unique in the newsgathering business because its photo and word operations were separate but equal. Not only did UPI photo bureaus operate independently of their "news side," but in many cities, and for years that included the New York headquarters, "photo" was in another building entirely. The unorthodox management structure was a secret weapon, since almost every UPI photo coverage decision—from plan to execution, and especially the film editing—was done by photographers or photo editors who had never been reporters.

AP functioned more in the manner most newspapers do, with the photo operation an ancillary extension of the newsroom. Until the 1970s, AP's regional newsphoto editors in Boston, Washington, Atlanta, Chicago, Dallas, and Los Angeles were all former "word men" with little photo experience or expertise.

AP's photographers were easily as capable and skilled as UPI's, but the minute they surrendered their film to an AP "photo editor" they often ceded advantage to UPI, because the best pictures didn't always get picked. AP would win year-end contests with excellent pictures that a "photo editor" had failed to select back when the story was news.

Lou Garcia, a UPI photographer, began his news service career with AP, where his duties included producing a picture page a week using pictures from AP photographers around the world. Garcia and his boss, Max Desfor, were regularly "amused and amazed," Garcia says, to find that some of the AP's best pictures hadn't been selected by AP's photo editor.

"Picture-taking [AP] photographers were often dismissed early to avoid overtime," Garcia recalls, "leaving an editor who was considered management to pick the frame, a picture [chosen not on its own merits but] because it matched the AP wire story."

Every UPI photo bureau had fewer photographers than the AP photo bureau in the same city. In Philadelphia in 1960, AP had seven photo staffers to UPI's one. UPI photographers often made up the staff disparity by being more nimble, able to assign themselves and scramble to a story— something as simple as catching the last commercial flight of the day—while an AP decision percolated through its cumbersome, word-oriented process.

UPI photographers, while anonymous, were not leaderless. Frank Tremaine, vice president for newspictures, had distinguished himself as Honolulu bureau manager when the Japanese bombed Pearl Harbor. He filed the first news reports on the attack, and his wife, Kay, dictated the first eyewitness accounts of the bombing. He was aboard the USS *Missouri* when Japan surrendered in 1945. Tremaine adapted well to the rowdy "picture side" full of colorful characters and great photo editors.

UPI's executive picture editor Harold Blumenfeld believed that UPI photographers on assignment should carry a camera wherever they went. He met several shooters arriving for the 1960 World Series at the Pittsburgh airport and noticed that John Quinn, of the Chicago bureau, carried no camera. It was, Quinn explained, in his luggage. Blumenfeld turned away and loaded everybody else into UPI's car, leaving Quinn to contemplate his future while catching a cab to the hotel.

Thanks to Blumenfeld, UPI embraced 35mm cameras in the late 1950s, when most newspaper and AP photographers were still in their "Mexican Justice" mode: stand-'em-up-and-shoot-'em with flash and a 4 x 5 Speed Graphic. Though a few AP photographers regularly used 35mm cameras, AP did not begin a systemwide 35mm conversion until after AP member papers began complaining that AP photos of events, shot with a flash on the camera, lacked the "liveliness" of UPI's pictures of the same situation.

At the 1960 political conventions Blumenfeld decreed that UPI would shoot only 35mm, allowing photographers to use far smaller cameras using available light and streamlining the lab operation. He hand-picked photographers from around the system who were already comfortable with the small format.

In the field, UPI photographers were their own editors.

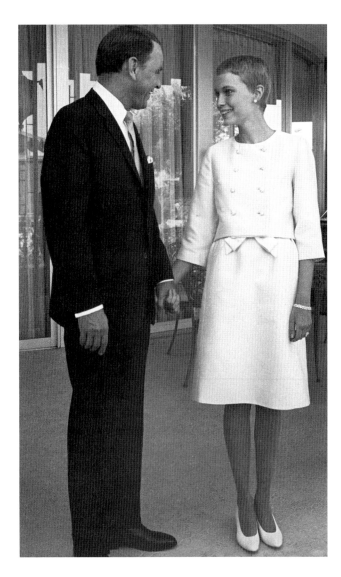

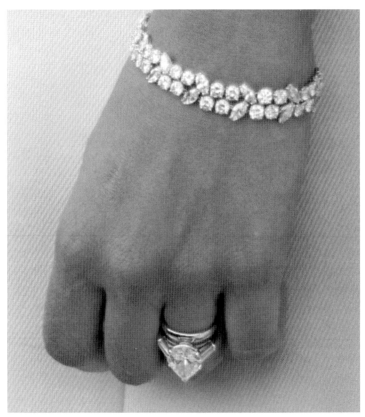

Rock. Frank Sinatra, 50, married Mia Farrow, 20, in Las Vegas in July 1966. (The marriage would last 17 months.) No news photographers were permitted at the ceremony, but the couple posed for a few minutes afterward, just standing there. Editors loved UPI's telephoto closeup of Mia's tiny hand and 9-carat ring. AP later tried to match UPI's shot in the darkroom by enlarging that tiny portion of their negative, resulting in a photo showing more film grain than ring. *Photo by Gary Haynes.*

On major national and international stories—Super Bowls, inaugurals, political conventions, World Series—involving a large staff, New York headquarters worked out the plans and logistics involving multiple photographers, and sent excellent film editors who could find that needle in a haystack. New York's top editors, Ted Majeski and Larry DeSantis, were a breed apart, able to "rephotograph the photographs" as the film blurred past their editing loupes. The 35mm format guaranteed that photographers would shoot a lot of film. Young staffers tended to use more film than the "old timers," like Washington's Frank Cancellare, who learned careful shooting during his years with 4 x 5 cameras. "Cancy" could shoot five or six excellent pictures on a single 35mm roll. UPI photographers at the 1964 Democratic National Convention shot ten cases, 3,000 rolls of 36-exposure 35mm film—a potential of 108,000 individual pictures.

Newcomers to these events were always startled to see just one editor, Schneider 4x magnifying loupe in hand, zipping past every frame like a human motor drive, pausing only to notch the numbered edge of an occasional frame to be printed. Fearing that the speed of the edit meant good pictures were being missed, at the end of the day new shooters would examine their own film. They were invariably amazed to see that UPI's photo editor hadn't missed a frame.

And UPI had *attitude*. For most young UPI photographers, UPI was their home, their family, their political base, and

their distraction. Everything else could wait, including their families and friends, who were expected to understand as they rushed to catch the next plane to another big story. Photographers willing to do that were rewarded with more and more big stories, and a far-above-average divorce rate.

Photographers from the two agencies shared a mutual respect. Trying to beat the other guys by day didn't mean that UPI and AP photographers didn't schmooze at night after the work was done. Eddie Adams of AP and Gary Haynes of UPI could be found prowling Shinjuku nightspots together during the Tokyo Olympics in 1964, signing autographs for eager young Japanese who refused to believe that the (then) athletic six-foot Americans weren't Olympians.

Still, the relationships weren't always cordial. UPI's Bill Lyon, Southern Division photo manager, once dangled AP's photo editor, Bob Otey, off a third-floor balcony at Orlando's Cape Colony Inn, forcing the terrified Otey to admit he had held back a roll of NASA pool film he was supposed to have given to UPI—a violation of the pool agreement.

Morty Dagawitz, facing a wave of UPI layoffs, got a job at AP as a photo editor in 1971, and experienced culture shock. "AP staffers acted more like civil servants, going by the book and watching the clock," he says. "I never met an AP photographer who had the love of photography that my New York UPI colleagues did."

Accustomed to the UPI culture in which editors grabbed cameras, Dagawitz spent one lunch hour photographing a horse-jumping contest right outside AP's office in Rockefeller Center. His photos of horses amid the skyscrapers got AP lots of play, but threats of a union grievance instead of praise from fellow staffers. AP editors don't take pictures, his boss explained. "Once you've become an editor for the AP there is no going backward."

However comprehensive a news service photo report might be at day's end, its value to clients was to have a variety of photos at deadline time. Newspapers large or small use news service pictures in the same way—a mix of national and regional news, sports, and features.

Only one picture could be transmitted every eight minutes on either agency's national picture network. UPI's editors always tried to pace UPI's pictures on major stories so as not to bury editors in more photos of a single event than any publication could possibly use, to the exclusion of everything else that happened that day.

The AP, until the mid-1970s, didn't so much edit its picture report as dump a hundred-plus photos a day on members with no apparent pacing, or grasp of members' needs or deadlines. A single major story would often dominate AP's picture wire to the virtual exclusion of all else, dozens of photos on a single subject that left editors on deadline desperate for pictures of other events—foreign, national, sports.

In the 1970s large newspapers began to hire photo editors to direct photo staffs who also monitored news service pictures, and they began to critique the AP picture report. At first, AP claimed to serve so many masters that it couldn't be all things to everybody. But the criticism continued, and *Editor & Publisher* magazine invited photo editors from a dozen papers large and small to comment. David Yarnold, assistant photo director of the *San Jose* (Calif.) *Mercury*, said that he was "as touched as anyone by the royal wedding, but forty-one transmissions from London (noon to noon) the day BEFORE was a bit bloody much."

The article led to several New York sessions with AP executives and member photo editors who wanted to see AP picture service improve, to better serve their needs. AP president Louis Boccardi sat in on one marathon session, and not long after, AP's picture report became more user-friendly.

UPI pictures gave AP a run for the money right up until UPI ran out of money. UPI didn't wither away because AP provided superior pictures of the world news. UPI's "enemy" was within—its owners operating well beyond their competence, fumbling and frittering away a great enterprise, despite the heroics of loyal UPI staffers who made concession after concession after personal sacrifice. They kept competing with AP while trying to keep the ship afloat as the captains were scuttling it.

"The strongest bonds that hold UP together," observed author Stephen Vincent Benet, "and what it boils down to, when the sentiment and wisecracks are skimmed off, is an actual and genuine love of the game. Other factors may well be that UP is an organization of young men, average age about twenty-eight, from small towns and Midwest colleges of journalism, plain fellows of Nordic stock with scarcely a Harvard B.A. among them, and every executive has come from the ranks."

UPI Newspictures, RIP.

UPI Downhold $$$

The author's personal recollections.

UPI staffers knew their company pinched pennies, and heard occasional rumors that paychecks might bounce. But there was news to cover and AP to beat, and nobody really believed that a company with 223 bureaus around the world, 6,000 employees, 5,000 nonstaff "stringers," and 7,500 customers in 100 countries, wasn't making money.

UPI, after all, was owned by a "deep-pockets" company, Scripps Howard, whose own newspapers depended upon UPI's news and pictures.

The watchword was "downhold." Hold down expenses: don't compromise news coverage but use materials wisely, limit long-distance calls, and entertain no clients or sources if there was a graceful way not to do so—or get them to pay.

"I don't want this to be interpreted as a panic letter," a 1977 downhold memo began. Superintendent of bureaus Bernie Caughey warned managers that stringer invoices exceeding the month's budget wouldn't be paid. "A really good manager will sparkle in less than ideal circumstances," Caughey concluded. How nonstaff stringers might sparkle if they didn't get paid for their work, Caughey didn't speculate.

UPI was notoriously stingy with supplies, and bureaus stayed "in budget" by making every frame of film count. If an assignment required only half a roll of 36-exposure film, the camera went into the darkroom, where the exposed frames were cut off and processed, saving the rest of the roll for the next assignment. Bureaus experimented with loading their own film. A bulk roll of 35mm Kodak Tri-X was good for about 18 rolls of 36-exposure film, saving a third the cost of the same number of rolls of factory-loaded film. But that false economy was always abandoned; repeated reuse of film cassettes can scratch and ruin every picture.

It sounded impressive when I was named UPI picture bureau manager in Philadelphia, America's fourth-largest city, in 1959, a "bureau" consisting of just me, a desk and a chair situated in a corner of the *Philadelphia Inquirer* photo department. AP had a photo staff of seven. "Don't worry about that vast AP staff," vice president Frank Tremaine wrote after I pointed out the odds. "It's not the volume you turn out, but the pinpoint coverage." Tremaine soon visited and asked if there were any costs to cut. Other than photo supplies, the photo transmitter, and one phone line, UPI owned nothing. The furniture and even the typewriter belonged to the *Inquirer*. UPI did pay $2 a month for a key that switched off the desk phone so nobody could pick it up and interrupt a photo being transmitted from the extension in the darkroom. A few weeks later New York said "cancel the key." A few ruined transmissions after that, UPI paid $12 to have it reinstalled.

UPI's commercial photography division, "Compix," sometimes asked the news staff for help. Bill Lyon, Southern Division picture manager, volunteered himself and (without asking) me to shoot a skydiving assignment for Eastman Kodak on what otherwise would have been our day off. We'd go up in two different Cessnas with pilots not old enough to shave. The diver would jump from my plane, with Kodak's newest video camera attached to his helmet, and Lyon's plane would follow his descent. Our photos would be used in ads for the new camera.

The right-hand door of my plane was removed and I was secured to the floor with nylon straps. On signal, the diver let go and my pilot rolled right, providing me a clear shot of the diver plummeting to earth. I realized that only nylon straps kept me from joining him. Lyon's plane had gone into a power dive, the pilot having taken too seriously Bill's instructions to "keep up with the diver" until the parachute opened.

Back on the ground, Bill was an odd color, and cursing. Then he threw up. He swore he would not—as in NEVER—

put a foot back into any plane that day, or maybe ever, including the one that was to fly us home. NEVER again would we help Compix. Bill swore some more when Compix called a few weeks later to thank us for saving UPI "more than a thousand bucks" that freelancers would have been paid to shoot Kodak's pictures.

David Kennerly lost a shoe while covering celebrities affected by 1968 Los Angeles floods. Actress Ann-Margret's front yard was a quagmire, and her muddy drive claimed his shoe. New York balked at paying $32.95 for a pair of new shoes until they reluctantly conceded that you can't replace just one shoe.

Photographers and reporters shared an intense company loyalty that is difficult to describe and more difficult for non-UPI people to understand. UPI photographers were paid less than their AP competitors, and often far less than photographers from metropolitan newspapers who worked alongside them. In key bureaus the photo "managers" who had a staff to direct often earned less than their unionized staffers, who could claim overtime. UPI considered its "managers" of "one-man bureaus" to be exempt even after the National Labor Relations Board ruled otherwise, and few managers ever claimed overtime. The best assignments went to staffers who ignored the clock—regular national and foreign assignments that many newspaper staffers only dream of covering.

Martin McReynolds flew from New York to Nicaragua for a violent presidential election. Not only did he write all the UPI stories, he shot and transmitted all the pictures, working against AP's staff of three. UPI was ecstatic about his one-man word and picture extravaganza until he claimed 64 hours of overtime for having worked nonstop and on his days off. Offered an extra 21 hours of straight time, he eventually collected time-and-a-half for 72 and a half hours.

Miami staffer Russ Yoder and I were attacked in separate incidents during racial unrest in St. Augustine, Florida, and our cameras were stolen—mine by a "deputy sheriff" who also broke my hand in three places with his nightstick. UPI's treasurer A.P. Bock pointed out that our gear was "used." Yoder would receive only $400.92 for more than a thousand dollars' worth, and I'd get $248.35 for my $900 worth of lost Nikons. Aware that staffers would be less eager to risk both their skins and their personal cameras if UPI didn't stand behind them, the company eventually paid us the full replacement cost.

Motorcycle daredevil Evel Knievel planned to jump 1,700 feet over Snake River Canyon in 1974 on a rocket-powered "Sky Cycle," and LA bureau manager Carlos Schiebeck reserved a helicopter for $500. He knew New York would balk, so he told them the chopper would cost $1,000. If he sought thrills, he was told, he should come to New York so they "could throw [him] out the sixth-floor window." When Schiebeck got the chopper at half the price they were so happy they paid without a word.

"Line" bureaus outside of New York had meager budgets. At major events—championship fights, national political conventions, the Olympics, NASA launches—New York shipped in equipment, darkroom goodies, and 300-roll cases of 35mm, 36-exposure Tri-X film. We helped on the story, and helped ourselves to two 20-roll "bricks" of film a day, one for the day's photos and the other to take home to our bureaus. We also volunteered to help pack up after events, and would sometimes put new labels—our own bureau's—over those directing photo gear back to New York. After the Mexico City Olympics in 1968, I redirected a new enlarger to my Chicago bureau, only to learn later that it ended up in Atlanta, sent there by Bill Lyon, my former boss, who stuck his bureau's label over mine.

Some UPI veterans, including former Southern Division news manager Lewis Lord, to this day carry vintage membership cards: THE DOWNHOLD CLUB OF UNITED PRESS, signed by superintendent of bureaus L.B. "Save a Nickel" Mickel. "Being dedicated to the proposition that nothing is so cheap it can't be done cheaper, and not having demanded a new pencil since the last meeting, is a member in good standing entitled to no special privileges, consideration or credit whatsoever," the cards read. "Lots of us worked for other outfits longer," Lord says, "but it's the UPI days that are the most memorable."

Years, perhaps decades, after UPI's heyday as an important worldwide news agency, most of its uniquely trained and inspired news and photo "graduates" have moved on to other endeavors or have retired. Many stay in touch by way of a dedicated Internet Listserv, where they reminisce about UPI, their experiences, and UPI's penny-pinching ways, and sound off on current events. Appropriately, they call their list "downhold."

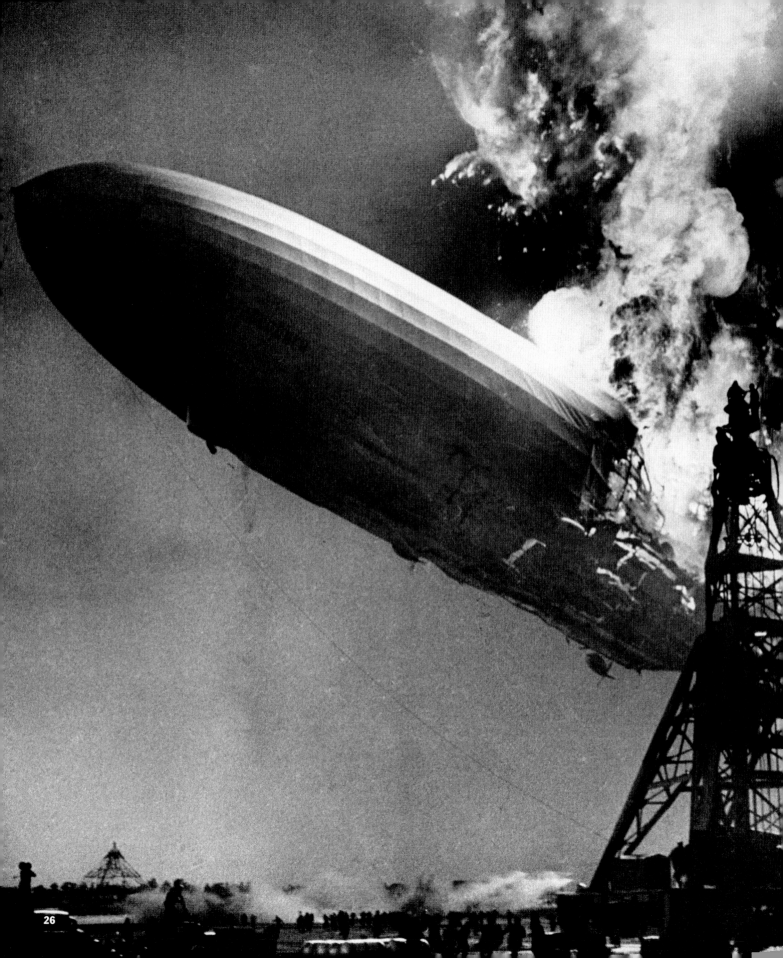

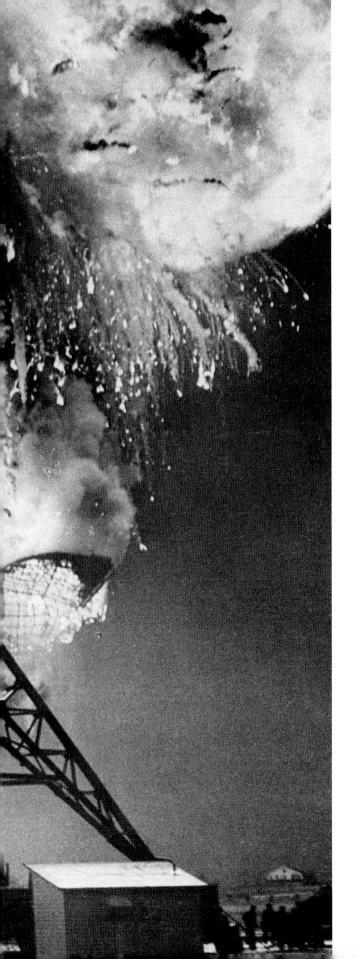

Early Years

Words traveled by wire—phone lines—long before there was any way for the "wire services" to transmit pictures. Through the mid-1930s photos were dispatched to subscribers by autos, trains, airplanes, bicycles, foot messengers, dirigibles, and even ocean liners. Delivery took days, or weeks.

In 1903, the Newspaper Enterprise Association (NEA) provided its clients with a photo of the Wright Brothers' "flying machine" in the air, delivering it by mail and messengers well after the fact. It was received as a lightweight printer's mat, which, cast in molten lead, recreated the original photoengraving.

To provide "hard news" photos in 1923, E.W. Scripps established United Newspictures, renamed Acme Newspictures two years later. Acme was experimenting with sending photos over phone lines as early as 1924. When Calvin Coolidge was sworn in as president on March 4, 1925, AT&T arranged for simultaneous reception of the picture in New York, Chicago, and San Francisco. The novel electronic delivery of a news photo the same day as the event made news of its own: "PHONE BRINGS PHOTO," proclaimed the *New York Evening Graphic* on March 4, 1925. The caption under the president's picture bragged that "this picture was sent from Washington over telephone wires to New York, Chicago and San Francisco." Not until the end did the caption mention Coolidge.

By 1936 Acme had developed photo transmitters and receivers put to the test at that year's political nominating conventions in Philadelphia and Cleveland. Ever cautious, photo editor Harold Blumenfeld readied a flock of carrier pigeons should they be needed to fly small film packets to New York. Fortunately the new transmitter/receivers worked, because a storm near Philadelphia grounded Blu's birds.

In 1952 Acme became part of United Press, and in 1958 UP merged with Hearst's International News Service (INS) to become United Press International.

Fiery end. The largest manmade object ever to fly, the 800-foot airship *Hindenburg* erupts in a fireball at Lakehurst, N.J., on its arrival from Europe in 1937. Static electricity ignited the airship's flammable fabric skin, and 37 seconds later the airship crashed to the ground, killing 35 of its 97 passengers and crew. This spectacle ended the era of the passenger airship. *Photo by Sam Shere.*

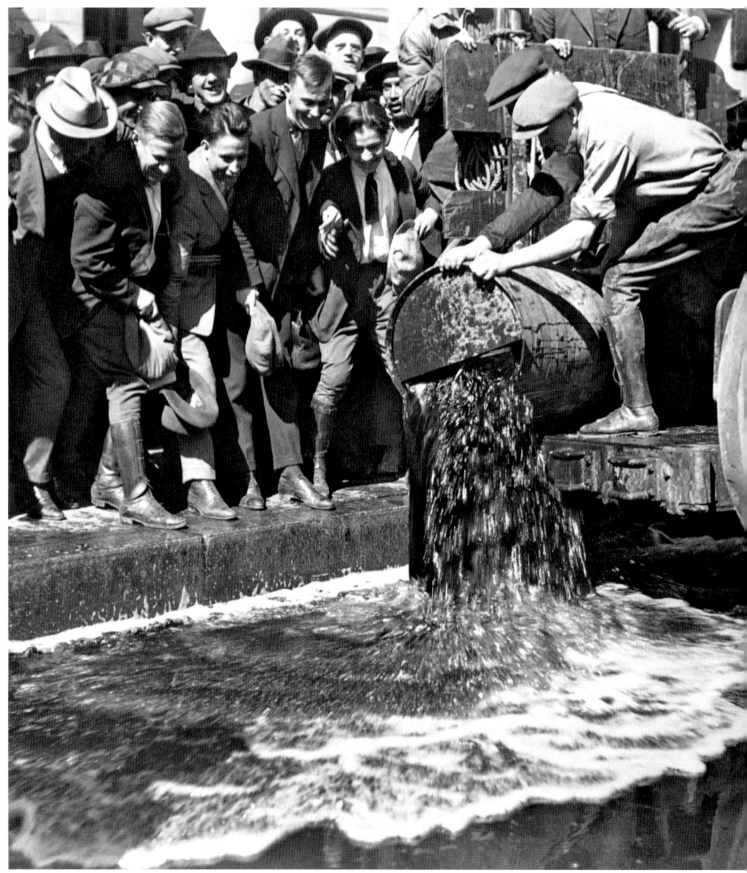

Chateau catastrophe. Prohibition began in January 1920; that very year, these spoilsport federal agents poured 900 gallons of choice California wine down a Los Angeles gutter. Streetcars and automobiles splashed through the good stuff and hundreds of "mourners" seemed poised to go wading.

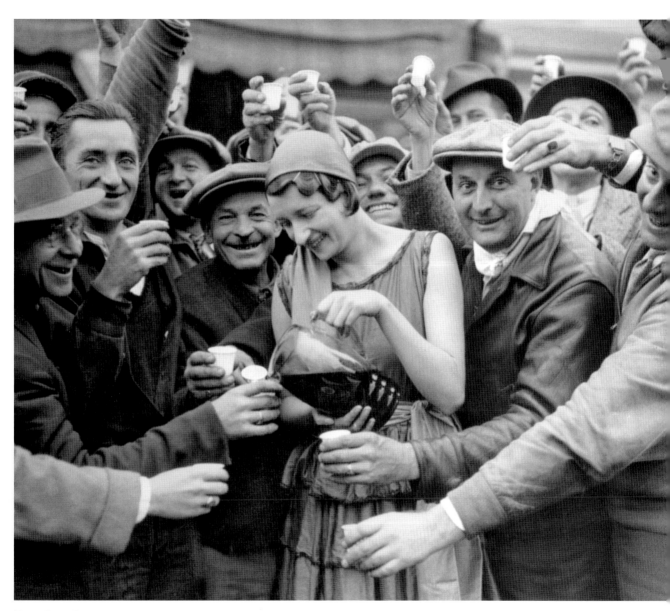

Drought ends. Pouring as fast as she can, a young woman serves nearly legal wine to merrymakers at a New Jersey winery on December 3, 1933, the day before Franklin Roosevelt proclaimed an end to the country's 13-year prohibition of the sale, transport, and production of alcoholic beverages.

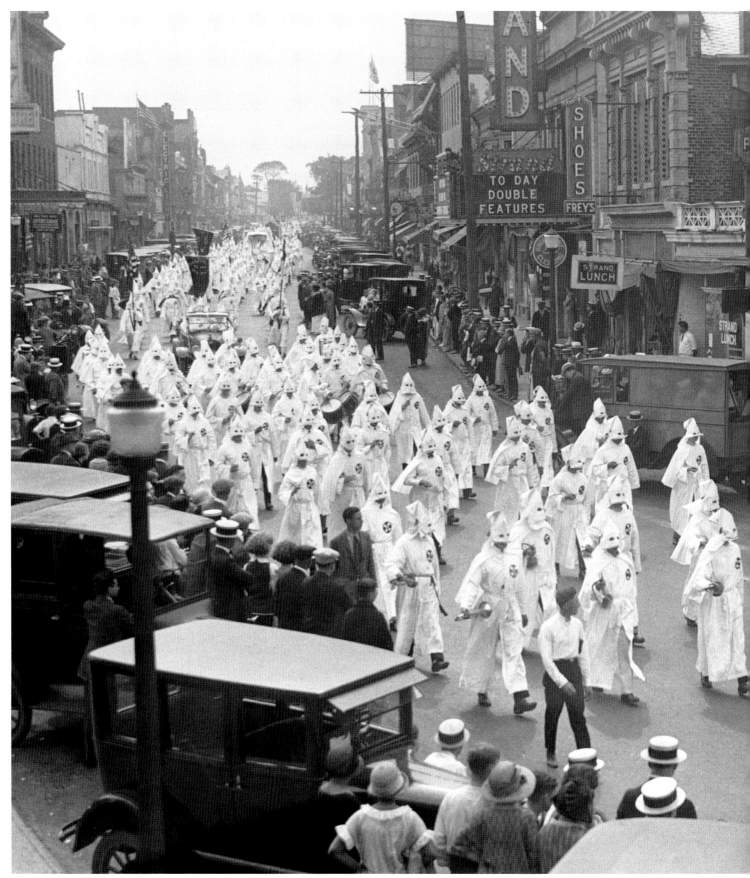

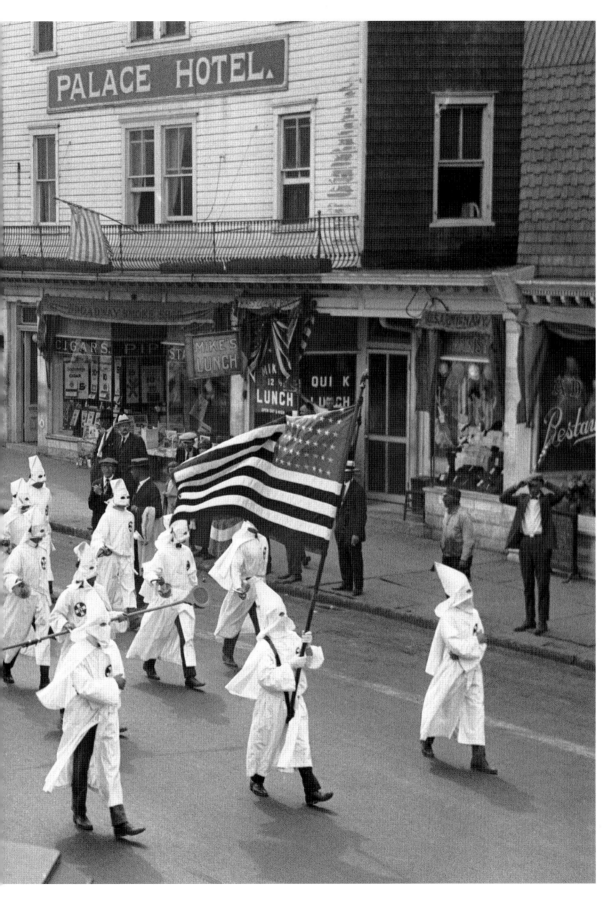

KKK parade.
Hooded Klan members parade through Long Branch, N.J., on July 4, 1924. In the '20s Klan membership was estimated at 4 million nationally, 60,000 of them in New Jersey—more than in Alabama, Louisiana, or Tennessee. Though New Jersey never saw serious Klan violence, there were cross burnings and intimidation, usually of fellow white Protestants believed guilty of immorality—or drinking.

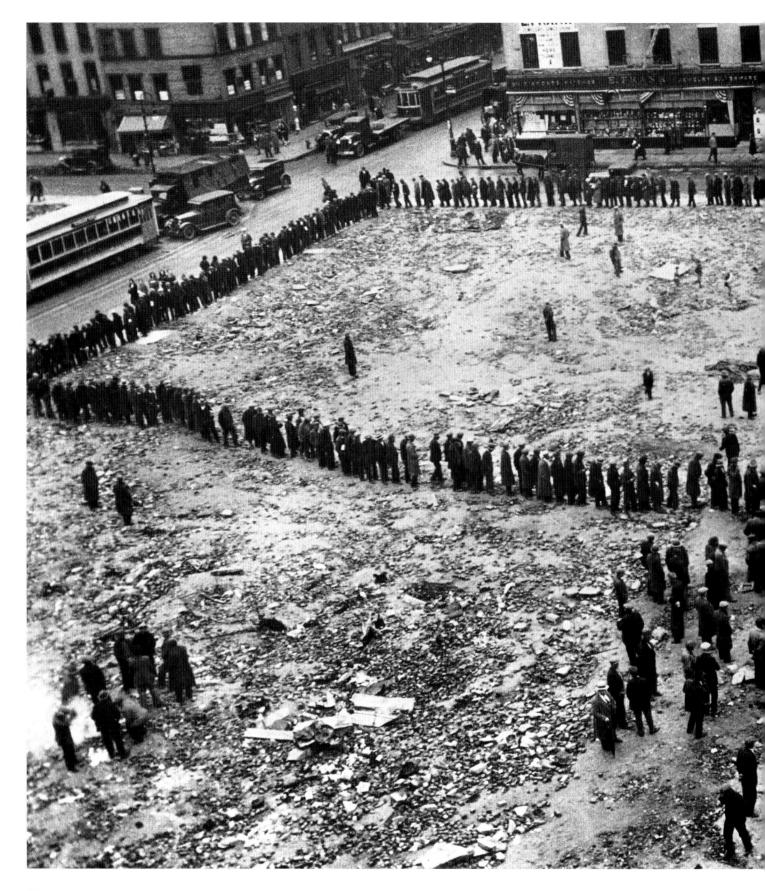

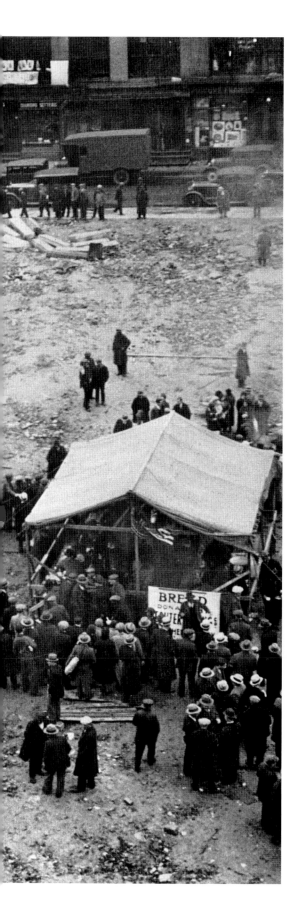

Depression hunger. Jobless Americans line up in the rain for a free meal in New York, 1930. After a year of wild market speculation, the stock market crashed in 1929, taking investors and the economy with it. The misery would last about 10 years. By 1932 at least 200,000 young people and 25,000 families roamed the country seeking food, clothing, shelter, a job. By 1933, 26.6 percent of wage earners were jobless—either fired or laid off. Cities near bankruptcy fired police, firemen, and teachers. Nine thousand bank failures wiped out 9 million savings accounts. Unable to pay mortgages, people lost their homes and farms.

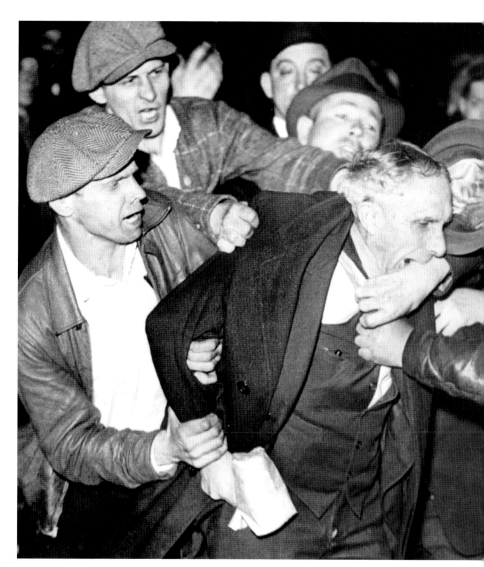

Chomping mad. Labor unrest in the '30s often got rough. Strikers trying to prevent Rev. H.L. Queen from crossing their picket line learned firsthand a whole new meaning for the phrase "management mouthpiece."

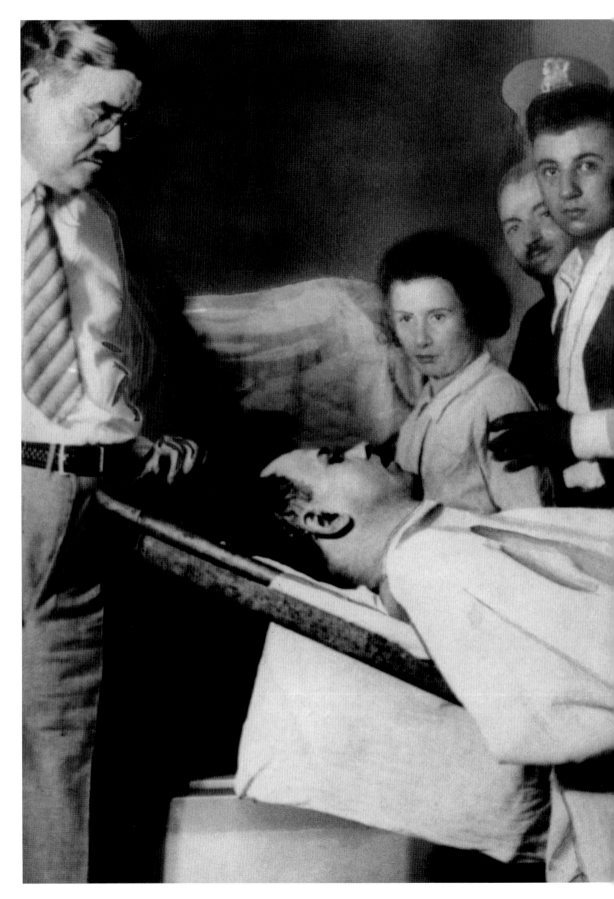

Through the looking glass. John Dillinger lost a shootout with the FBI in July 1934, and a curious public filed past his body at a Chicago morgue. Dillinger and gang's daring daytime robberies caught the fancy of Depression-weary America, as did his Robin Hood touch: after making his gunpoint withdrawals, he destroyed the bank's mortgage records.

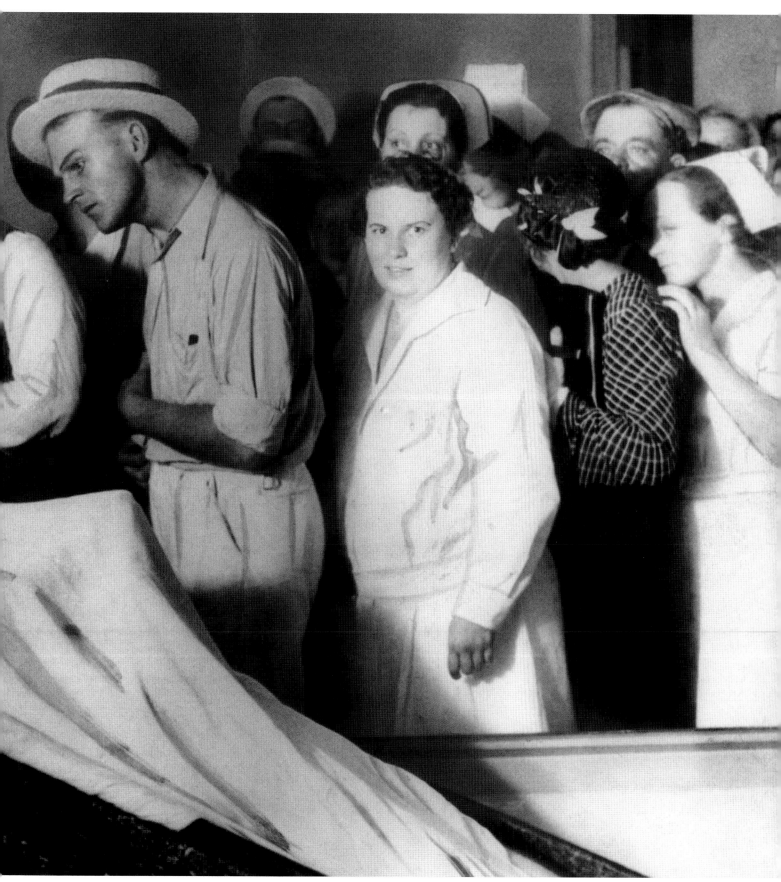

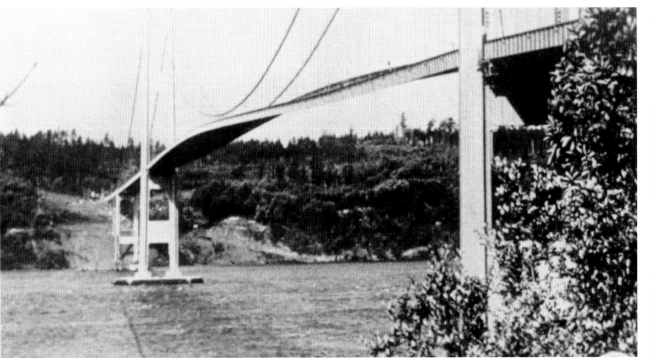

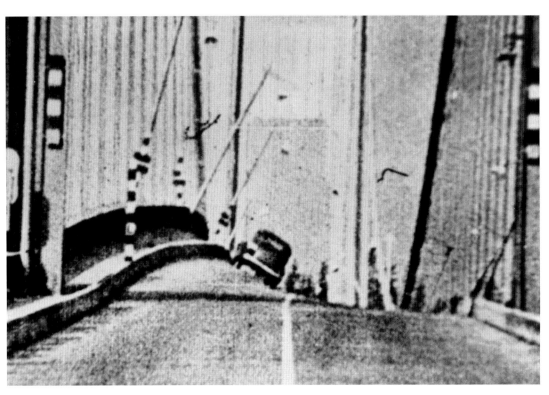

"Galloping Gertie." The $6.5 million, 5,939-foot-long Tacoma Narrows Bridge across Washington's Puget Sound opened in July 1940. It "galloped" in the wind and crossing it became a tourist attraction. Less than five months later the roadway did something new—twisting wildly, one side rising 28 feet higher than the other for three hours before the bridge came apart. A car on the bridge belonged to a reporter who abandoned it—and his pet dog—to save himself. A new and safer replacement bridge opened in October 1950. Gertie's sunken remains were listed on the National Register of Historic Places in 1992 to protect them from salvagers. The exact cause of the bridge's failure remains a mystery. UPI obtained these frames from 16mm movie film. *Photo (from 16mm movie film) by F.B. Farquarson.*

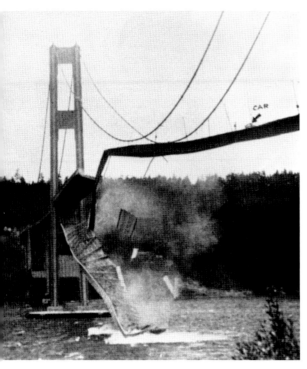

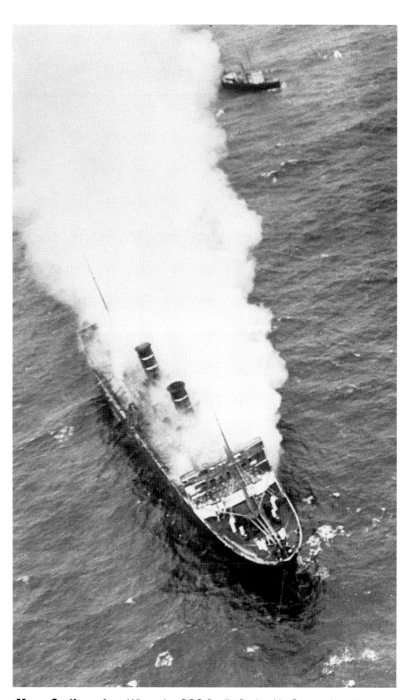

Morro Castle mystery. When the SOS finally flashed in September 1934, the luxury liner carrying wealthy passengers from Havana was just six miles off Atlantic City, N.J. The captain had died mysteriously, the ship was on fire, and its firefighting equipment had been turned off. The crew lowered lifeboats—for themselves. The first 98 survivors to reach shore included only six passengers; 137 passengers and crewmen died.

Levittown.
In 1948, hundreds of acres of potato farmland about 30 miles from New York City became Levittown, named for its builder, Arthur Levitt, who started out with 300 houses, each 4½ rooms on a large 40 x 100 foot lot. Buyers had two choices: a 750-square-foot Cape Cod for $7,990 or a larger ranch for $9,500. By 1967 the community had grown to 15,500 homes. Today, one of these Levitt homes, extensively modified, brings $200,000, provided you don't get lost trying to find it. *Photo by Arthur Green.*

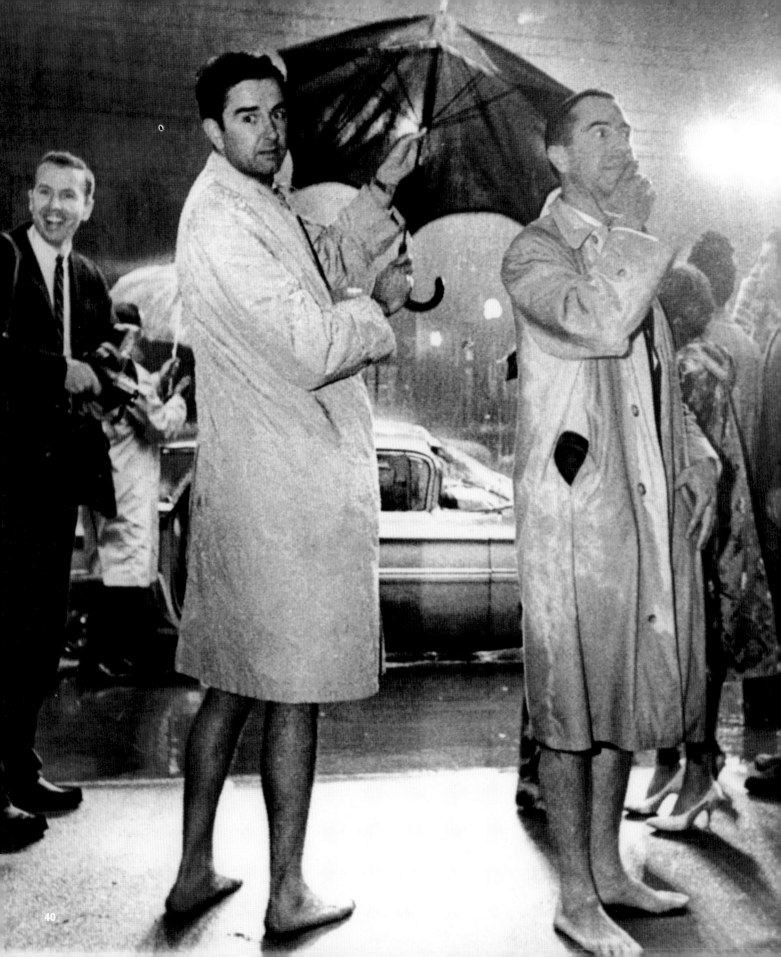

News and Features

Photography, after all, is just another way to tell a story. Serious or whimsical, photographs put people in visual contact with the world they live in: what their leaders and actors and sportsmen, and foreign lands—and floods and earthquakes—look like.

News events come large and small, with speakers and audiences, casualties and survivors, rescue vehicles, flames and firefighters, police and pandemonium. It's difficult *not* to get good photos in such situations. Or is it?

The best photographers make it seem that simple, but it's not. An unscripted twist can turn a routine assignment on its head, and split-second thinking separates the best from the button-pushing rest of the pack. Photographers working shoulder to shoulder do not put equal effort into the assignment, see the event the same way, or come up with the same pictures.

Robert Kennedy addressed a crowd in 1968 and most of the photographers were packed up to leave when shots rang out in the hotel kitchen. Only a couple of photographers had tried to follow Kennedy, and for those who had not, it was too late.

Pennsylvania State Treasurer Budd Dwyer met the press in 1987 on the eve of his sentencing for bribery, fraud, conspiracy, and racketeering. Ending his unphotogenic and rambling news conference Dwyer pulled a .357 Magnum from an envelope, stuck the barrel into his mouth, and pulled the trigger. Several button-pushers saw, but failed to photograph, major news right before their eyes. One worried about "taste." That is a debate to hold only after you get a photo to debate about.

UPI counted heavily on freelance and newspaper photographers for feature photos. Dick Van Nostrand of the *Bay City* (Mich.) *Times* says that "national exposure boosted my ego and UPI's few extra dollars meant nights out with my spouse."

No singin' in the rain. Atlanta operagoers weather opening night barefoot in their tuxedos, shoes in their pockets and their trouser legs rolled up under their raincoats on a night they would have traded their limo for a canoe. *Photo by Gary Haynes.*

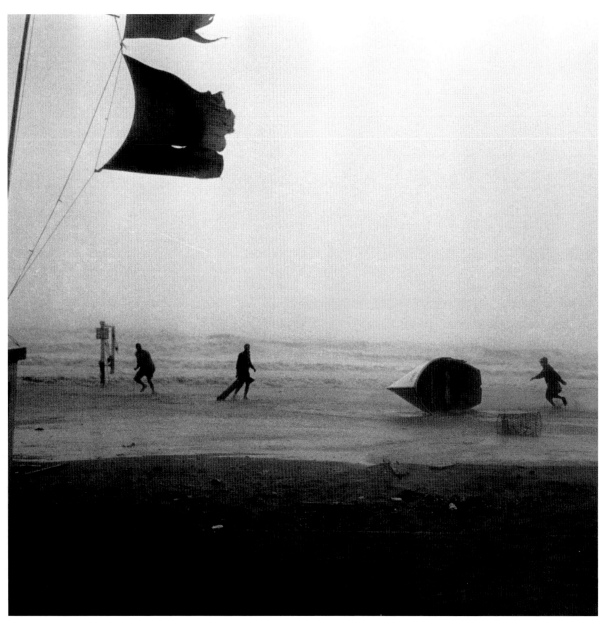

Blowin' in the wind. Hurricane Donna tatters storm flags and the Atlantic City beach patrol hustles to catch runaway lifeboats in September 1960. Sixty mph winds and high tides tore up several miles of the city's famous boardwalk. The photo won first prize for news in the 1960 National Press Photographers Association contest. *Photo by Gary Haynes.*

Crowning touch.
A youngster waves his American flag from one of the 25 windows in the Statue of Liberty's crown. Closed head to toe after 9/11/01, the statue and Liberty Island were off limits for three months, and her observation deck did not reopen until August 2004. The crown is no longer accessible. The inside stairway to the torch was closed in 1916.

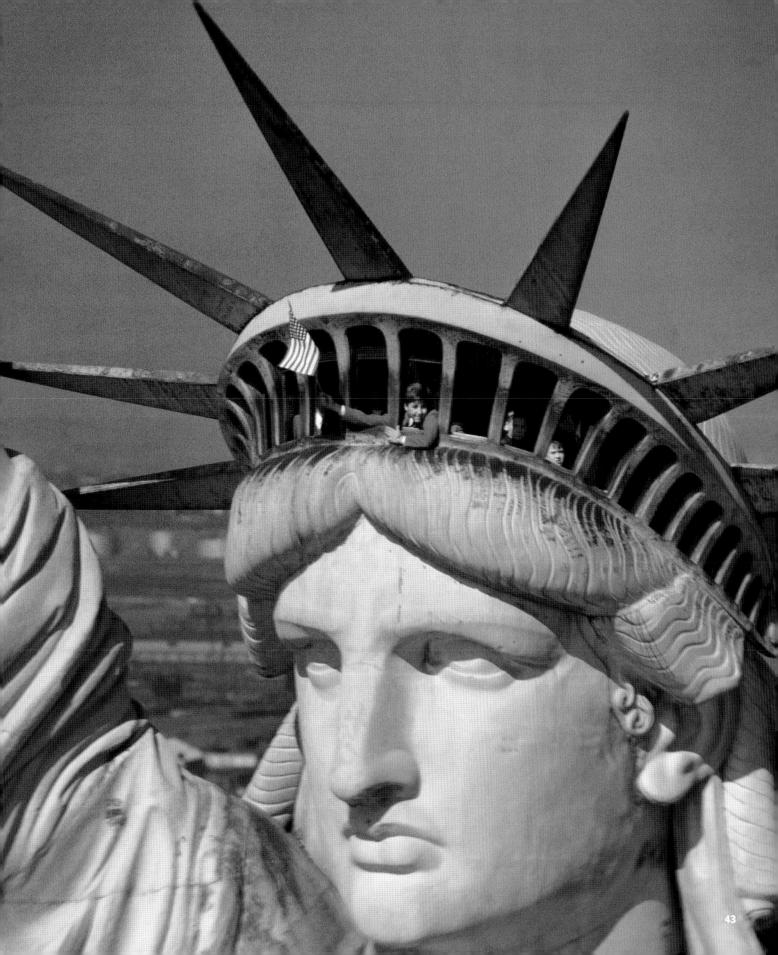

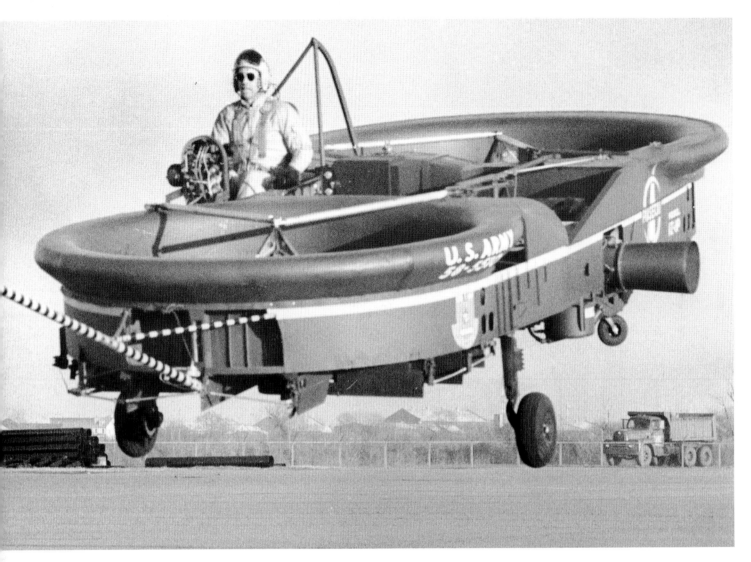

Flying jeep. As if America's enemies didn't have enough high-tech weaponry to worry about, imagine their surprise when the Army shows up in a flock of flying jeeps. In 1959 the Defense Department spent a bundle of tax dollars on this prototype of a one-man jet-powered aerial jeep. It lifted, helicopter-style, with rotors back and front. This Philadelphia test is piloted by Bob Kennedy of Piasecki Aircraft, the contractor. The Army gave up on flying jeeps, deemed unstable and unsafe.
Photo by Gary Haynes.

Ho, ho, who?
John "Santa" Kaufman is frisked
at an Ohio sheriff's station following
his arrest December 7, 1978,
for soliciting money in an
"aggressive manner."

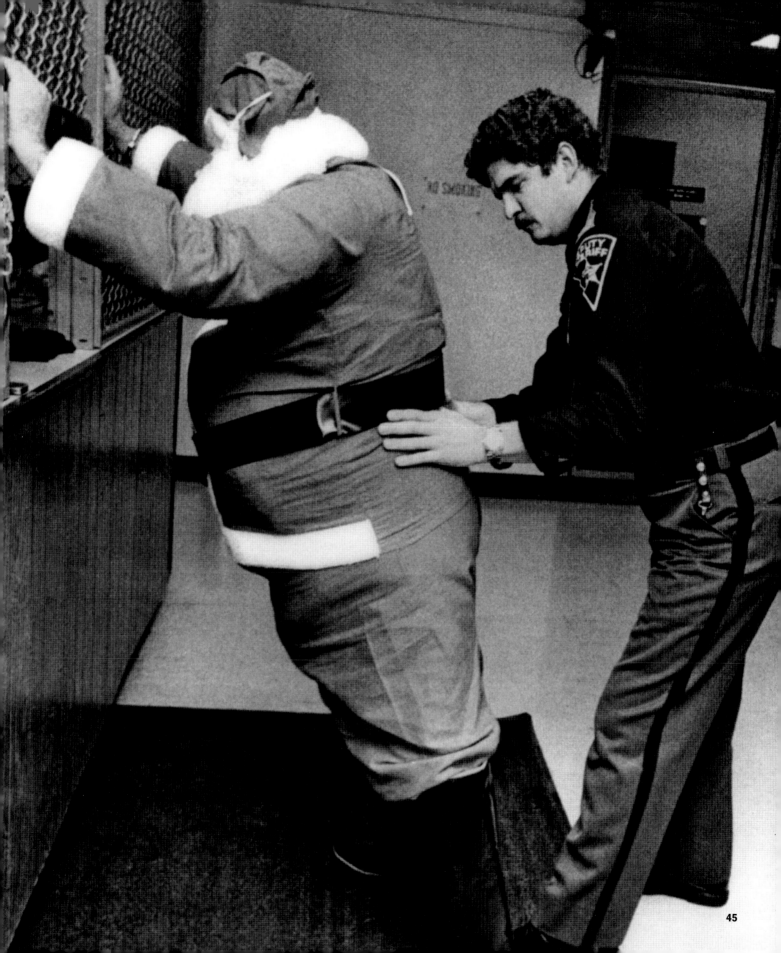

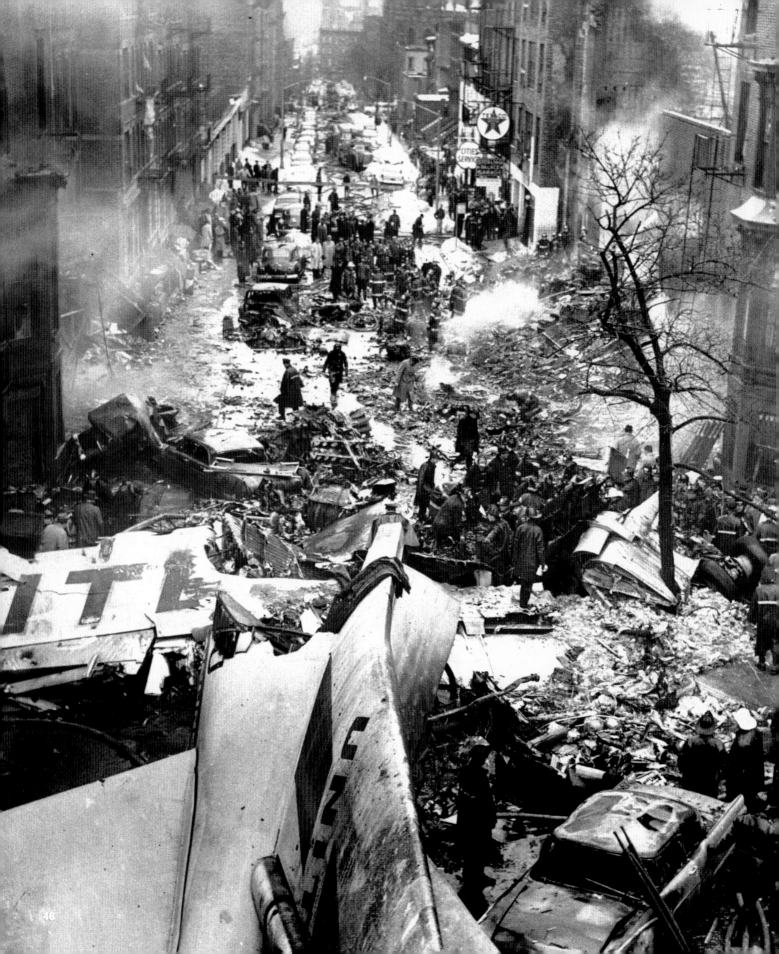

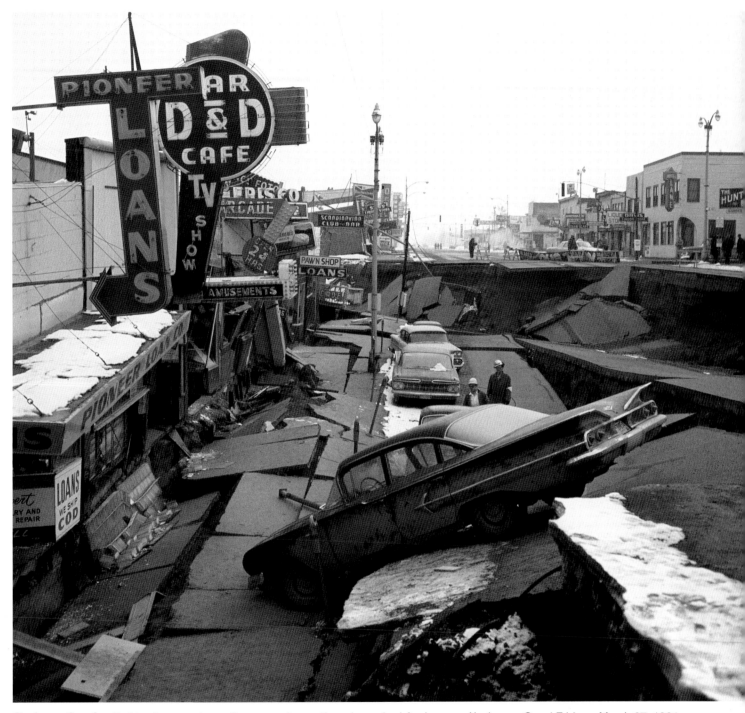

Alaska earthquake. Parking is precarious after a massive earthquake rocked Anchorage, Alaska, on Good Friday—March 27, 1964, dropping a section of this street 20 feet. 131 people died: nine in the earthquake itself, 106 from tsunamis it triggered in Alaska, and 16 from tsunamis elsewhere. Property damage was estimated at over $300 million (1964 dollars), or $1.8 billion in 2005 dollars. *Photo by Maurice Johnson.*

Disaster in Brooklyn. What's left of a United Airlines DC-8 and a block in Brooklyn, New York in December 1960, where the DC-8 crashed after colliding with a Trans World Airlines plane over Staten Island. All 128 passengers and crew on both planes died, along with six people on the ground. *Photo by Maurice Maurel.*

To save a killer. Less than an hour after Philadelphia cops pumped Kyrol Czupirozuk full of bullets, a team of surgeons at Hahnemann Hospital worked to take them out—and save his life. Two people died and five others were injured when Czupirozuk appeared at a busy downtown intersection and opened fire at "Communists" sunning themselves at the windows of a nursing home.
Photo by Gary Haynes.

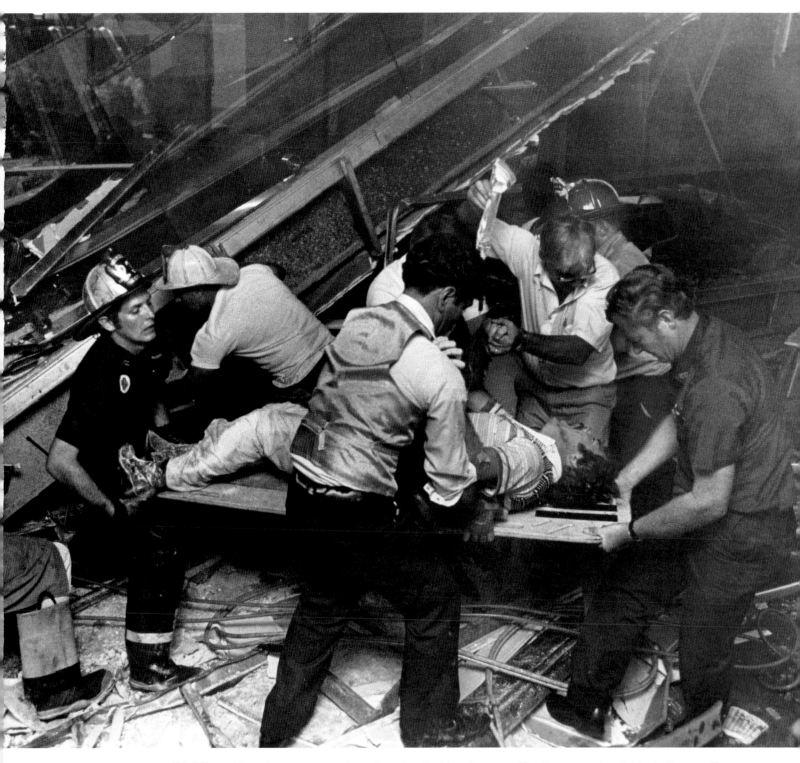

Fatal flaws. More than 2,000 people gathered at the Hyatt Regency Hotel's open-atrium lobby in Kansas City in July 1981. Partygoers were dancing on the first floor and on aerial walkways suspended from the ceiling when the 2nd- and 4th-floor walkways collapsed, dropping the dancers and structures to the crowded first floor. 114 people died and more than 200 were injured. An unauthorized design change in the walkway suspension system was blamed for the tragedy. *Photo by Tom Gralish.*

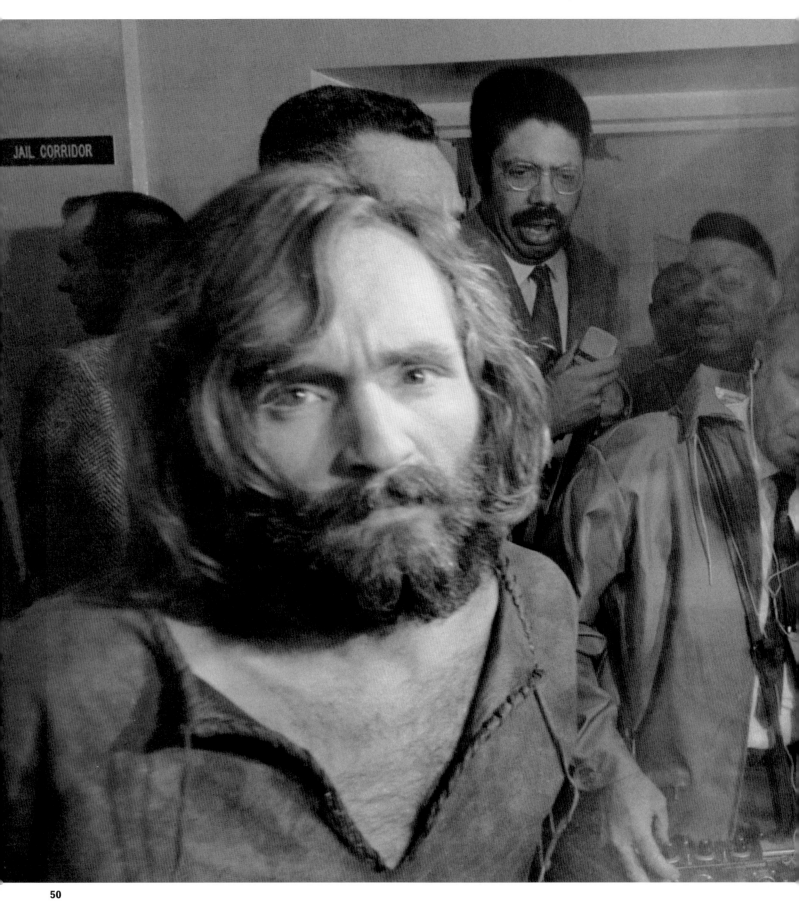

JAIL CORRIDOR

"You could be next" stare. Charles Manson is brought to a Los Angeles jail in 1969, and would be convicted of the grisly murders of actress Sharon Tate and her unborn child along with several of her friends, one shot twice and stabbed 51 times. Manson headed a commune-based cult that attracted drifters and hippies as "family" with copious amounts of LSD and other substances, and was regarded as a "Christlike" figure. His April 1971 death sentence was reduced to life in prison a year later when California's Supreme Court declared the death penalty unconstitutional. He has repeatedly been denied parole.
Photo by Ernie Schwork.

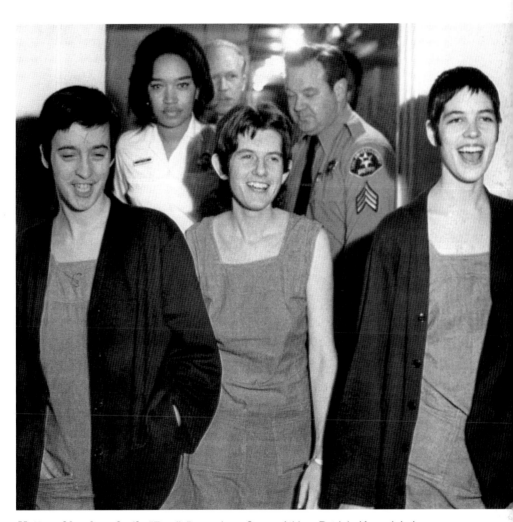

Matter of laugh or death. "Family" members Susan Atkins, Patricia Krenwinkel, and Leslie Van Houten have just heard themselves sentenced to die for their roles in the Manson murders in 1971. Their sentences were commuted to life in prison when California abolished the death penalty. Atkins, now 51, married a Harvard law school graduate, her second marriage in prison; she, Krenwinkel, 51, and Van Houten, 49, are held at California Institution for Women at Frontera.

Out of the fast lane. His dad, Willie "Flukey" Stokes, wanted Willie J. "The Wimp" Stokes to go out in style. Son and dad sold drugs and became wealthy. "The Wimp" was shot dead in 1964. Grieving dad invited thousands to the funeral, and even more invited themselves. Not often do you see the recently departed at the steering wheel of a coffin resembling a Cadillac Seville with flower wheels and flashing lights. Blues artist Stevie Ray Vaughan even had a song for it: "Willie the Wimp was buried today. They laid him to rest in a special way." *Photo by Jim Smestad.*

Hula hoop hubbub. No one person invented it, but the Wham-O corporation trademarked the Hula Hoop name in 1958, and its hoop made of Marlex captured the nation's attention. In just six months 20 million hoops were sold for $1.98 each. These devotees congregated in San Francisco for a hoop-de-doo.

Nothing to hide.
Dressed only in shoes and masks, university students "streak" a California restaurant in March 1974. "Streaking" means removing all your clothes and running through a public place. A beautiful 22-year-old female streaker, Tracy Sergeant, created a sensation at an English bowling championship in 2000, and officials concluded: "Having studied the whole unsavoury incident on 43 occasions, including slow-motion replays, we have decided against implementing a rule that spectators should remain clothed at all times."

Man, oh, mannequin. A female mannequin trio gets the once-over by a boy mannequin who might get his ears boxed if any of the females had arms. This whimsy appeared in 1965 at a clothing shop in Rome, Italy, as the mannequins awaited a change of clothes. *Photo by Luciano Mellace.*

Down and out in Beverly Hills. In January 1976, the buttoned-down order of California's most exclusive community erupted in chaos after the mother of the Shah of Iran sought sanctuary there from the strife in her own country. A thousand Iranian protesters stormed her house, set fires, and overturned cars, forcing the queen mother and the princess to take refuge in Palm Springs. *Photo by Glenn Waggner.*

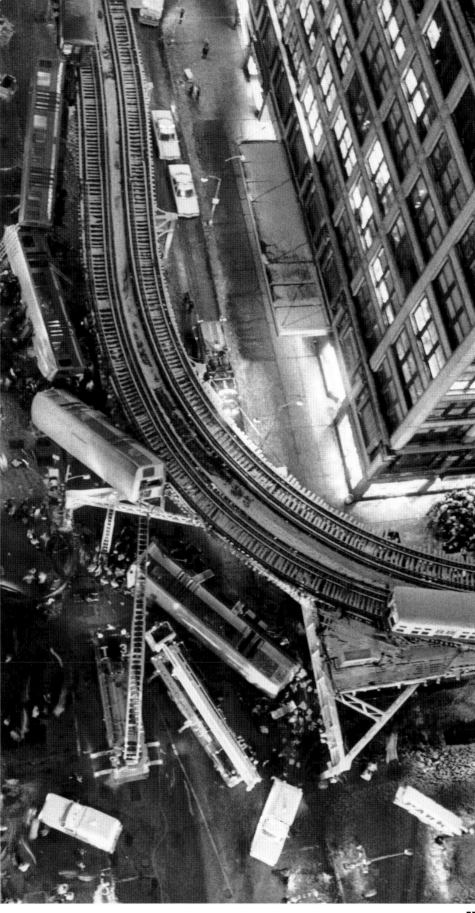

Hell on the El. A six-car elevated train full of rush-hour passengers had stopped when an eight-car train struck it from behind in February 1977. The front four cars of the first train left the tracks and dropped 20 feet to the ground. Both trains, fully loaded, carried more than a thousand passengers. It was Chicago's worst rapid transit accident. Eleven died and 255 were injured. *Photo by Jim Smestad.*

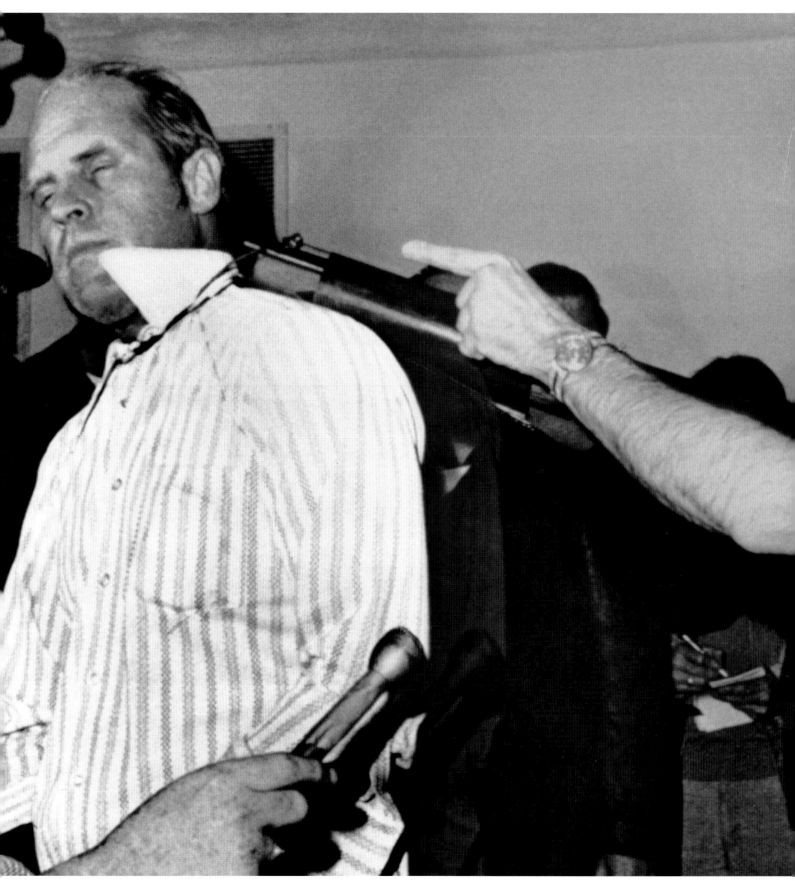

John H. Blair

UNITED PRESS INTERNATIONAL

Money borrower seeks revenge

A deranged borrower captures his mortgage banker and wires a shotgun to the banker's head and the trigger to himself.

Moments after Richard Hall, president of Meridien Mortgage in Indianapolis, arrived for work in February 1977, he was taken hostage by a dissatisfied customer, Anthony Kiritsis. The bank had loaned Kiritsis money to build a shopping center, but the loan came due and Kiritsis couldn't pay. He claimed that the bank discouraged investors so it could foreclose on the property.

Still wired to the shotgun, the banker is taken to Kiritsis's apartment, where over three days the area is an armed camp. Police finally negotiated Hall's release. Both UPI stringer John Blair and his mentor, UPI photo bureau manager Jim Schweiker, record the moment. "I had phenomenal angles," Blair recalls, and he was so close he could have reached out and touched the shotgun. UPI paid him $5 for the picture.

The photo wins a Pulitzer for Schweiker; Blair claims it's his. Bill Lyon, UPI vice president, flies to Indiana, compares Blair's film to Schweiker's, and agrees with Blair. Schweiker is encouraged to resign. Kiritsis is confined to a mental institution, where he somehow manages to contact Blair and ask for prints of the picture.

Claiming he had been cheated in business, a man holds his banker hostage in Indianapolis. *Photo by John H. Blair.*

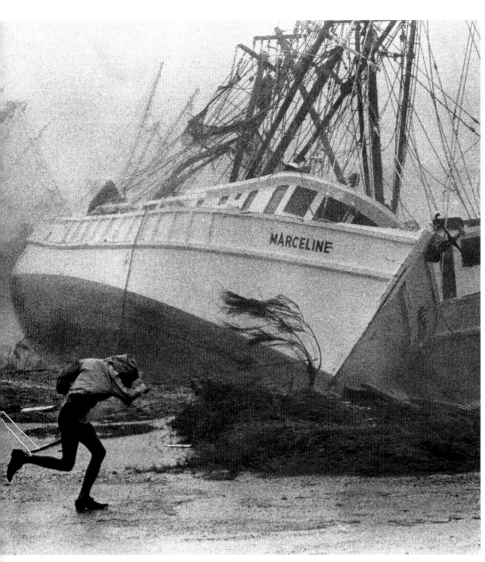

Beulah and the boats. Beulah, the third largest hurricane on record, wreaked havoc on shrimp boats in Port Isabel, Texas, in September 1967, buffeting the area with 100-mph winds and producing some 150 tornadoes after making landfall.
Photo by Walter Frerck.

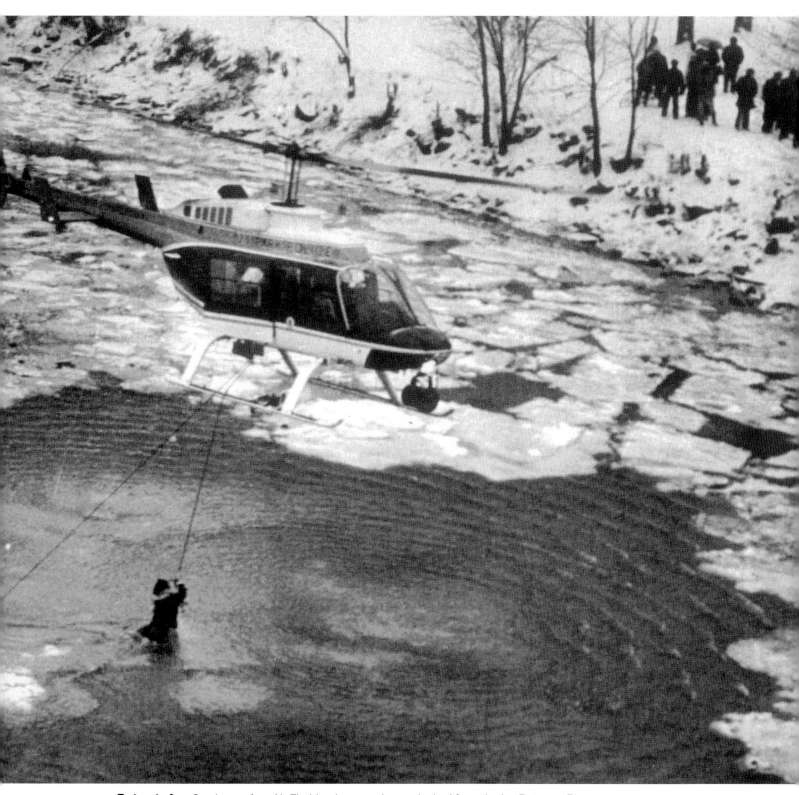

Fortunate few. Survivors of an Air Florida plane crash are plucked from the icy Potomac River in Washington in January 1982. Moments after takeoff, an Air Florida jet crashed into a bridge about a mile from the airport, broke apart, and sank through the ice. Only five of the plane's 79 passengers and crew lived. The aircraft struck seven vehicles, killing four motorists and injuring four others. An investigation blamed icing and pilot error.
Photo by Ron Bennett.

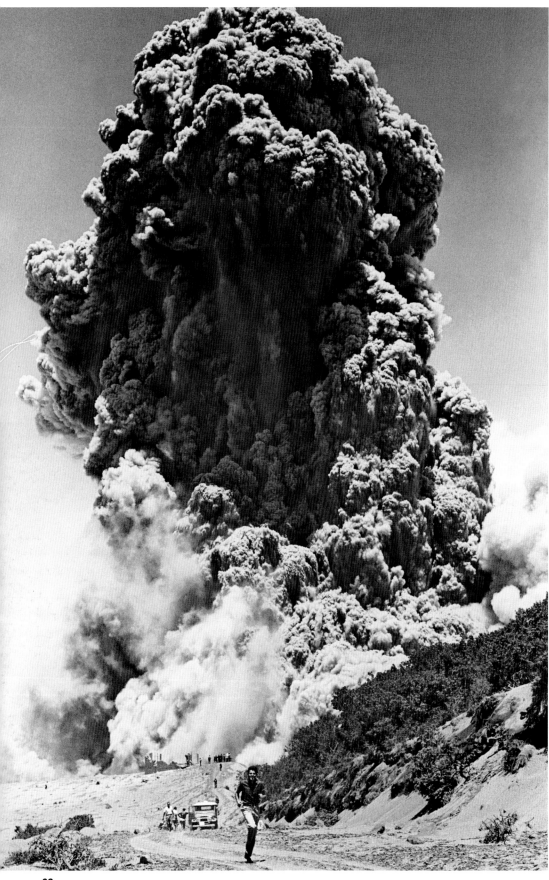

Where there's smoke.
The best view of an erupting volcano is as you run away from it. In Costa Rica, Irazu National Park is a must-see tourist attraction named for Irazu, one of the few accessible active volcanoes in the Americas. In March 1963, right after President John Kennedy landed in Costa Rica for an official visit, Irazu captured the headlines with an eruption that lasted two years.
Photo by Carlos Schiebeck.

Homework?
When local beauties in high heels paraded near the pool for the photographer in Los Angeles in 1967, several youngsters swam over to see what the fuss was about—and after they found out, stayed.
Photo by Bob Flora.

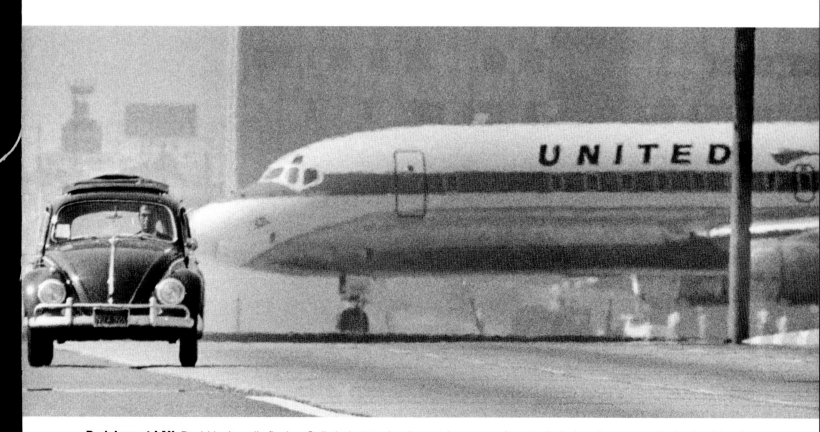

Rush hour at LAX. David isn't really fleeing Goliath, but tourists in rental cars are often startled when it appears a jet is about to join them at the next intersection. The roadway doesn't really meet the runway but even the natives get nervous on this stretch near Los Angeles International Airport. *Photo by Bob Flora.*

63

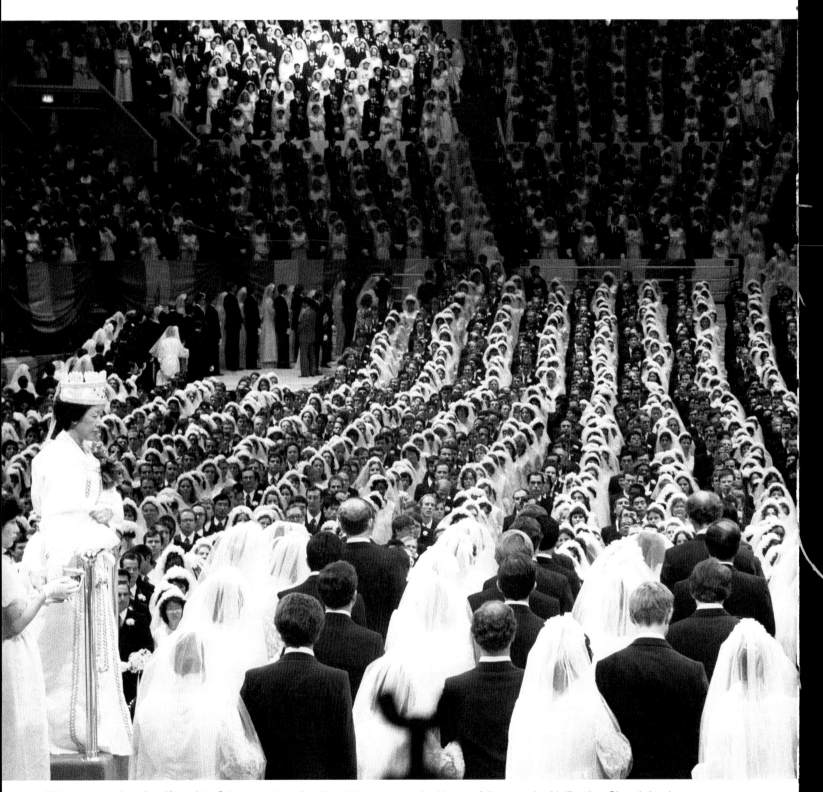

Did you remember the gift registry? One wedding fits all: 2,075 couples united in one fell swoop by Unification Church leader Rev. Sun Myung Moon and his wife at Madison Square Garden, New Year's Day, 1982. There's no record of how many truckloads of rice were tossed at the newlyweds. *Photo by Ezio Petersen.*

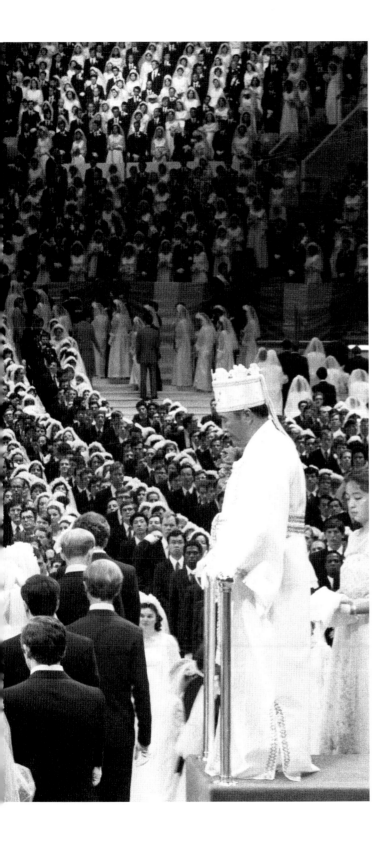

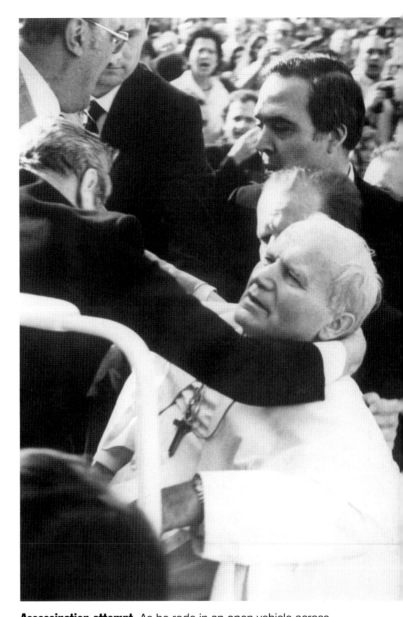

Assassination attempt. As he rode in an open vehicle across St. Peter's Square in May 1981, Pope John Paul II was shot twice at close range by a Turkish gunman, Mehmet Ali Agca. The Pope forgave the man from his hospital bed, made a full recovery, and visited Agca in his cell in 1983. Agca's request to attend the Pope's funeral in April 2005 was denied. *Photo by Francesco Sforza.*

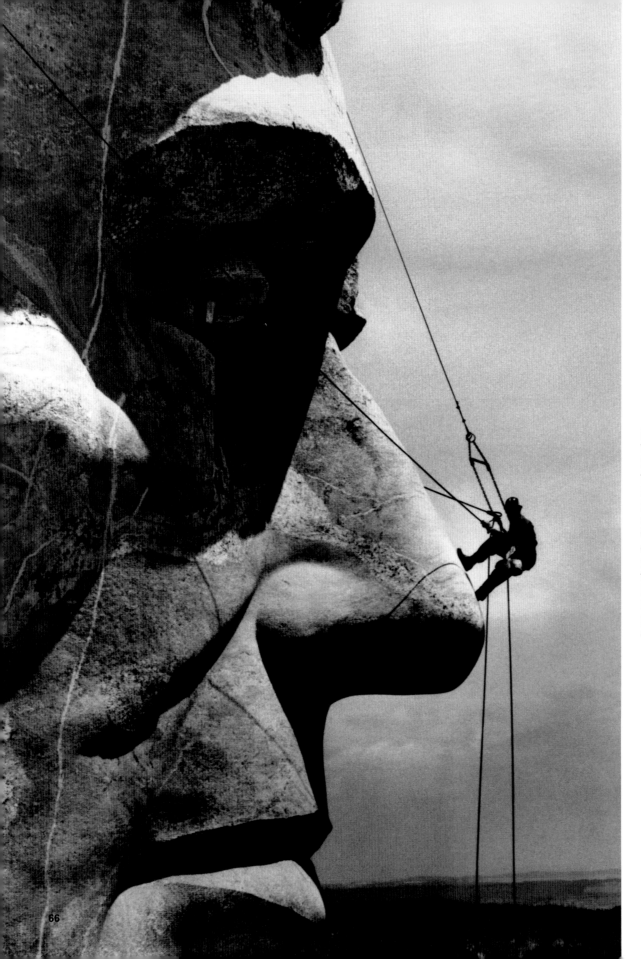

Nose job!
With a nose this big you'd be 465 feet tall. In South Dakota's Black Hills, granite repairman Mike O'Meara rappels down Lincoln's nose as he surveys the famous Mt. Rushmore likenesses of four presidents for wear and tear in 1962.

Flea marketing. Prof. Roy Heckler with a star of his Marvelous Trained Flea Circus, which performed stunts "as seen before (and on top of) crowned heads of Europe." A flea in harness can pull many times its own weight. The show played Hubert's Dime Museum (in New York's Times Square) until it closed in 1957. Heckler used only female performing fleas. Males, he said, are "utterly worthless and can't be trained."

Mess not with my mouse. In 1968, Shampa, a female elephant at Hamburg's Hagenbeck Zoo, offers impressive protection and a perch for her pet white mouse, though a sneeze could ruin this beautiful friendship. *Photo by Dieter Hespe.*

Hopalong classily. After this kangaroo's foot was amputated in 1983 to save it from a deadly infection, the Kansas City Zoo fitted "Tracks" with a size 13 sneaker that let him hop comfortably without damaging the stump of his leg. The photographer, who would later win a Pulitzer Prize, says that "'Tracks' is still the most published photo of my entire career." *Photo by Tom Gralish.*

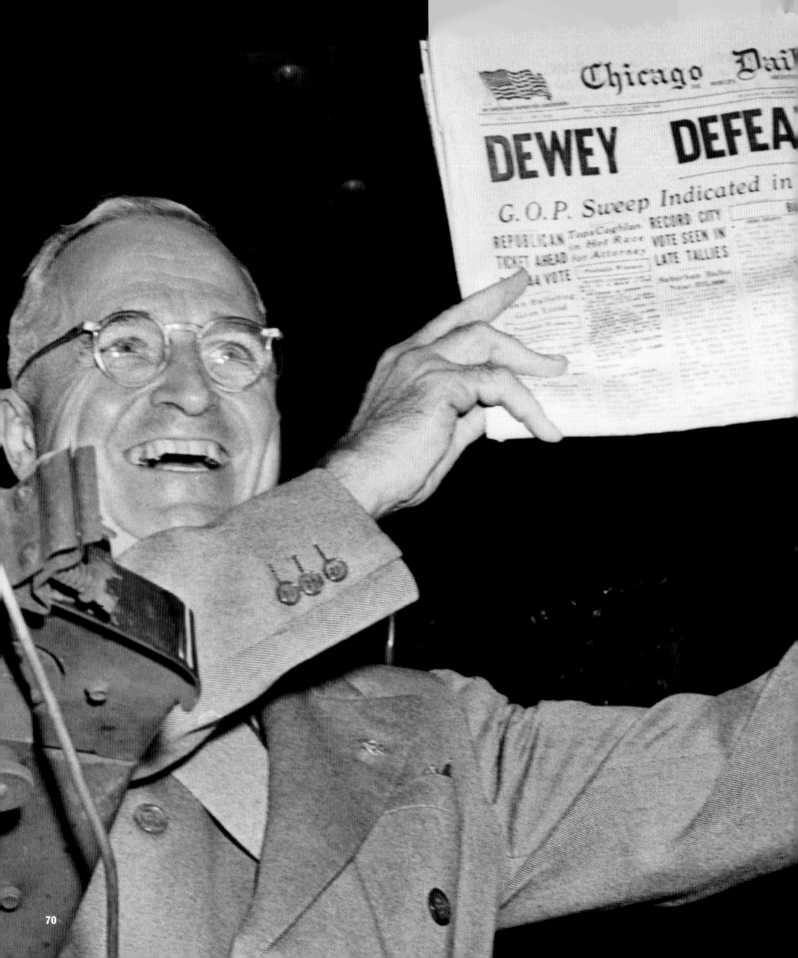

Politics

"**A** *pessimist is one who makes difficulties of his opportunities, and an optimist is one who makes opportunities of his difficulties.*"—President Harry S. Truman

Nobody believed that President Harry Truman, running for reelection in 1948, could beat Republican challenger and New York governor Thomas E. Dewey. Skeptics included the *Chicago Tribune*. Truman carried 28 states and got 303 electoral votes to Dewey's 189 from only 16 states.

Photographers have a love/hate relationship with political assignments at the national level because access to the subjects is limited and even timed, and it becomes difficult to separate the real from the stage managed. Photographers and the press offices have had an uneasy relationship through multiple presidents; "photo opportunities" and the press office usually prevailed.

UPI's photographers were often at their best when political events strayed from the script, proving that no assignment is ever "routine." A presidential winner displays the banner headline saying he's a loser. A routine political appearance ends in assassination. A national political convention spills out of the hall and onto city streets. Skills show when the photographer makes a remarkable photograph of something unscripted.

The UPI Washington bureau was populated by some of UPI's best photographers, who mixed with the power elite and often traveled with the president aboard Air Force One. Seductive as it was to tell friends that you'd be "out of town with the president," many UPI photographers offered assignment to the Washington bureau declined, because for all its glitz and glamour, Washington is essentially a one-story, shoot-behind-the-ropes town.

"We hang the petty thieves and appoint the great ones to public office."—Aesop

Stop the presses! The actual president-elect, Harry Truman, brandishes the November 3, 1948, *Chicago Tribune* proclaiming his opponent, Thomas E. Dewey, president. *Photo by Frank Cancellare.*

Having a ball. Dwight Eisenhower, an avid golfer, sat down at a GOP dinner in Philadelphia in 1960 and brandished a golf ball he found in his pocket. Ike played more than 800 rounds during his eight years as president, and at age 77 shot a hole in one on a 104-yard, par-3 hole.
Photo by Gary Haynes.

Feeling courage. Helen Keller, who was blind, virtually mute, and deaf from infancy, has an unusual first encounter with President Dwight Eisenhower at the White House in 1953. She later told Polly Thompson (holding her hand) that Ike had "courage and a gentle smile." Keller was honored as a pioneer in helping the handicapped, and proved how language could liberate the blind and the deaf. "Literature is my utopia," she wrote. "Here I am not disenfranchised." *Photo by Charles Corte.*

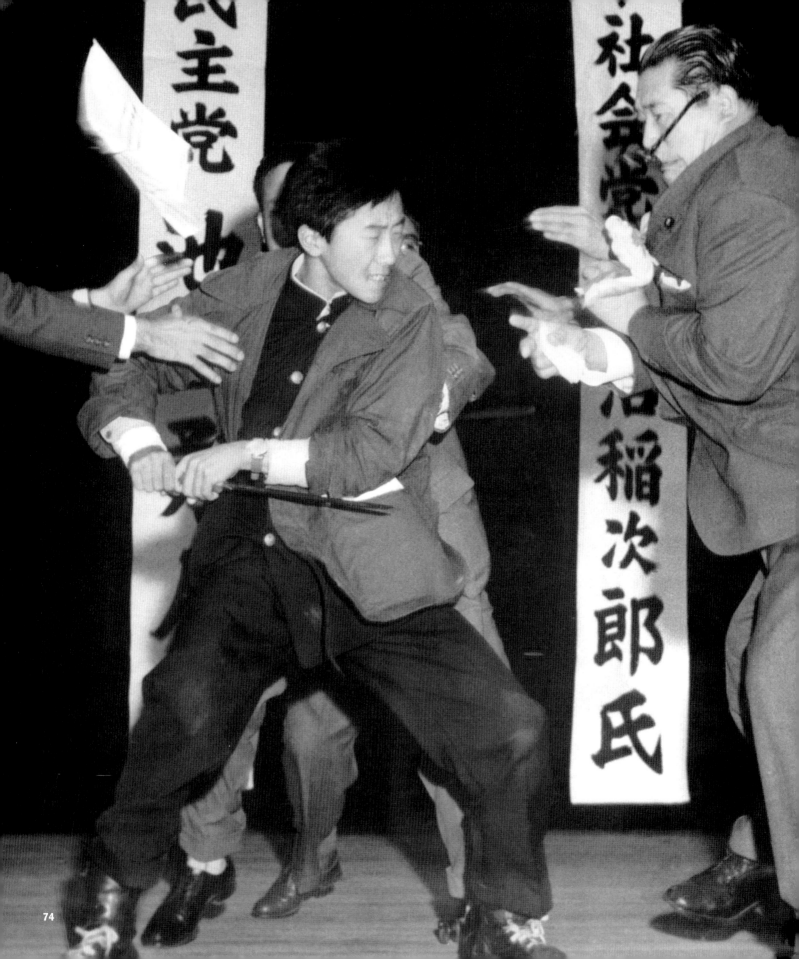

Yasushi Nagao

MAINICHI SHIMBUN NEWSPAPER

Yasushi Nagao

Assassination of Asanuma

Japan's political turbulence and an attack on an American contingent making advance arrangements for a 1960 visit by President Eisenhower caused Ike's visit to be canceled.

In October more than 3,000 people showed up for major party speeches and a debate about the U.S.-Japan Security Treaty. Photographer Yasushi Nagao was there on assignment for *Mainichi Shimbun*, his Tokyo newspaper employer.

Debating opposite sides were Inejiro Asanuma, chairman of the Japanese Socialist Party and leader of opposition to the U.S.-Japan Security Treaty, and Hayato Ikeda, the Liberal-Democratic Prime Minister.

As Asanuma began to speak, a man lunged toward him with a two-foot sword. Nagao frantically refocused his camera as the man stabbed Asanuma, withdrew the sword, and prepared to strike again.

The photographer watched in horror and froze the moment using the one shot left in his 4 x 5 film pack. The assassin, Otoya Yamagucha, a right-wing extremist, was captured on the spot. Sentenced to jail, he hanged himself in his cell, and more people attended his funeral than had attended the state service for Asanuma.

UPI had exclusive rights to all of Mainichi's photographs and soon the picture was seen around the world. It won every top U.S. photo award, including the Pulitzer Prize.

Swift sword. Stabbed once, Inejiro Asanuma slumps as his assassin prepares a second strike. Asanuma died on the way to the hospital. *Photo by Yashushi Nagao.*

Rare: JFK hat trick. Other than the top hat he wore at his inaugural, JFK tried never to be photographed wearing anything resembling a hat. No Indian headdresses, no Army helmets or construction hard hats. During his presidential campaign against Richard M. Nixon, he arrived in a hat against a downpour at the Philadelphia airport at 3 a.m., not suspecting that a photographer might be on hand. One was. *Photo by Gary Haynes.*

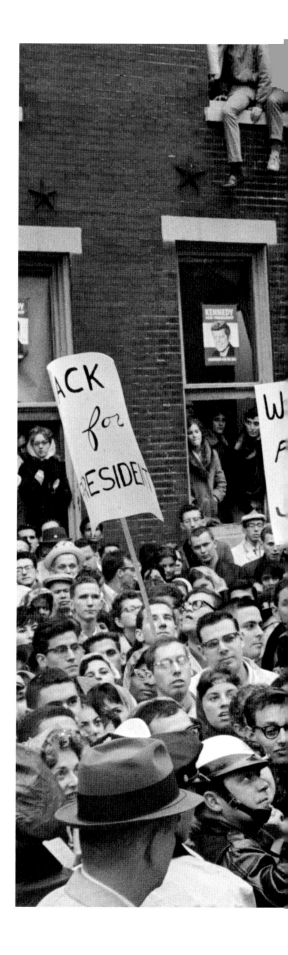

Up close and personal.
College students loved JFK, and they turned out in droves at Temple University in Philadelphia in October 1960, to hear him campaign against Richard Nixon. They filled the streets and hung out of every window, something the Secret Service no longer permits. He wanted a fifth debate with Nixon, he told them—and Nixon could bring Ike along to help. *Photo by Gary Haynes.*

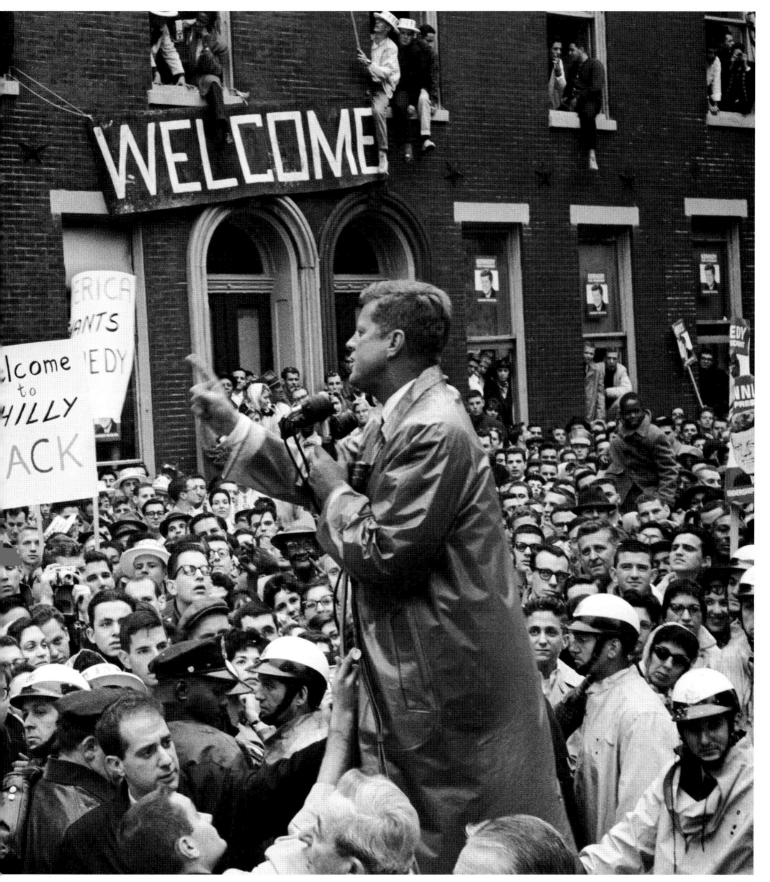

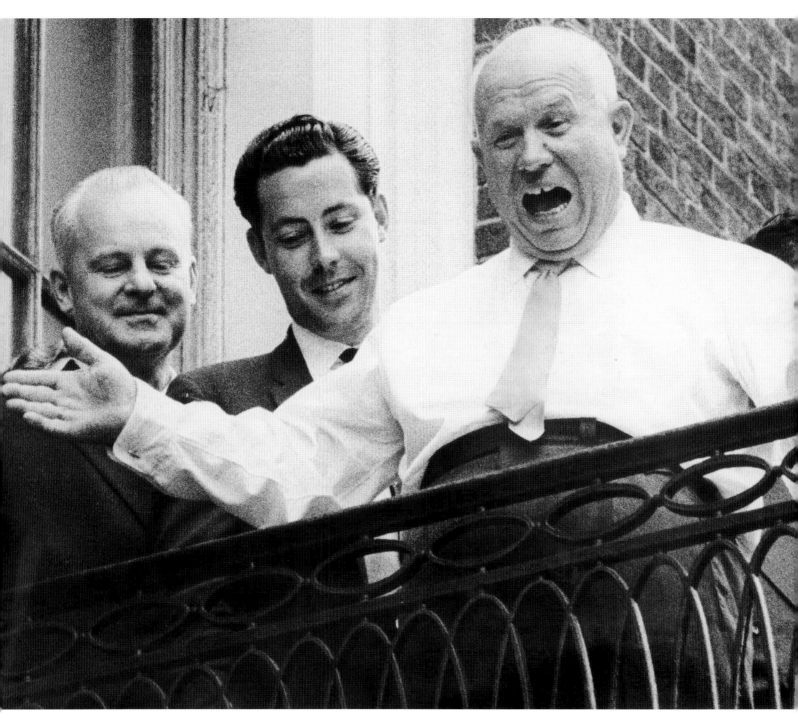

Nikita. Soviet Premier Nikita Khrushchev shouts, "This is my America!" at a New York cabbie who kept driving past the Russian UN delegation's headquarters in New York yelling, "Go home, ya Commie!" out his window. The real Cold War kept the atmosphere tense as Khrushchev joined other world leaders for the historic 1960 session of the United Nations' General Assembly. *Photo by Gary Haynes.*

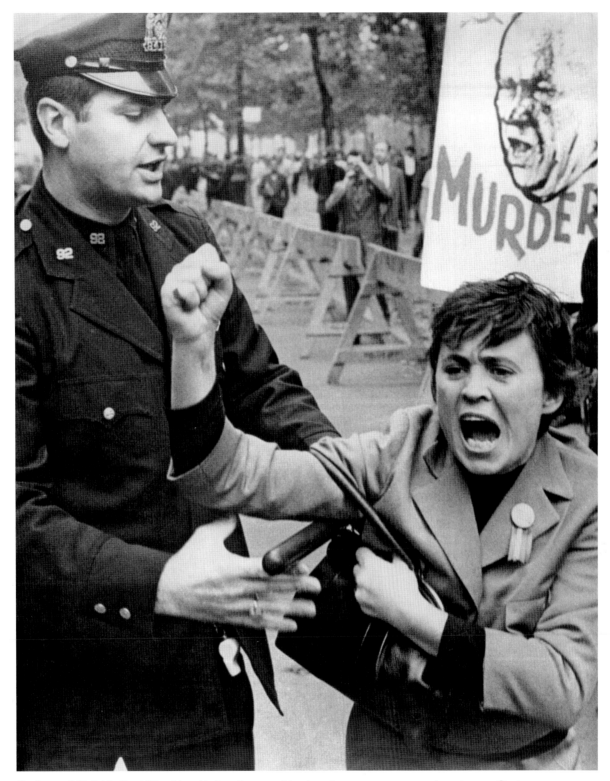

Castro, no! Outside the UN, a New York policeman tries to calm a woman screaming at a pro-Castro group, September 20, 1960. (This UPI photo appeared on page one of four New York newspapers the next day.) *Photo by Gary Haynes.*

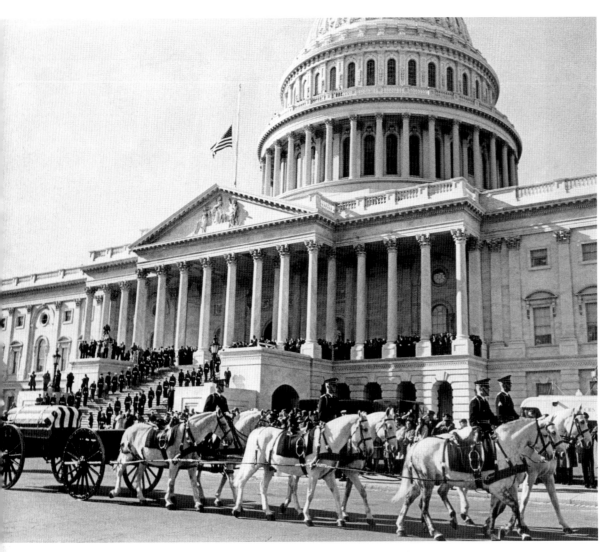

Sad procession. Six gray-white horses, two of them riderless, draw the body of JFK from the Capitol to services. Massed companies of men preceded it; the new president, Lyndon Johnson, followed it. *Photo by Gary Haynes.*

Caisson at Capitol.
JFK's casket is placed on a gun carriage to begin its processional across Washington, past the White House to St. Matthew's Cathedral and then to Arlington National Cemetery. Mrs. Kennedy is at the left between her husband's brothers, Robert and Edward. *Photo by Gary Haynes.*

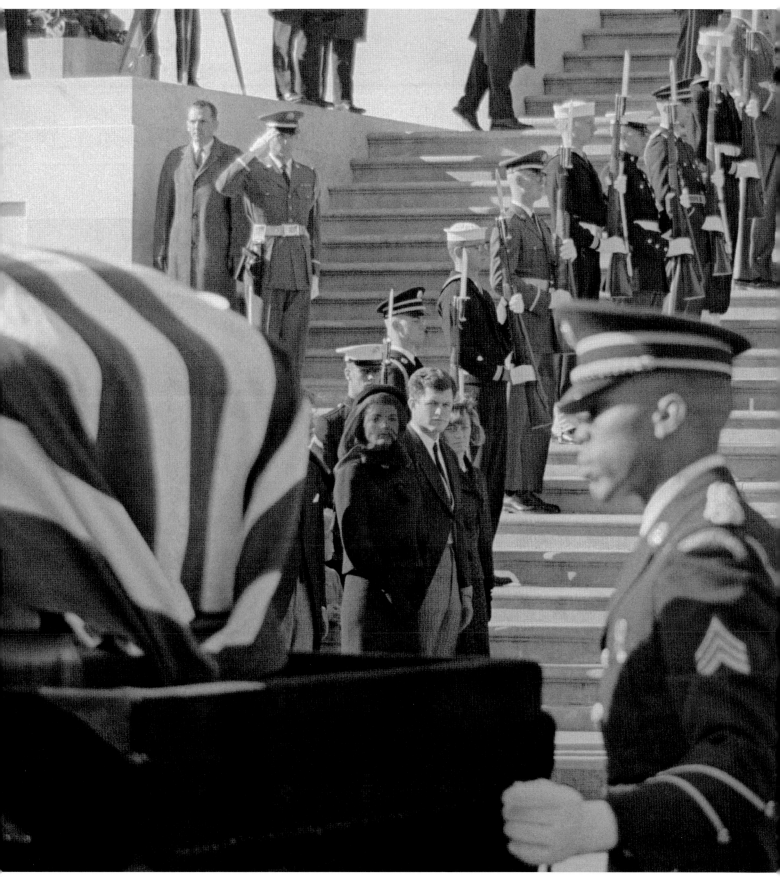

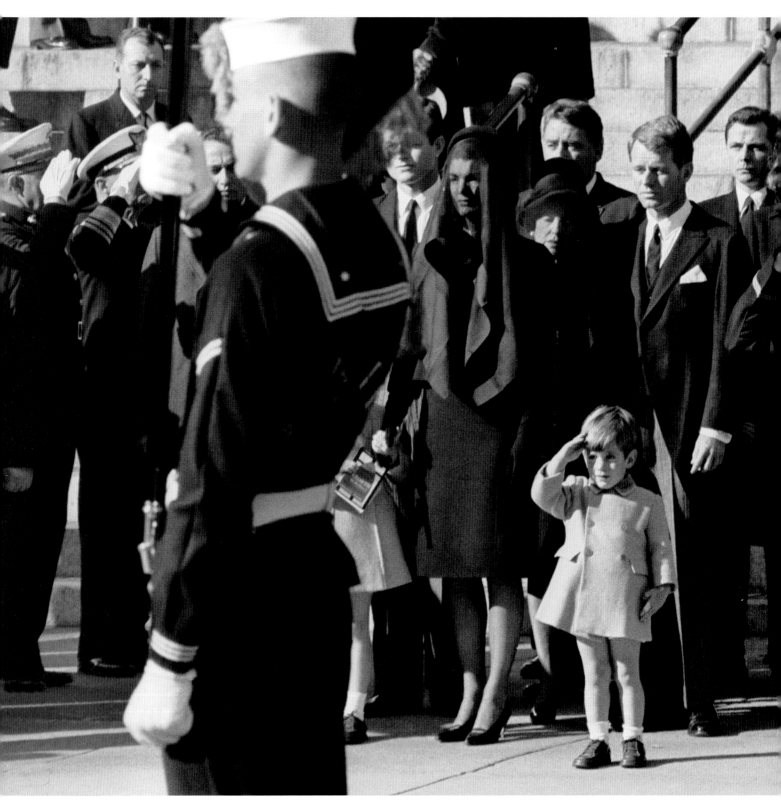

Son's salute. John-John Kennedy salutes his father's casket following the funeral of John F. Kennedy at St. Matthew's Cathedral on November 25, 1963. Photographer Stanley Stearns was in a crowd of about 75 photographers but "had a hunch" and put on a 200mm telephoto lens. Suddenly Jacqueline bent down and whispered to the boy, and he saluted. Stearns got this one frame of the salute, the military guard, and the Kennedy family. *Photo by Stanley Stearns.*

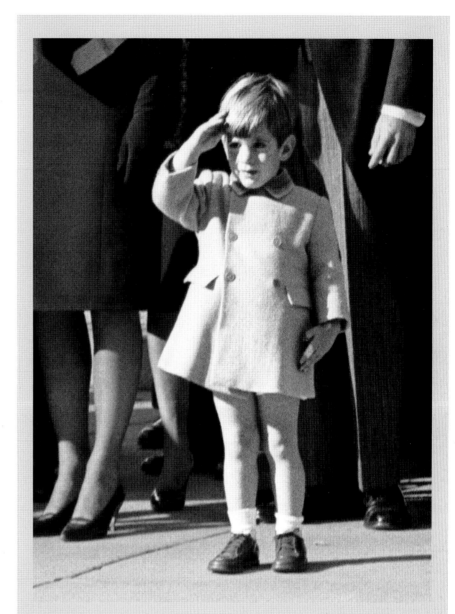

Second look

Great film editors scan a photographer's film for pictures within a picture. Ted Majeski was a world-class editor handling UPI's film at the JFK funeral. Stearns knew he had a great salute shot. Majeski saw a photo within that photo, a tiny part of the frame that turned a great photograph into an even greater one. Majeski had the lab crank the enlarger to the ceiling and put the print easel on the floor, creating a "close-up" of John-John and the salute. Ironically, November 25 was the boy's birthday. UPI transmitted both versions of the picture, and the close-up dominated play worldwide.

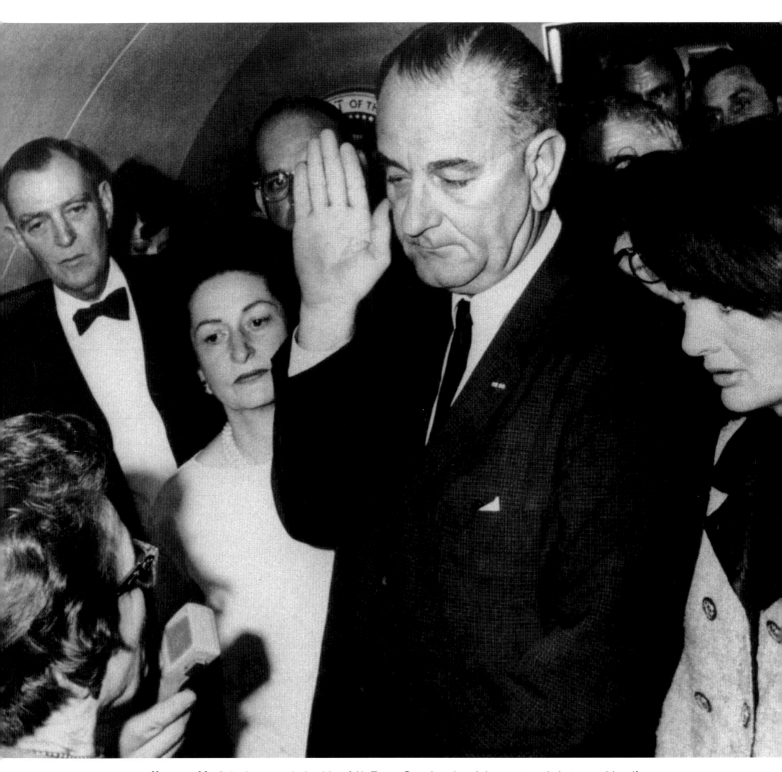

New president. In the crowded cabin of Air Force One, Lyndon Johnson stands between his wife and Jacqueline Kennedy, and takes the oath of office at 2:38 p.m. CST, November 22, 1963. *Photo by Cecil Stoughton, The White House.*

JFK's chair. It was odd that a rocking chair, of all personal objects, was so closely associated with the youngest president ever elected. It was unceremoniously removed from the Oval Office being readied for a new president. There were more than a hundred press photographers on hand at the White House; this photo was exclusively UPI's. *Photo by Gary Haynes.*

Oswald's rifle.
An officer carries a gun that ballistics tests proved was the JFK murder weapon. Lee Harvey Oswald's fingerprints were on it. Paraffin tests found gunpower residue on Oswald's hands. Dallas police were quick to claim all that, but the circus atmosphere surrounding every aspect of the investigation left the public uncomfortable about due process in Dallas.

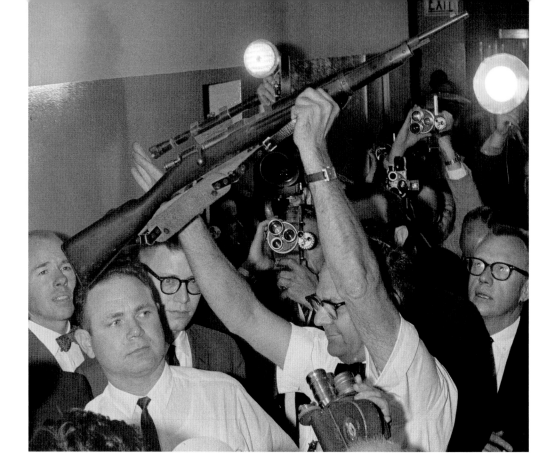

Ruby to jail. Charged with murdering Oswald, strip club owner Jack Ruby, 52, is off to jail. Well-known to Dallas police, he managed to get himself and his gun into city prison almost unnoticed—just one of the boys.

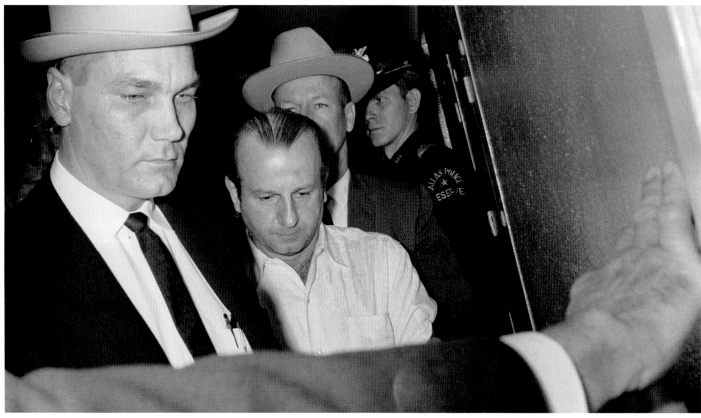

Nabbed. Lee Harvey Oswald is brought to Dallas City Hall, defiantly showing his handcuffs to photographers after his arrest as the prime suspect in the assassination of President John F. Kennedy.
Photo by Darryl Heikes.

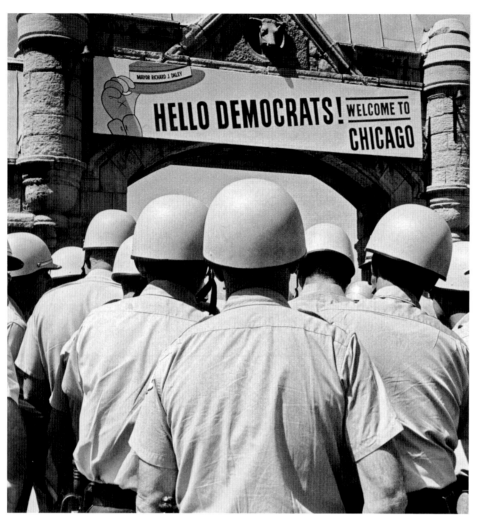

Some welcome! Democrats are greeted by a sea of helmeted police outside their national convention in August 1968. Most convention excitement took place not in the hall but in Chicago's streets, where 11,900 Chicago police, 7,500 Army troops, 7,500 National Guardsmen and 1,000 Secret Service agents skirmished for five days. *Photo by Gary Haynes.*

Political debate, '68.
Police mix it up on Michigan Avenue with antiwar demonstrators who tried to march on Convention Hall, where Sen. Hubert Humphrey received the Democratic presidential nomination. The display of social unrest overshadowed the convention proceedings.
Photo by Les Sintay.

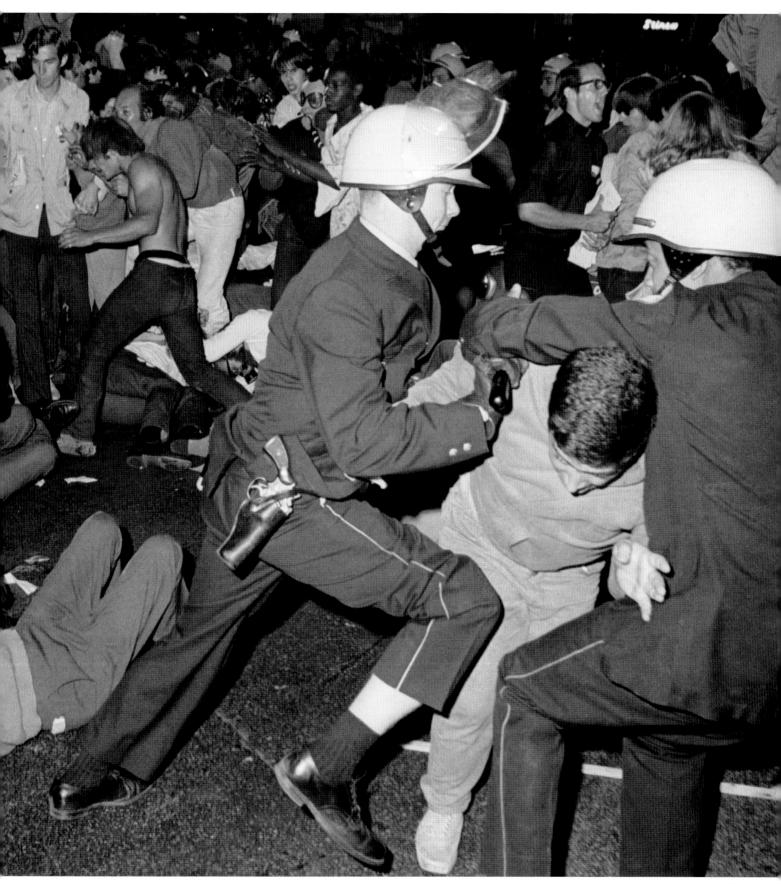

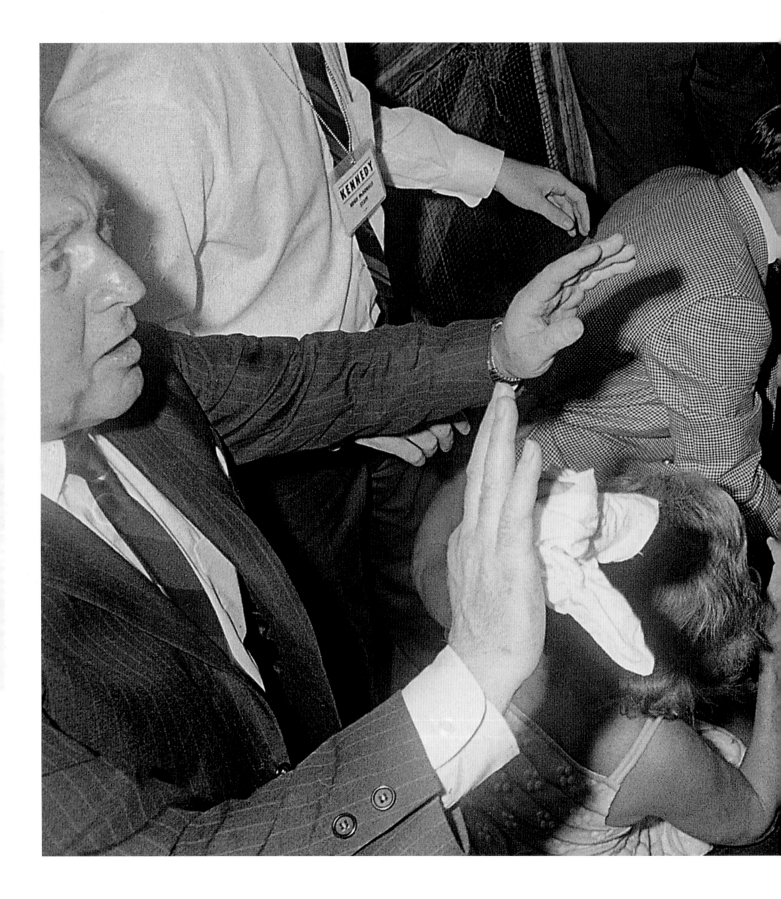

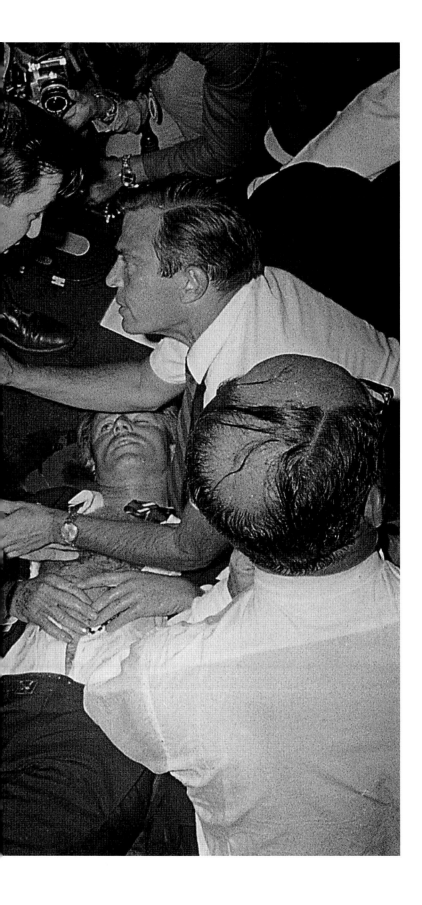

RFK shot. Sen. Robert F. Kennedy lies mortally wounded just one day after winning California's presidential primary in June 1968, victim of a 24-year-old assassin, Sirhan Sirhan. His wife Ethel pleads for breathing room. In the pandemonium the photographer's press pass fell to the floor. Recovered later, it was soaked in Kennedy's blood.
Photo by Ron Bennett.

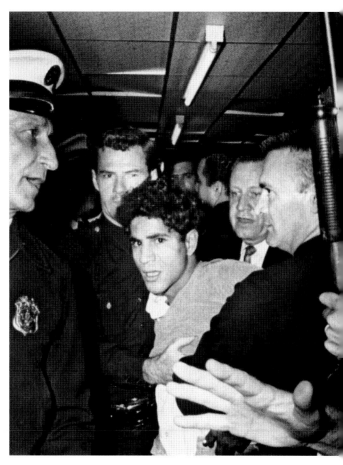

Assassin. Captured moments after he shot RFK with a .22 caliber revolver, Sirhan Sirhan is led away by police. Convicted of murder, his death sentence was reduced to life in prison after California's Supreme Court declared the death penalty unconstitutional in 1972.
Photo by Ron Bennett.

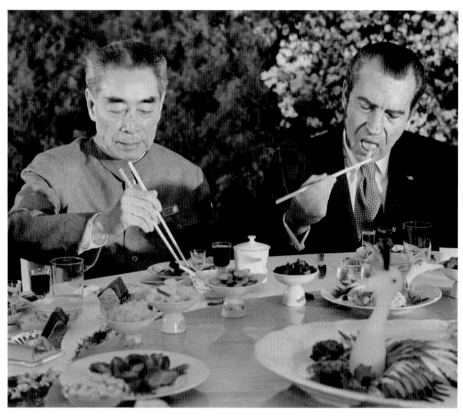

Chopsticks 101. The first U.S. president ever to visit China, Richard M. Nixon shares a welcome banquet with Premier Chou En-lai, but not his host's familiarity with chopsticks. The week-long visit paved the way for normal relations between the countries, estranged for more than 20 years.
Photo by Dirck Halstead.

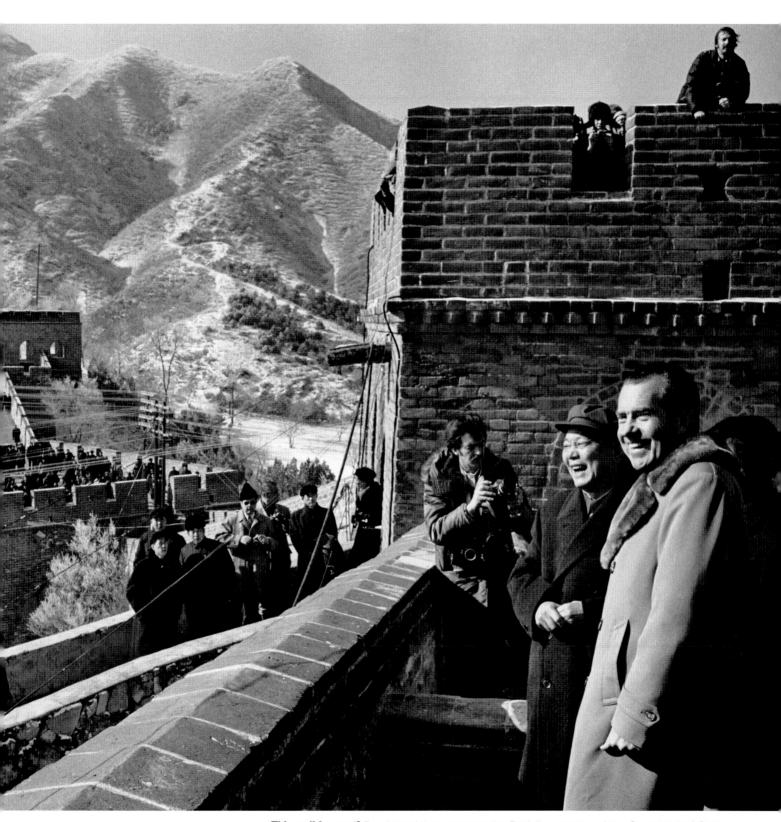

This wall is great! President Nixon surveys the Badaling portion of the Great Wall of China, one of the world's great wonders, accompanied by Vice Premier Li Hsien-nien.
Photo by Dirck Halstead.

Egyptian commute. President Nixon and Egyptian President Anwar Sadat wave to throngs (estimated at 3.5 million people along the route) trying to catch a glimpse of the presidents aboard a train from Cairo to Alexandria in June 1974. Nixon was only the second American president to visit Egypt since Franklin D. Roosevelt in November 1943. There were no seats on the flatbed car and the presidents stood for three hours. Nixon later said that he was having a "phlebitis attack, but it was worth it." He felt no pain while greeting the enthusiastic crowds. *Photo by Darryl Heikes.*

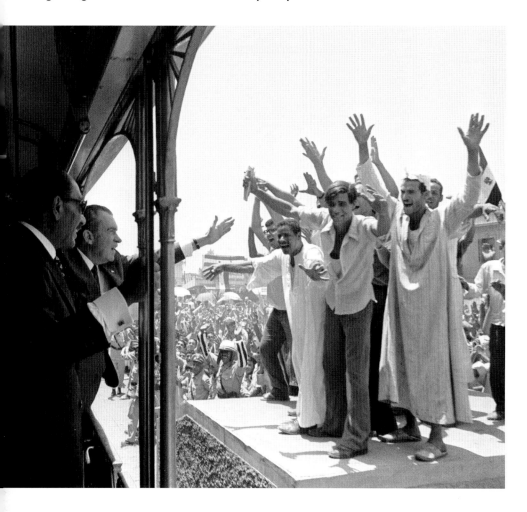

Belly laugh.
The Egyptian after-dinner entertainment in 1974 included a traditional belly dancer, who got up onstage so she could get a closer look at the world leaders—Kissinger, Nixon, and Sadat —and vice versa.
Photo by Darryl Heikes.

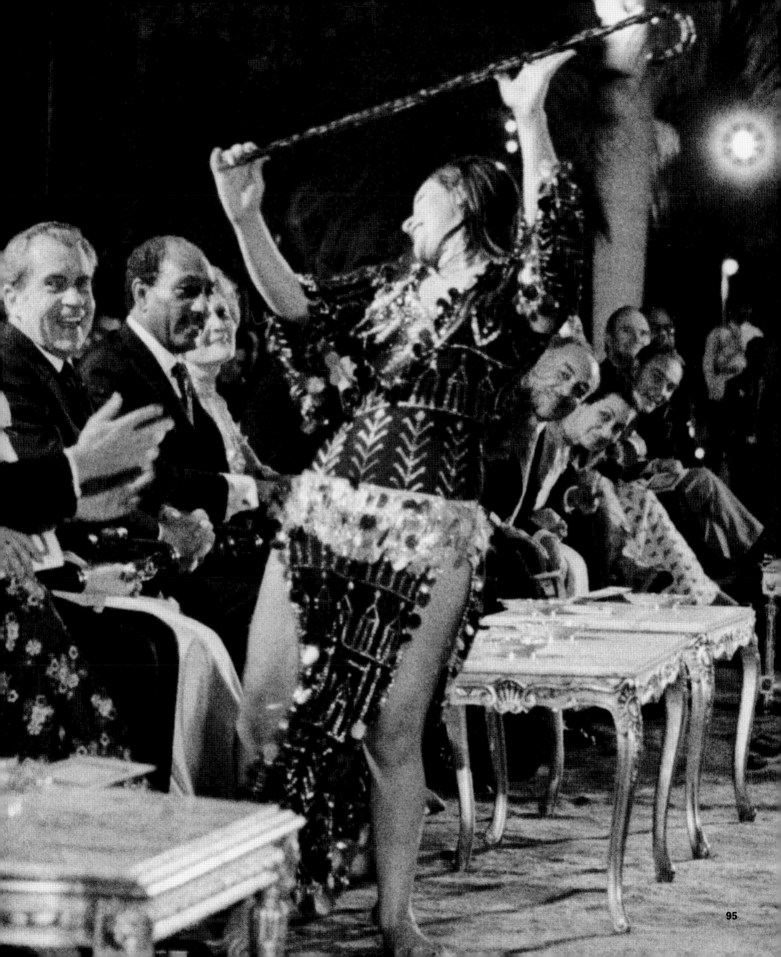

Hail from the chief. President Richard M. Nixon prepares to depart the White House after resigning office in August 1974. Disgrace sat well on Nixon. After a self-imposed four-year exile in California, he moved to the East Coast and tried to salvage his reputation. He wrote ten books. Presidents Reagan, George H.W. Bush, and even Clinton sought his advice. He left office in disgrace and lived and died in disgrace, but was nonetheless an ex-president of consequence.
Photo by Ron Bennett.

Not fashion police. Actual White House guards try to look serious, resplendent in their new over-the-top polyester uniforms more suited to a dinner theater operetta. This was both the first and last appearance of the bizarre outfits commissioned by President Richard Nixon. After nearly everybody roared with laughter at them, he decommissioned them and they have not been seen since.
Photo by Darryl Heikes.

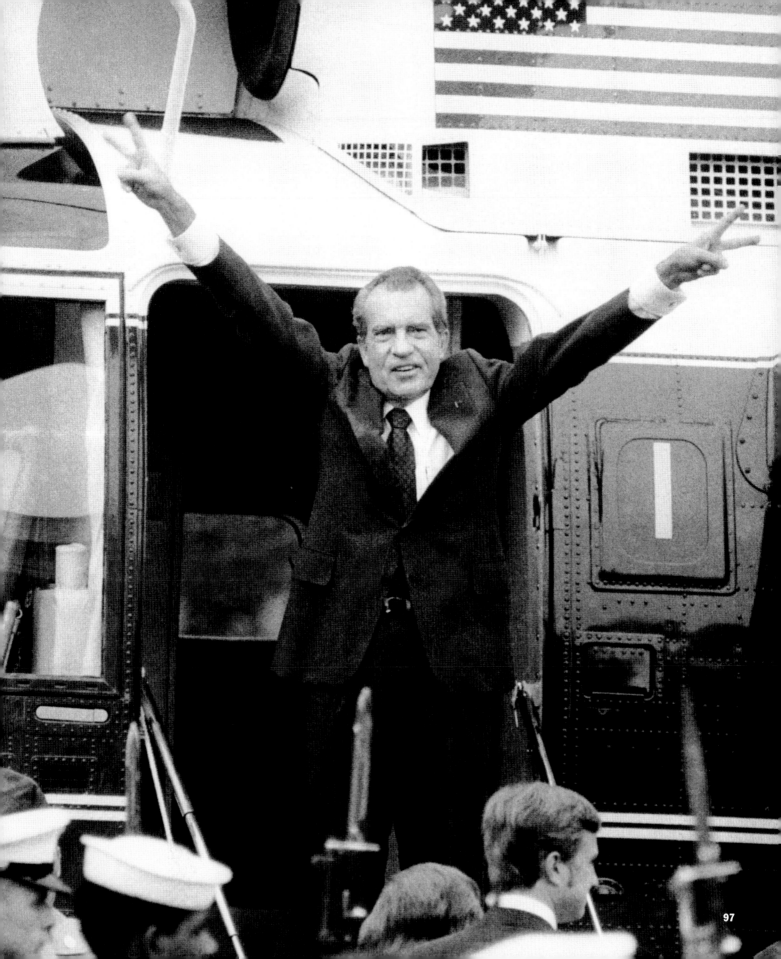

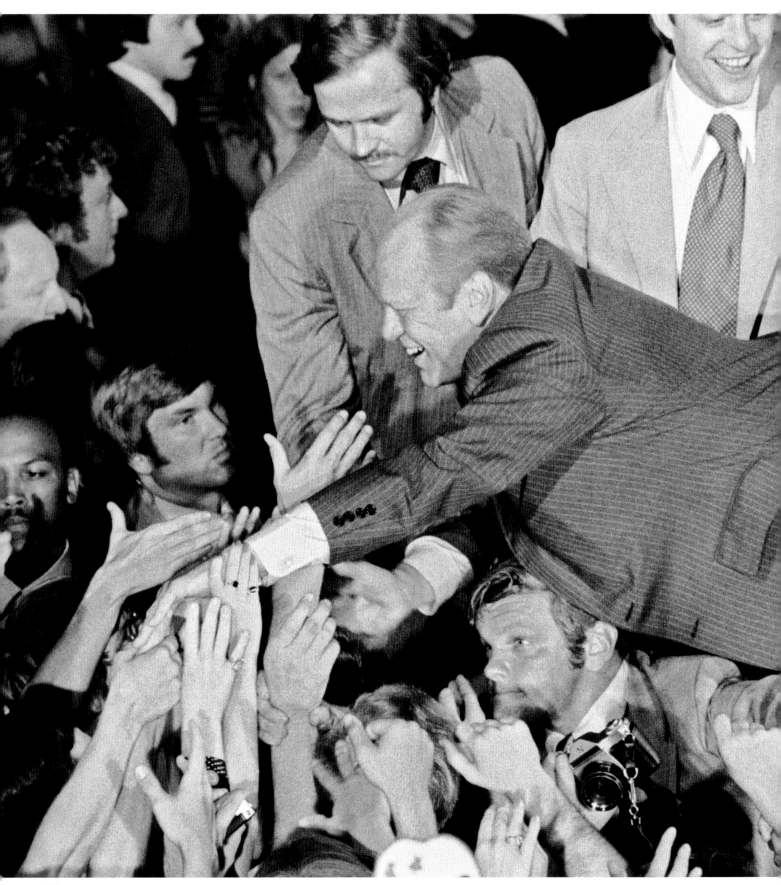

Smokescreen. President Ford puffs his pipe at a White House conference on the economy, September 1974. Ford inherited the weakest U.S. economy of the post–World War II years, but his "Whip Inflation Now" speech, complete with WIN buttons for citizens to wear if they agreed to save energy, was widely ridiculed. The buttons soon became a national joke, symbol of an administration incapable of dealing with the country's problems. *Photo by Darryl Heikes.*

Seat of his pants.
President Gerald Ford's son, Jack, helps keep his dad above the fray during the GOP Convention in Kansas City in 1976.
Photo by Ron Bennett.

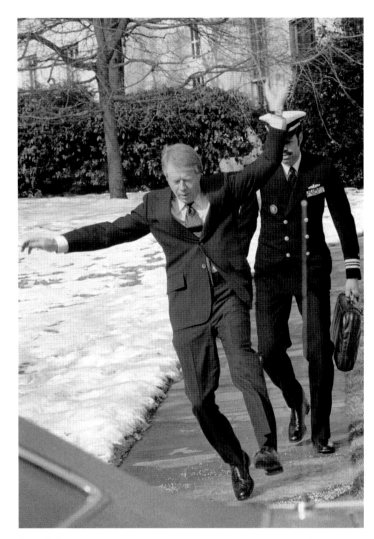

Slip slidin' away. Fancy footwork keeps President Jimmy Carter upright on an unexpectedly icy walk outside the White House in 1977. He is accompanied by his naval aide.
Photo by Dennis Cook.

Embracing peace. Israel's Prime Minister Menachem Begin (facing camera) embraces Egyptian President Anwar Sadat in 1978 after both signed a "Framework for Peace," normalizing diplomatic relations between their countries. A proud President Jimmy Carter, praised by Sadat as "the man who performed the miracle," applauds. Begin and Sadat would share the 1978 Nobel Peace Prize. A full peace treaty was signed at the White House in 1979. Two years later Sadat was assassinated by Muslim extremists. In 1979, this photo won a trifecta of awards: first in Pictures of the Year; first in World Press Photo, and first in General News, White House News Photographers' Association.
Photo by Darryl Heikes.

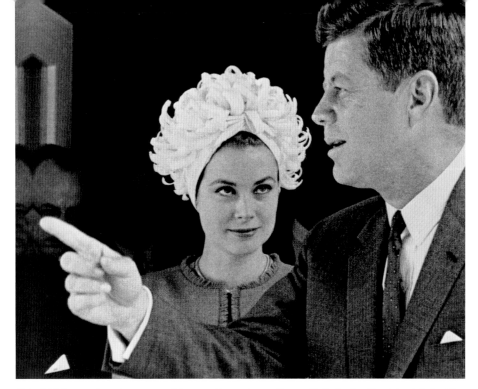

A look! Monaco's princess and former film actress Grace Kelly locks President John F. Kennedy in her sights during a White House visit in 1961. *Photo by James Atherton.*

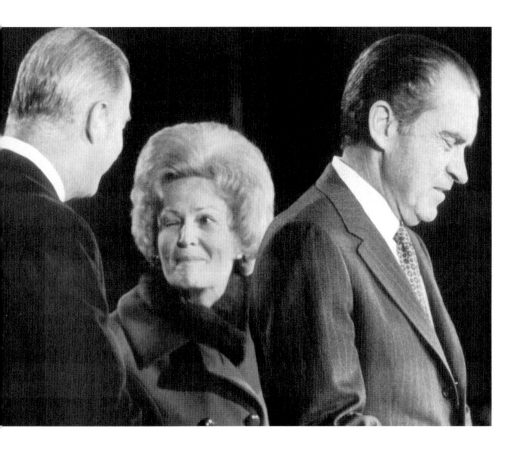

A wink! First Lady Patricia Nixon winks at Vice President Spiro Agnew as her husband, President Richard Nixon, addresses a crowd in 1973. *Photo by Darryl Heikes.*

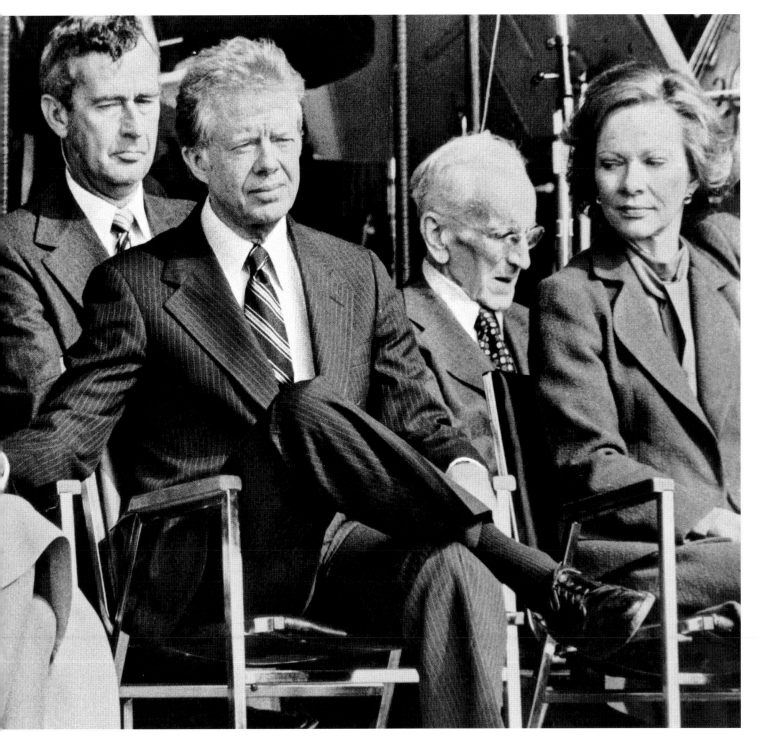

A frown! First Lady Rosalynn Carter checks out her husband, President Jimmy Carter, who holds Joan Kennedy's hand during a speech by her husband, Sen. Edward Kennedy, in 1979.
Photo by Frank Cancellare.

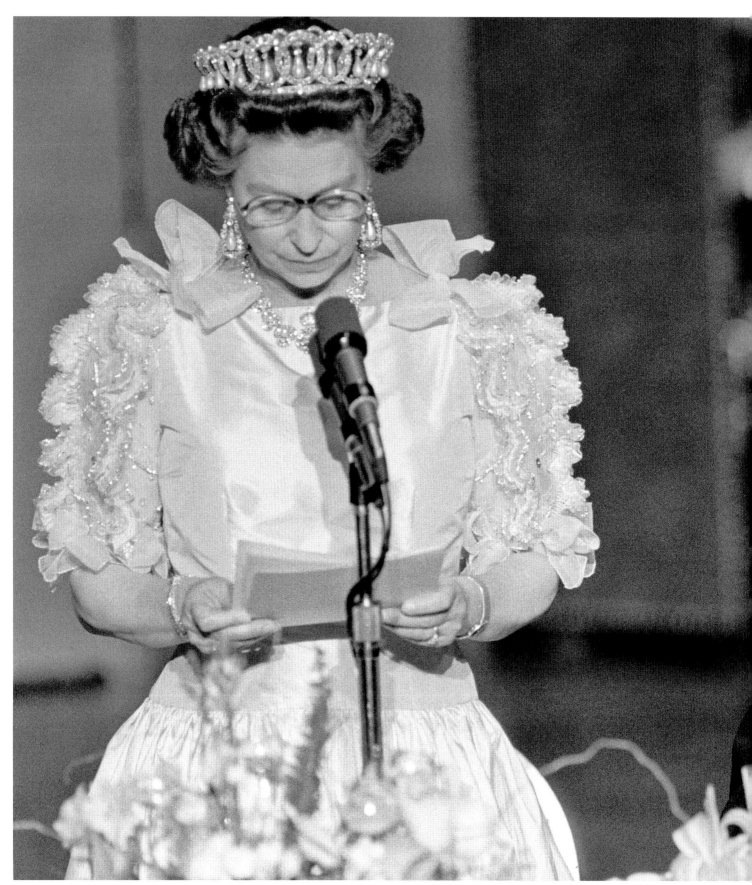

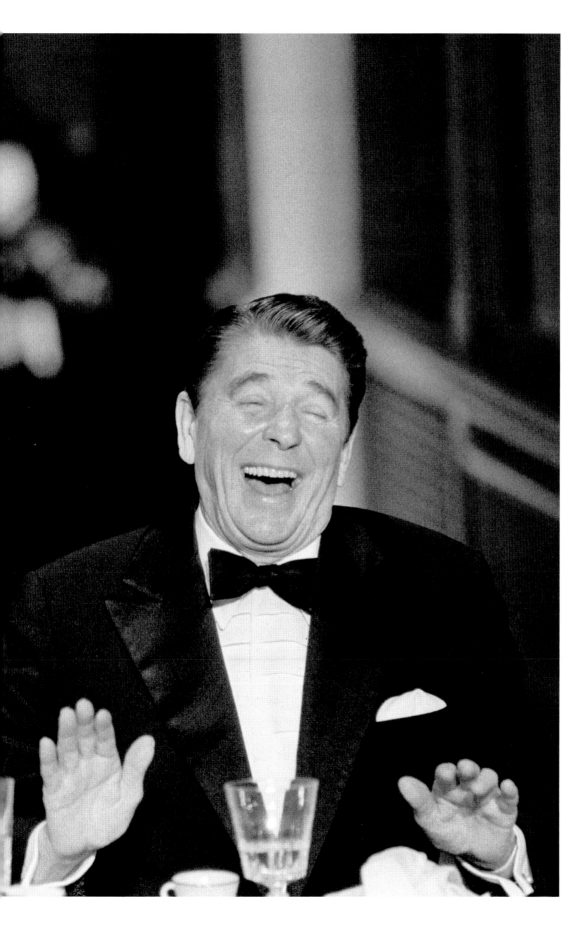

Weather or the dress?
Queen Elizabeth II, ever crisp, delights President Ronald Reagan with a genteel complaint about the wet and dreary weather California was experiencing. "I knew before we came that we had exported many of our traditions to the United States. But I had not realized before that weather was one of them." They were seated together at a state dinner held at San Francisco's M.H. de Young Memorial Museum in 1983.
Photo by Don Rypka.

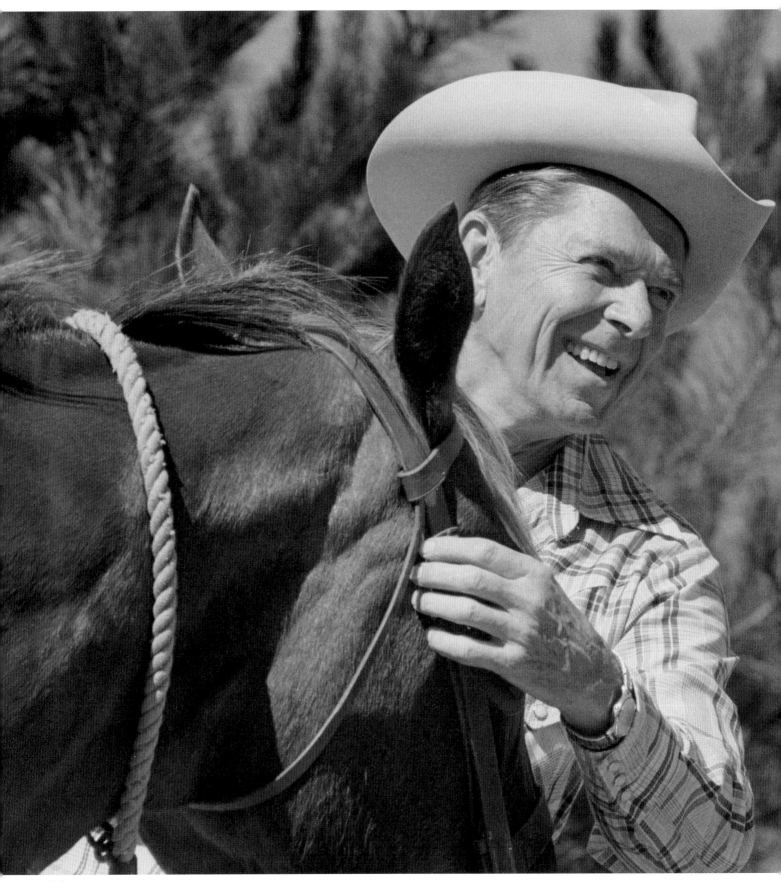

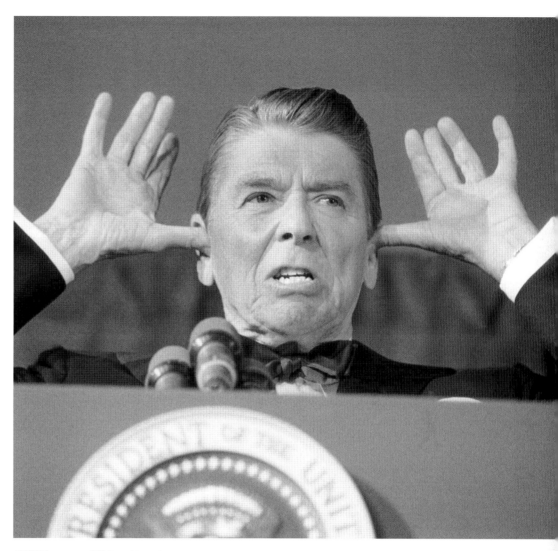

"Off the record?" President Reagan clowned before the White House news photographers in May 1983, and brought down the house. He joked that his grimace be kept "off the record," adding that the White House was adopting a new measure to keep the press in line—"tear gas." *Photo by Rich Lipski.*

Star power. Looking like the movie star he once was, President Ronald Reagan shows off his 700-acre Rancho del Cielo ("Ranch in the Sky") near Santa Barbara, Calif., in 1980. Reagan brought world leaders to his ranch but kept it a simple, down-to-earth place, lacking any hint that it belonged to the leader of the free world. He kept it humble and real, and it was quintessential Reagan. He used to say that if his ranch wasn't "heaven itself, it must have the same zip code." *Photo by Bob Flora.*

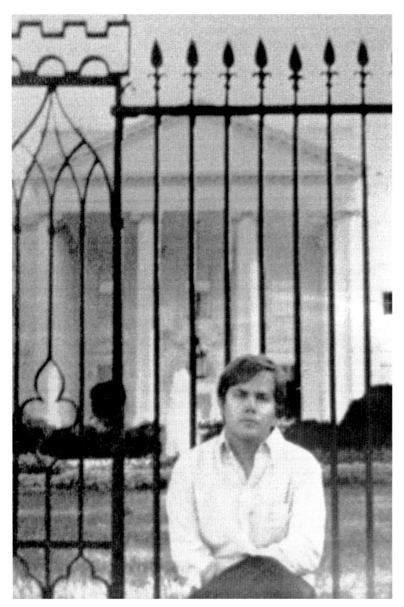

Mystery tourist. Months after he posed in front of the White House, John Hinckley Jr. tried to kill its occupant, Ronald Reagan. This photograph was provided to UPI photographer Joseph Marquette shortly after the failed attempt, on the condition the source would never be revealed. *Photo anonymous.*

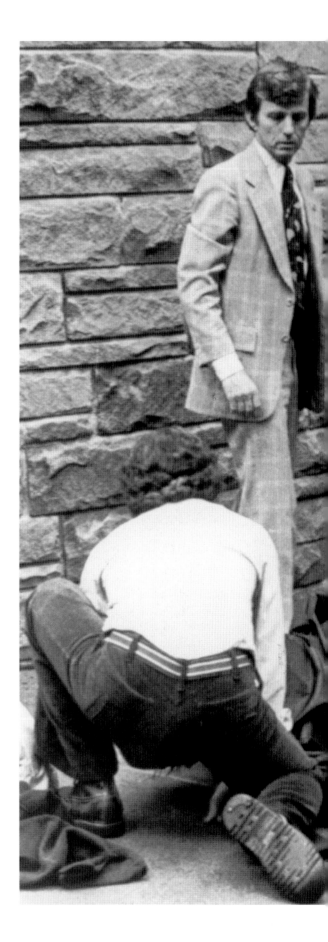

Assassination attempt.
John Hinckley Jr. got off six rounds at President Ronald Reagan on March 30, 1981, before he was subdued (right background). Reagan was hit once by a ricochet and would recover. Presidential Press Secretary James Brady (on sidewalk, center) caught a bullet in the brain and was permanently disabled. Also hit were Secret Service agent Timothy McCarthy and police officer Thomas Delahanty, who both recovered. Hinckley was found not guilty by reason of insanity and remains in a secure ward at St. Elizabeth's Hospital in Washington. *Photo by Don Rypka.*

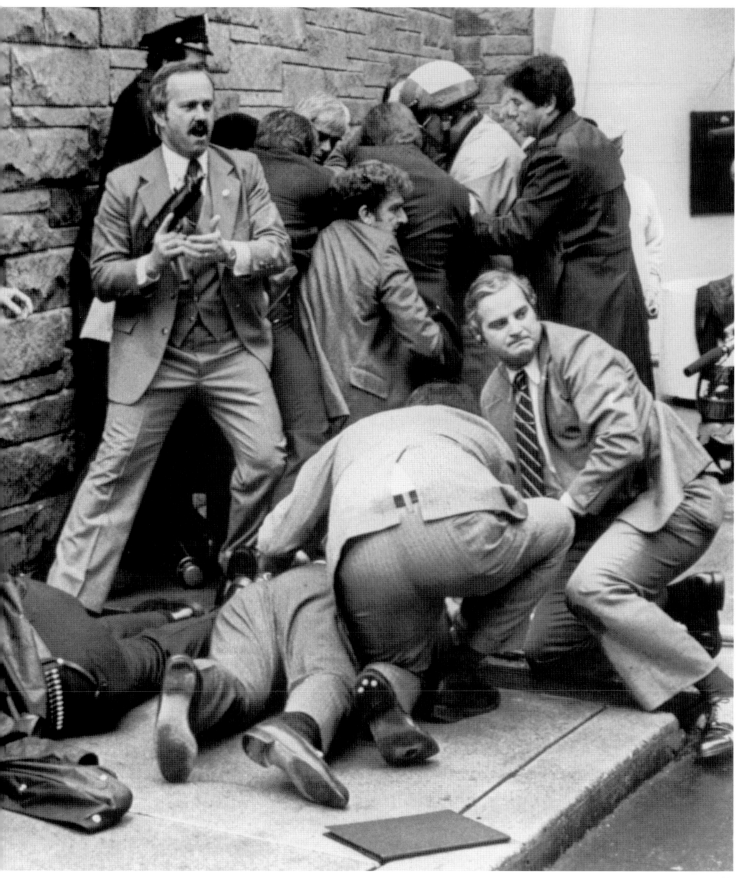

Pacific president.
On a 1990 holiday, President George H.W. Bush tested the Pacific waters off Honolulu. Invited to swim along, the photographer brought his Nikon Action Touch waterproof camera, and UPI had an exclusive photo.
Photo by Joe Marquette.

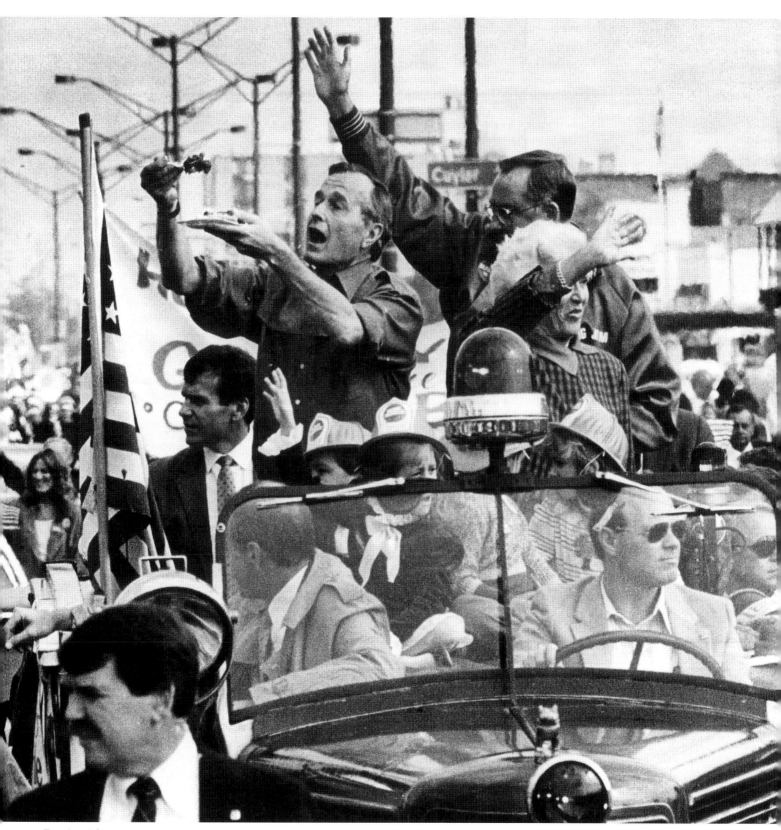

Free lunch? George H.W. Bush offers to share his lunch as he campaigns in Chicago's suburbs on a fire truck in 1988, accompanied by his wife, Barbara, and Illinois governor Jim Thompson. *Photo by Jim Smestad.*

Justin time. Canadian Prime Minister Pierre Trudeau arrives for a garden party in 1973 with son Justin under one arm. The youngster seems to be checking out the Royal Canadian Mountie's salute. This photo won Canada's national 1973 Best Feature Photo award. *Photo by Rod MacIvor.*

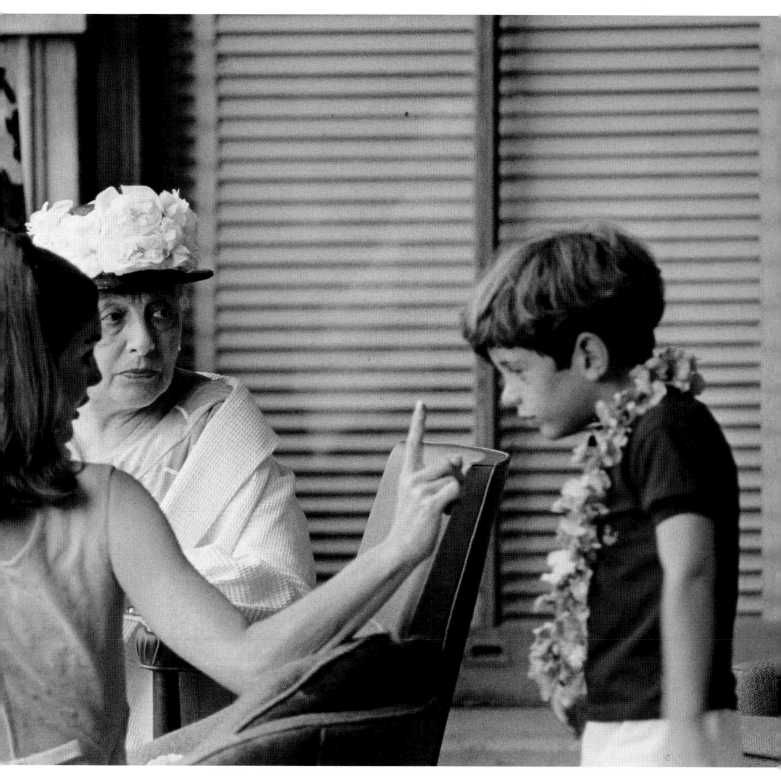

Now hear this! "John-John" Kennedy grew restless during the Kamehameha Day parade in Honolulu in June 1968 and his mom, Jacqueline, admonished him to remain calm. They observed the parade from the balcony of the Iolani Palace. Heiress Alice Campbell contributes a stern look. *Photo by Carlos Schiebeck.*

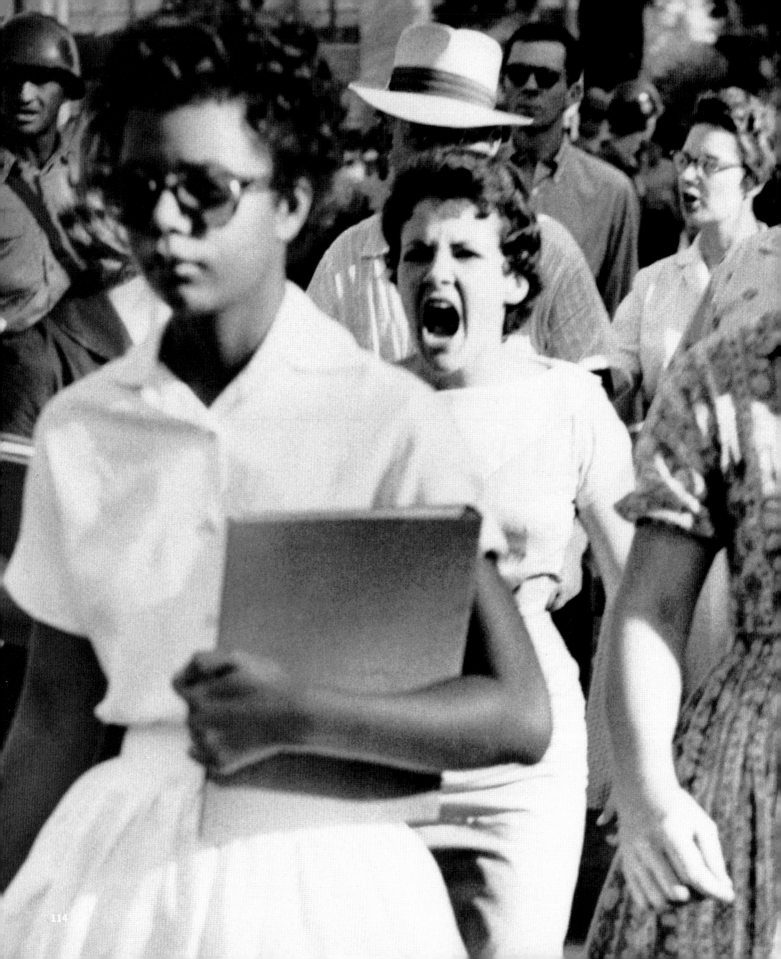

Civil Rights

UPI photographers distinguished themselves covering the biggest story of the generation, and a movement that profoundly changed the country—the civil rights unrest in the South in the '60s. In many Southern towns there was scant difference between the cops and the Klan. Many citizens were both, and whether wearing a badge or a hood, they did not hold the press in high regard.

Laws applied on a sliding scale based on skin color. Whites could call the police and get help. For blacks, the police were often part of the problem. Everything was segregated: schools, churches, drinking fountains, hotels, motels, theaters, restaurants, libraries, elevators, neighborhoods, and even cemeteries. Signs on public restrooms read "Men," "Women," and "Colored."

James Meredith enrolled as the first black student at the University of Mississippi in Oxford in September 1962. Before he got to his first class, 30,000 U.S. troops were needed to quell the rioting. The mayhem involved 3,000 people, including students, local citizens, and Klan groups from Florida to Texas incited by Mississippi governor Ross Barnett.

The mob fought U.S. marshals with bricks, bottles, stones, and homemade bombs. Two people died and 60 marshals were injured, 27 of them by civilian gunfire.

French journalist Paul Guilhard visited UPI for advice—get rid of the beard and suit and blend in—but he ignored it. He was found dead the next morning on campus, a bullet in his back.

Hundreds of students took part in the riot; not one was ever expelled. Thousands of outsiders participated in the mayhem; not one was ever convicted.

The small core of photographers who returned again and again to cover the civil rights struggles of the '60s have little doubt that the power of their photographs shifted the national conciousness, made a difference in people's lives, and helped spur passage of the Civil Rights Act of 1964.

Unwelcoming committee. Wearing a new dress she made for her first day at Little Rock Central High in September 1957, Elizabeth Eckford tries to ignore hostile white students. Arkansas governor Orval Faubus ordered the National Guard to admit only white students, and she was turned away.

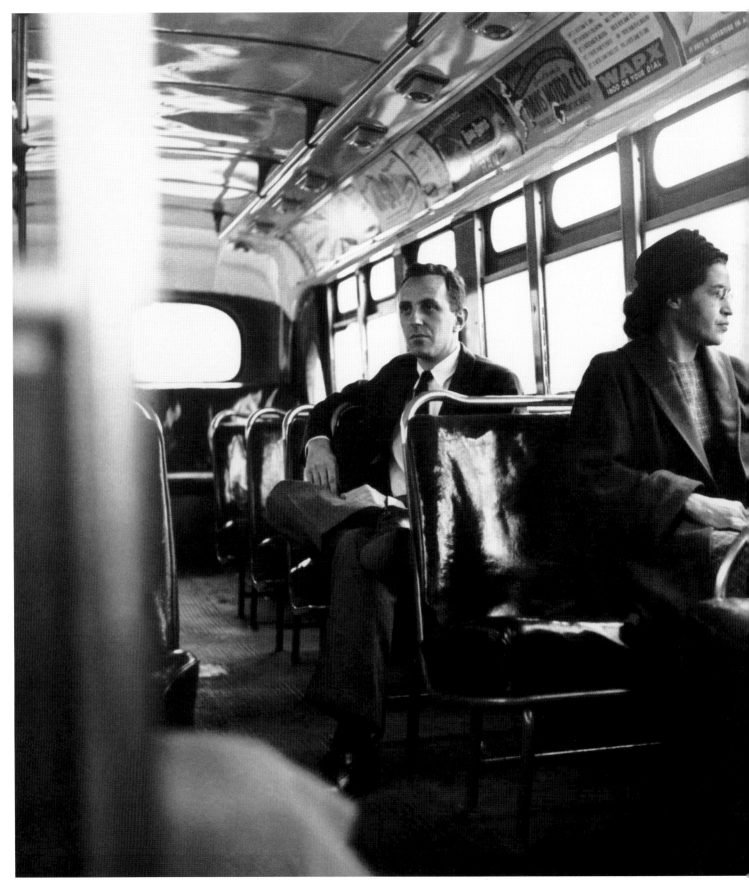

Up front. Rosa Parks sits up front on a Montgomery, Ala., bus December 21, 1956, the day the Supreme Court ruled segregated transit unconstitutional. Behind her is Nicholas Chriss, a UP reporter who arranged and posed for this symbolic picture. One year earlier Parks refused to give up her seat to a white man and was arrested. Black riders were expected to board the bus in front, pay the driver, get off, reenter through the rear door and sit in the back. Two-thirds of Montgomery's bus riders were black. If the "whites" section was full and another white passenger boarded, blacks were expected to give up their seats and move further back. They were not allowed to sit opposite whites.

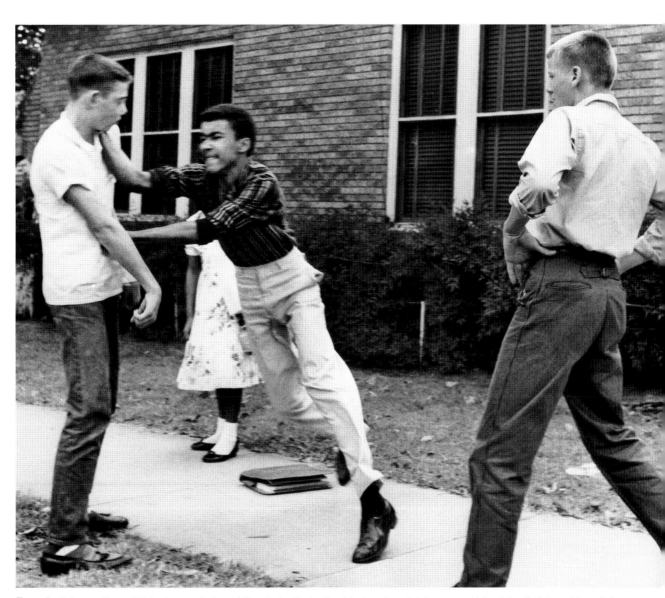

Enough. Johnny Gray, 15, lashes out at a white student who had just ordered Johnny and his sister "off the sidewalk" in Little Rock in June 1958. The surprised whites retreated. The photograph won first place for spot news in the 1958 Pictures of the Year competition, and the photographer became an executive at UPI Newspictures.
Photo by Charles McCarty.

Morning after.
Torched cars, cement posts, and debris testify to a campus in chaos over enrollment of the first black student, James Meredith, at the University of Mississippi, September 30, 1962.
Photo by Gary Haynes.

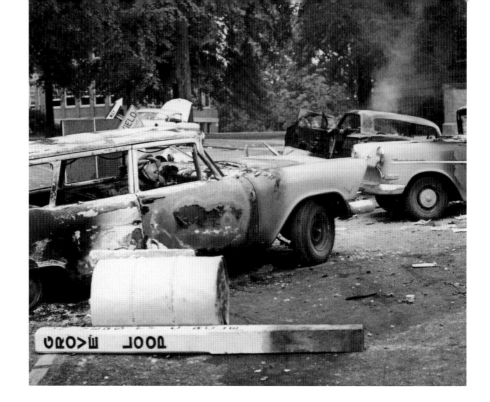

Tear gassed. Their eyes burning from lingering tear gas, Mississippi students breathe through handkerchiefs while a patrolling soldier still wears his gas mask. The street is littered with debris that filled the air during a night-long battle that raged over enrollment of the school's first black student since its founding in 1848. Two men died and 60 marshals were injured.
Photo by Gary Haynes.

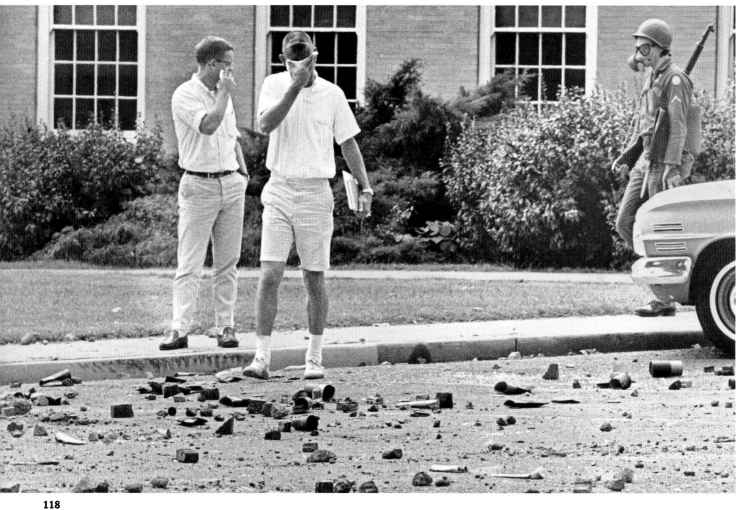

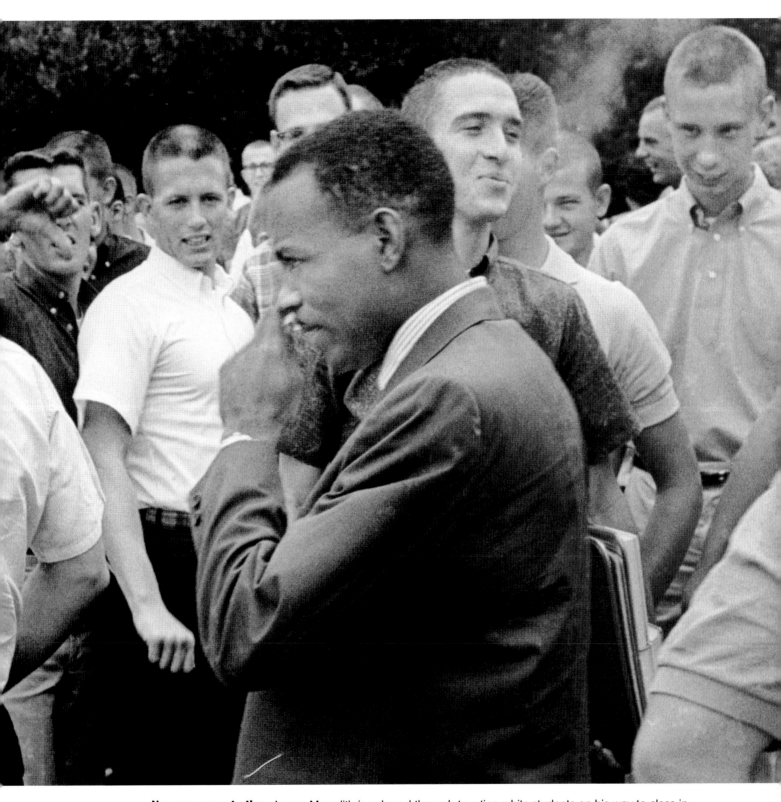

Nervous concentration. James Meredith is ushered through taunting white students on his way to class in October 1962. Tensions still ran high a week after his enrollment led to rioting. President John F. Kennedy ordered more than 20,000 U.S. Army soldiers from nearby Memphis to restore order on the campus. *Photo by Gary Haynes.*

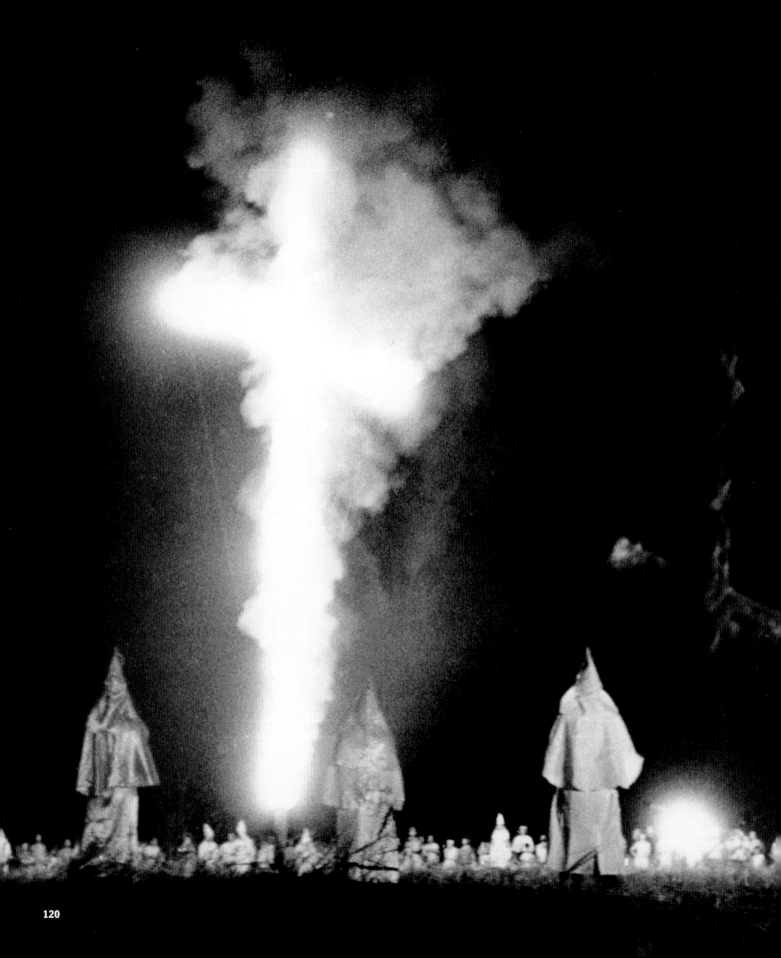

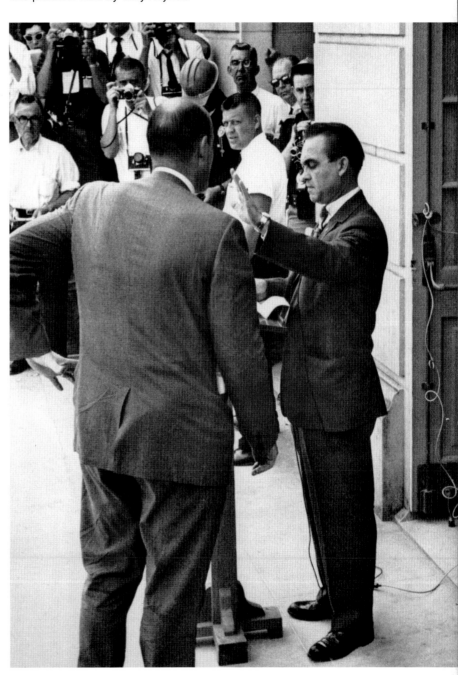

"Stand" in schoolhouse door. Trying to keep blacks out of the University of Alabama, Governor George Wallace halts Deputy U.S. Attorney General Nicholas Katzenbach to read a proclamation in June 1967. Following his symbolic "stand" Wallace stepped away, and with the federalized Alabama National Guard standing ready, Vivian Malone and James Hood enrolled. Wallace's polite and carefully orchestrated surrender left white supremacists free to fight another day. *Photo by Bill Lyon.*

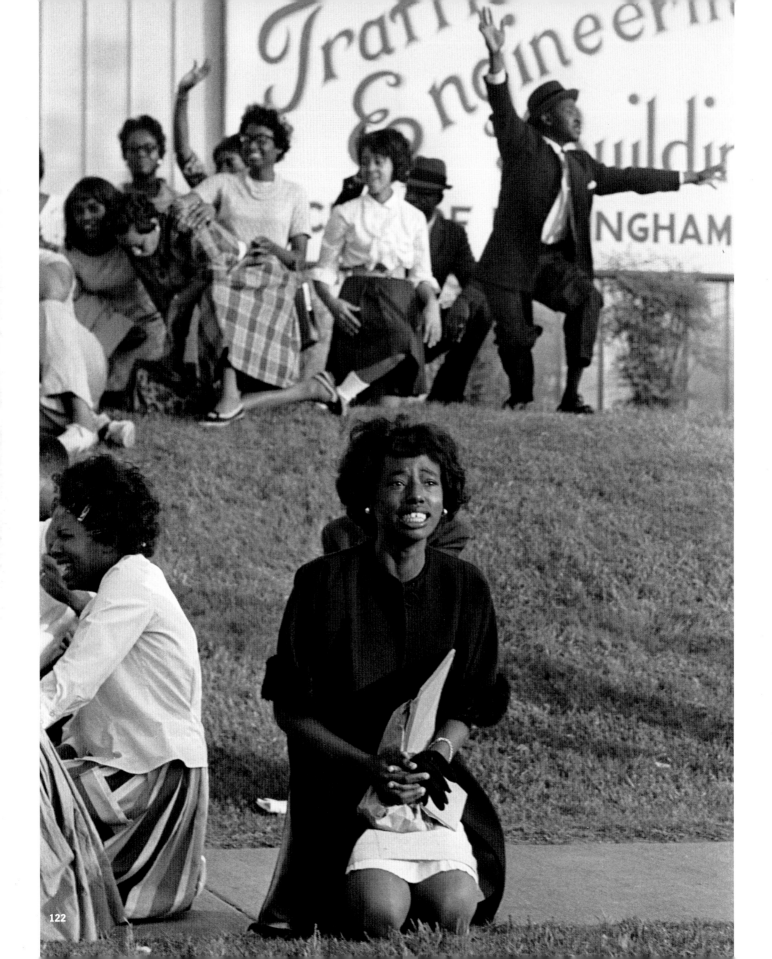

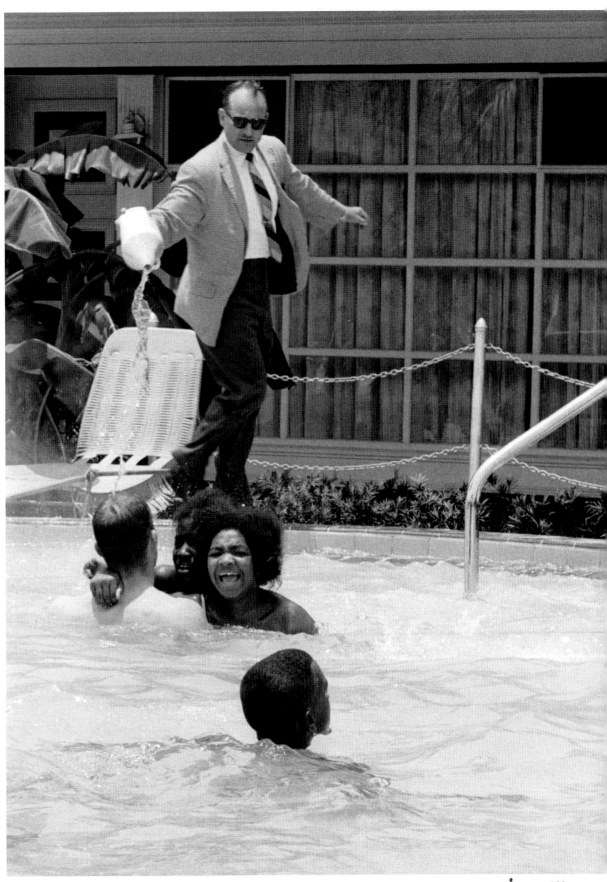

Acid bath.
A furious James Brock, manager of the St. Augustine, Fla., Monson Motor Lodge, dumps muriatic acid, a pool chemical, into his hotel's swimming pool in June 1964 after civil rights demonstrators jumped in. When the fracas was over, 34 people, including the swimmers and other civil righters who stayed dry, had been hauled off to jail.
Photo by Bill Lyon.

No permit, no "parade."
A young woman in tears kneels in prayer after Birmingham police stopped this group on their way to church because they had no "parade permit."
Photo by Gary Haynes.

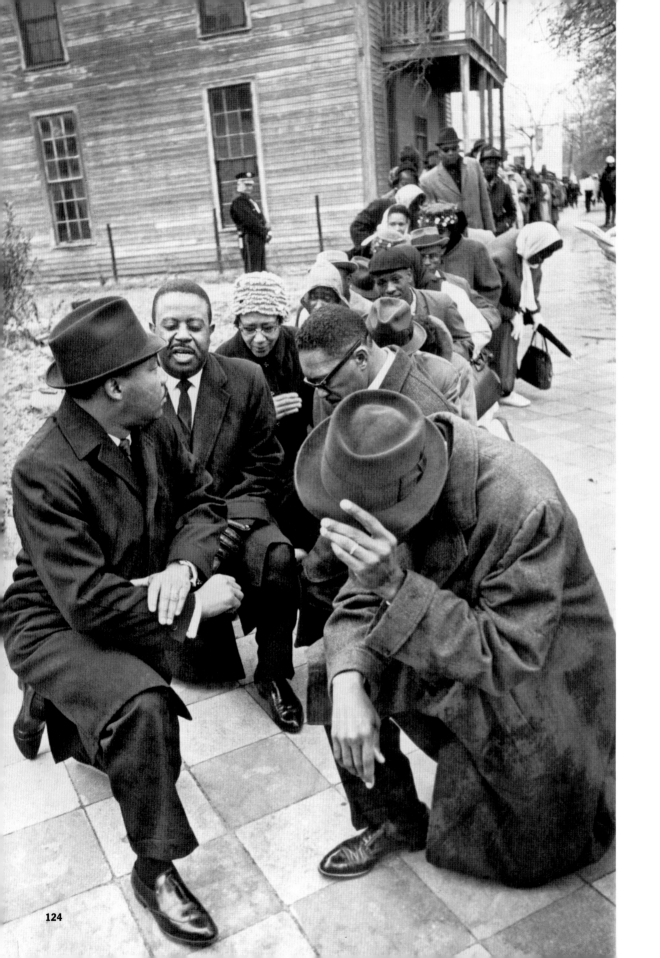

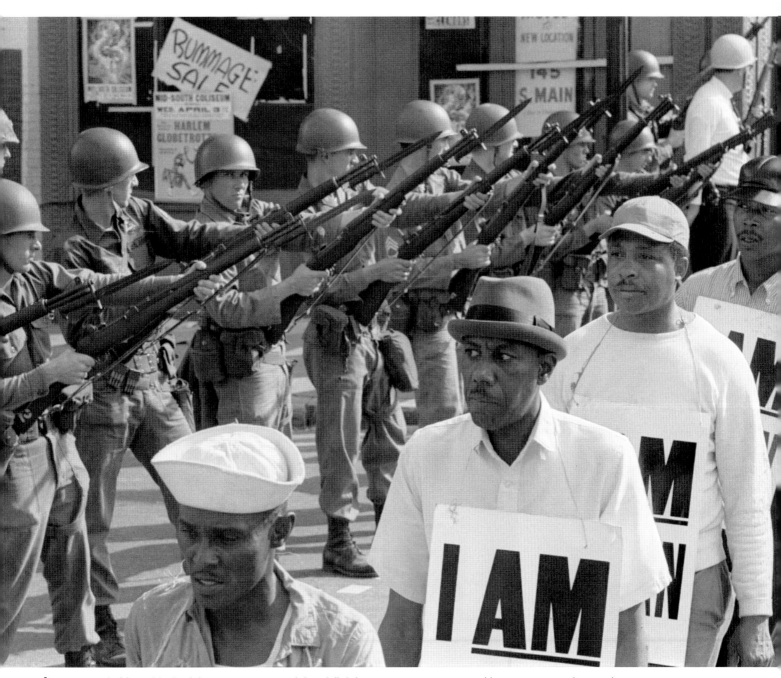

I am a man. In Memphis the labor movement and the civil rights movement converged in a monumental struggle for human and public employee rights in 1968. Sanitation workers—nearly all of them black—marched past combat-ready Tennessee National Guardsmen to demand their rights. Dr. Martin Luther King Jr. arrived in Memphis to lend support but before he could lead their march he was assassinated April 4.
Photo by Sam Parrish.

Prayer before jail. Dr. Martin Luther King Jr. and Dr. Ralph Abernathy (left, behind King) kneel to pray with fellow demonstrators arrested in February 1965 in Selma, Ala., demonstrating for the right to vote. Following the prayer everyone marched peacefully to jail. King said, "We will turn America upside down in order that it turn right side up."
Photo by Gary Haynes.

Comforting Coretta.
The widow of Dr. Martin Luther King Jr., is consoled by her family following her husband's funeral at Ebenezer Baptist Church in Atlanta in April 1968. Her father, Obie Scott, is at left; her daughter Bernice is at right, as is Harry Belafonte. King was assassinated in April 1968 on the balcony of the Lorraine Motel in Memphis, Tenn., as he prepared to lead a march supporting the predominantly black Memphis sanitation workers' union.
Photo by Sam Parrish.

Federal pass. To work in a small Mississippi town the press needed to register with the Feds and obtain this "press pass" in Oxford, Miss.

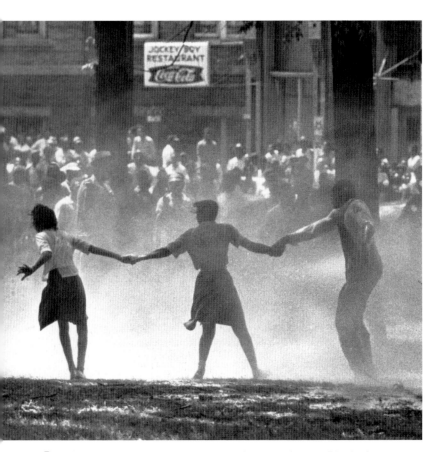

Pressure guns. Holding hands against the water hoses, Birmingham demonstrators stand strong. The city's totally segregated schools, drinking fountains, restaurants, and public toilets made the city one of the toughest segregated towns in the South. Parks were closed rather than integrate them following a court order.
Photo by Carey Womack.

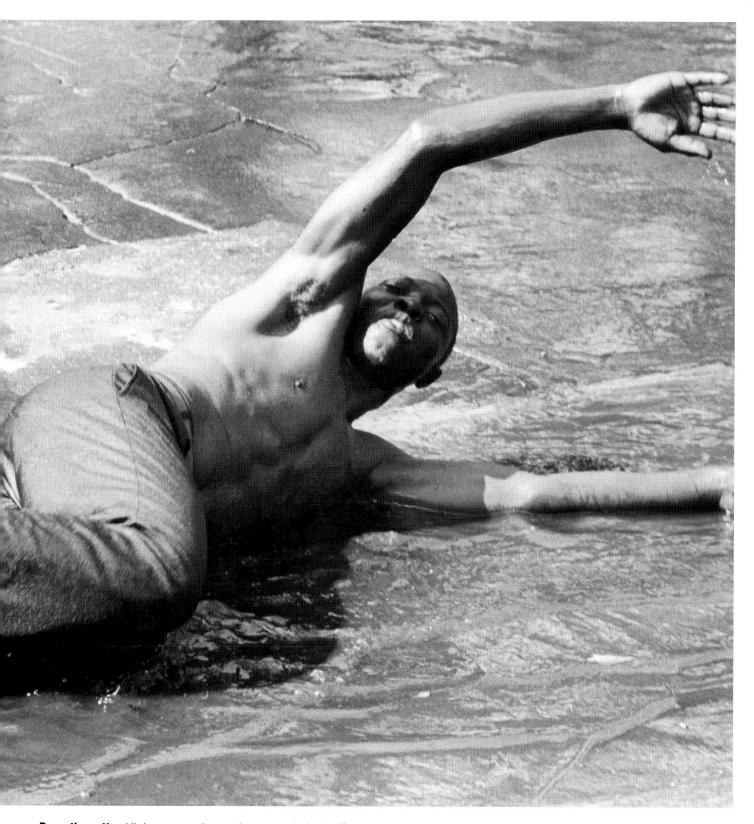

Down the gutter. High-pressure hoses that can strip bark off trees spin a protester down the street during a civil rights demonstration in Birmingham in 1963. The Metropolitan Opera company had stopped visiting because the city refused to integrate the public auditorium. Birmingham gave up its professional baseball team rather than have it play integrated teams in the International League. *Photo by Gary Haynes.*

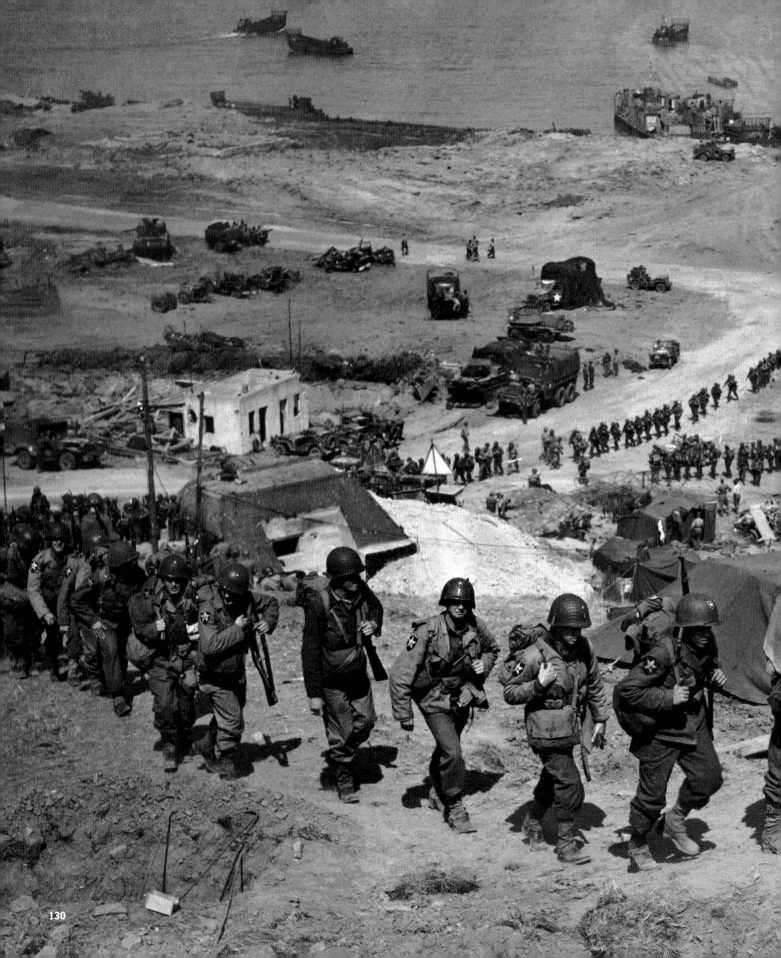

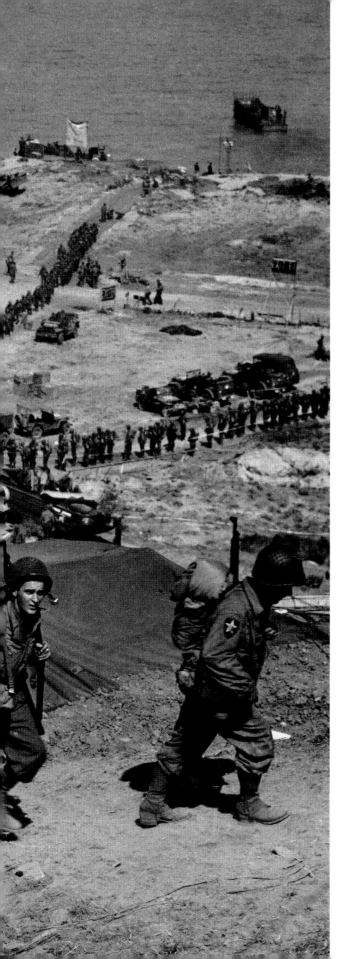

Conflict | 1

"*In many ways [war photographers] are counterintuitive, venturing into the most dangerous situations, when everyone else—who possibly can—is trying to get out. Many photographers develop their own particular ways of dealing with the chaos and death surrounding them. Some become detached from the reality of the battlefield by using the viewfinder as a way to block and immunize themselves against the madness.*"
—Dirck Halstead, UPI's first Saigon photo manager

Until photography brought the reality home, war was something that for Americans happened far away, with almost romantic notions of our brave soldiers going to battle and coming home whole, as heroes.

Early war photographers couldn't record actual combat because cameras of the day were clumsy and exposure times were in minutes. Photography in America was only 21 years old at the time of the Civil War, and most photos of that war were made on glass plates after the battles were over. Matthew Brady, Timothy O'Sullivan, Roger Fenton, and others shocked America with their photographic evidence of war's horrible costs.

"It was so nearly like visiting the battlefield," wrote Oliver Wendell Holmes about Brady's work, "that all the emotions excited by the actual sight . . . came back to us. [It] gives us . . . some conception of what a repulsive, brutal, sickening, hideous thing it is, this dashing together of two frantic mobs to which we give the name of armies . . ."

By World War II the compact 35mm camera and "fast" wide-aperture lenses (f/2 and f/1.4), made possible photos in fluid situations and extremely low light. Photographers could now skirt the war's front lines, closer to the combat and the truth, and the danger.

Omaha Beach. U.S. infantrymen stream up France's Omaha Beach in June 1944, where 2,200 American lives were lost trying to take the beach on D-Day, mostly because American high-altitude bombers had missed a majority of their targets, leaving German defenders on the beach largely unharmed.

131

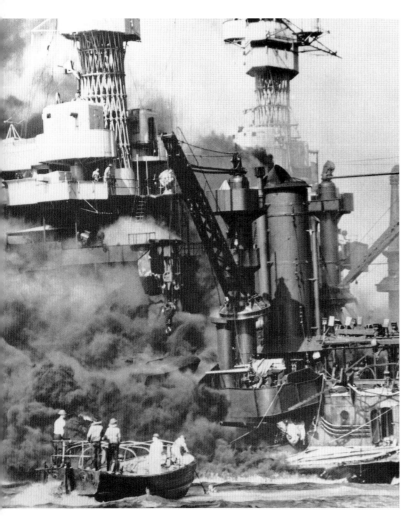

"A day that shall live in infamy." Rescuers search for survivors from the burning USS *West Virginia* on December 7, 1941, after the Japanese sneak attack on the United States Pacific Fleet center at Pearl Harbor, Hawaii, and other military targets. *Photo by Jim Sutherland.*

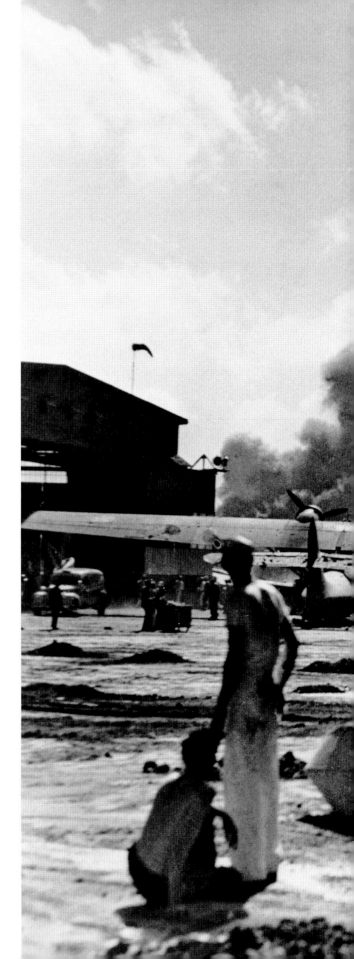

Pearl Harbor chaos.
From 274 miles across the Pacific came 353 carrier-based Japanese planes in two waves, 7:53 a.m. and 8:55 a.m. By 9:55 a.m. it was over, leaving 2,403 dead, 188 planes destroyed and 159 damaged, and 21 ships including eight battleships damaged or destroyed. Pure luck spared the Navy's three aircraft carriers, which were not at Pearl. Japanese Adm. Isoroku Yamamoto, who planned the attack, said afterward, "I fear that we have awakened a sleeping giant and filled him with a terrible resolve." *Photo by Earl Sever, U.S. Navy.*

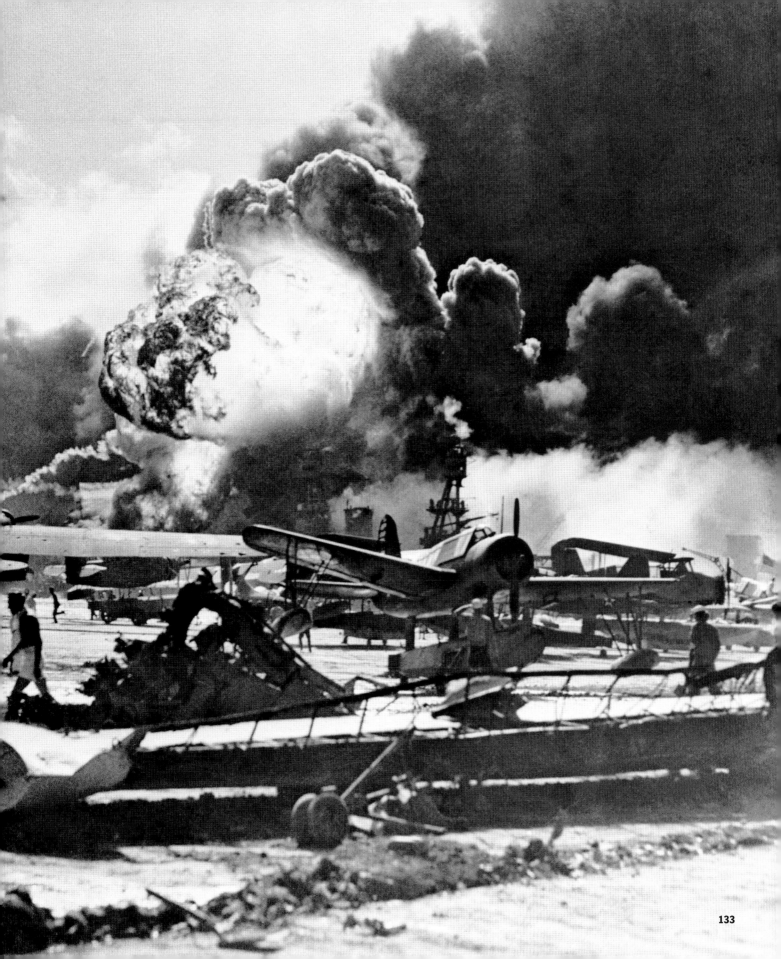

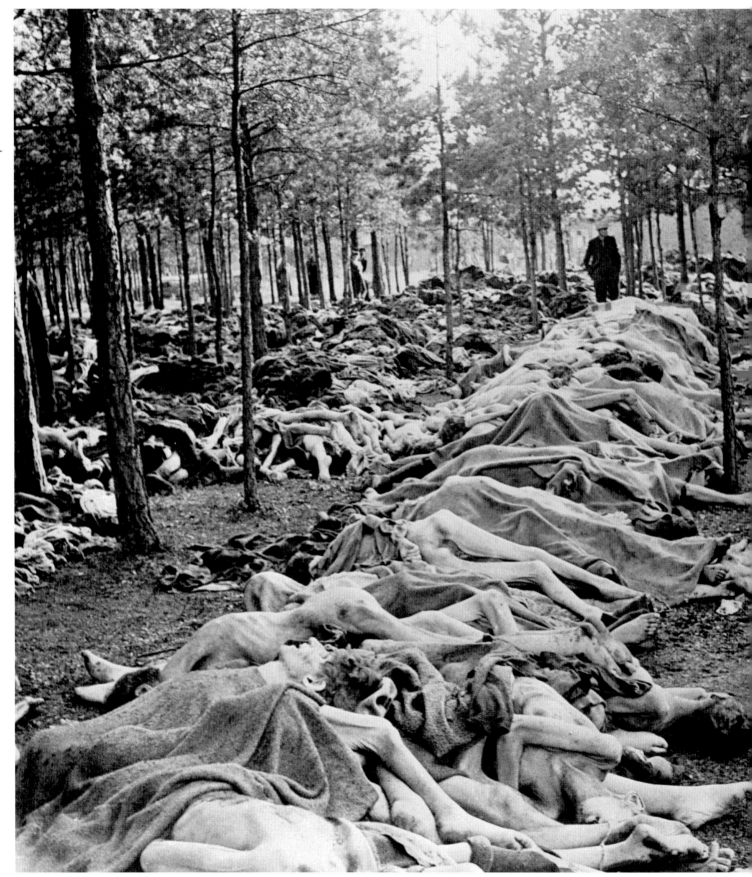

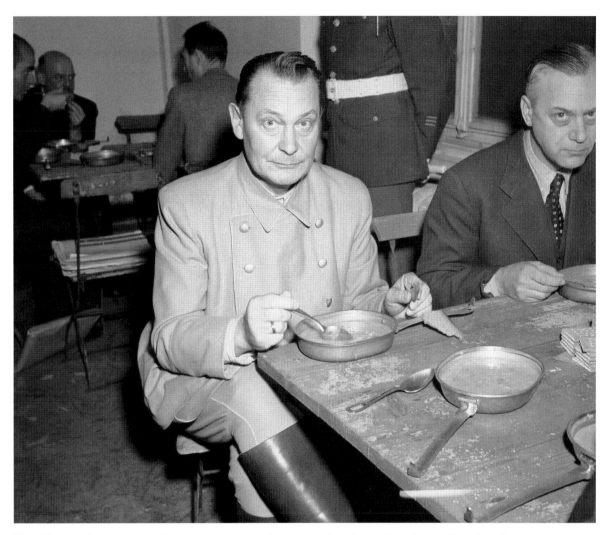

Tin plate monster. Hermann Goering, accustomed to ostentatious luxury (a palace in Berlin) and extravagant tastes (stolen art treasures, changing his uniform five times a day), eats from a tin plate during a break in his war crimes trial in Nuremberg. Found guilty, Hitler's designated successor was sentenced to death, only to cheat the executioner on October 15, 1946, by killing himself with a poison capsule he'd hidden from the guards just two hours before his appointment with the hangman.

Forest of death.
An estimated 60,000 civilian corpses await burial at the notorious Nazi Bergen-Belsen concentration camp, April 15, 1945. It had just been surrendered to the British, who found thousands of unburied victims in various stages of decomposition, a fourth of them killed in a typhus epidemic. Despite frantic efforts by British doctors to help survivors, 9,000 more died in the first two weeks and another 4,000 died the next month. British troops forced German SS guards to dig graves and bury their victims bare-handed, and made them sleep in the same filthy huts as the inmates had. Many contracted typhus. German soldiers who balked were shot.

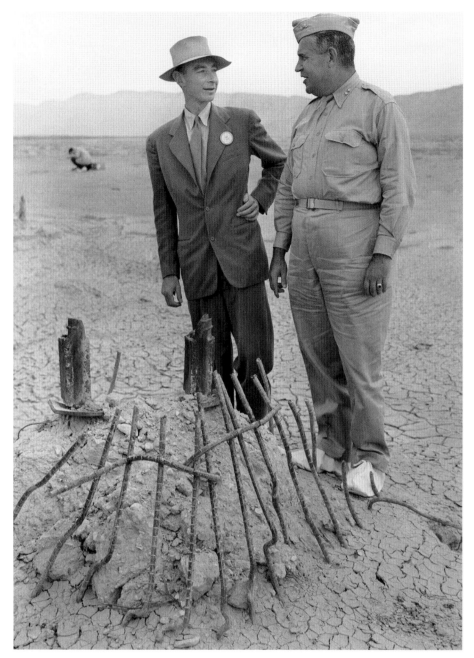

First atomic bomb. Near Alamogordo, N.M., Dr. J. Robert Oppenheimer, whose team of scientists developed the atom bomb, and Brig. Gen. Leslie Groves of the Manhattan Project, stand at what little remains of a tower vaporized by detonation of the world's first atomic bomb. After this picture was taken, a cheerful Army officer told the photographer that radiation at the site might not only fog his film, it could make him sterile. The film was fogged and difficult to print, but the photographer would later father five children. *Photo by Leo Stoecker.*

Big splash. A 23-kiloton atomic bomb is detonated 90 feet underwater in July 1946, sending up a column of water 6,000 feet high and 2,200 feet around, to test the effect of nuclear weapons on ships, equipment, and material. More than 90 scrap target vessels were assembled in Bikini Lagoon. Only three A-bombs had been previously detonated: a 1945 test in New Mexico and the two detonated over Hiroshima and Nagasaki, Japan, that convinced the Japanese to surrender.

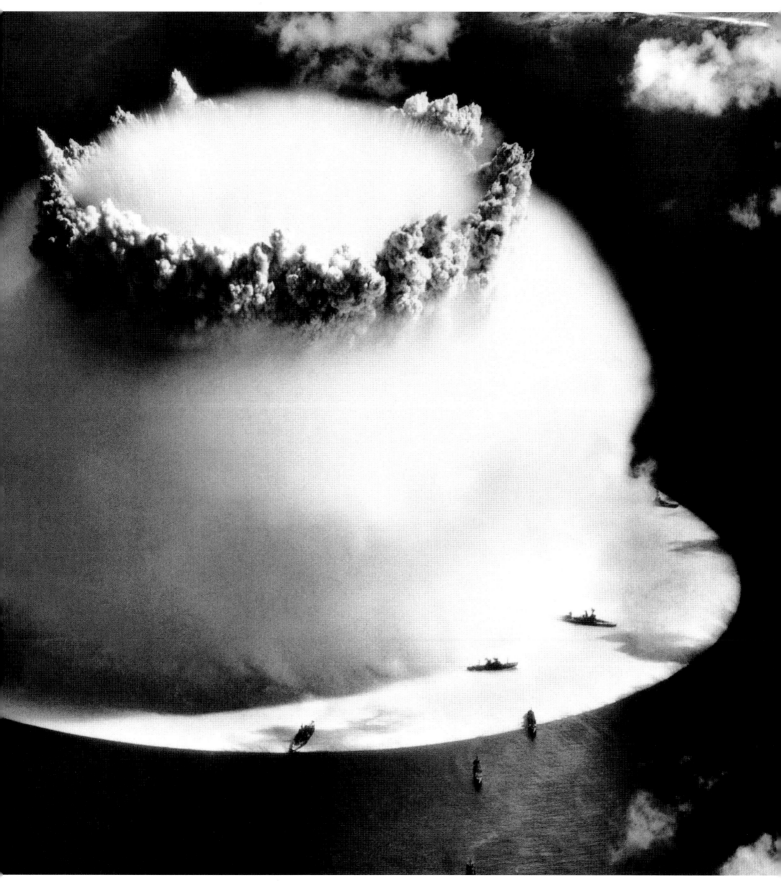

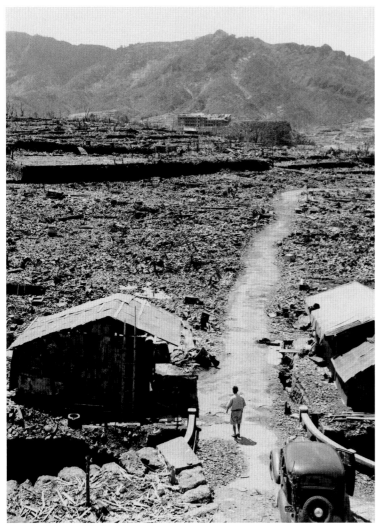

Nagasaki flattened. The first A-bomb ever used against an enemy was detonated by the U.S. over Hiroshima, Japan, August 6, 1945, killing 140,000. A second A-bomb was dropped three days later on Nagasaki, killing 70,000 and leveling 70 percent of the city's industrial zone. With their B-29 running dangerously low on fuel, the Americans bombed Nagasaki, their second target, instead of Kokura, which was saved by a cover of dense clouds. One week later, on August 14, Japan surrendered.
Photo by Stanley Troutman.

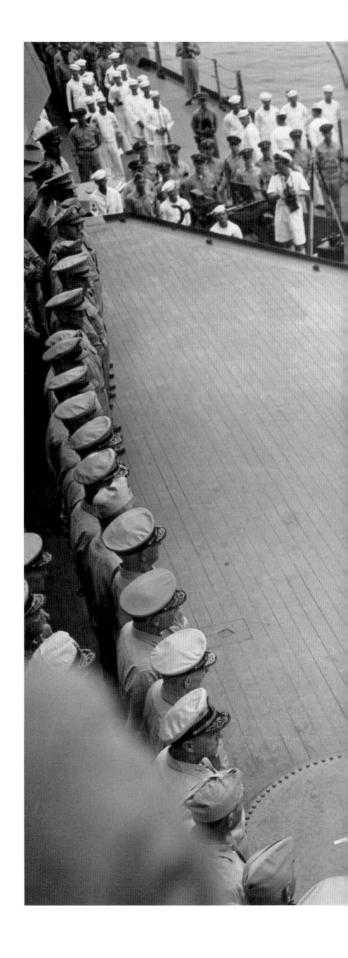

Japan surrenders.
September 2, 1945, Japan's Foreign Minister Mamoru Shigemitsu and Gen. Yoshijiro Umezu (seated) sign the "complete capitulation of Japan" aboard the USS *Missouri* in Tokyo Bay, under the watchful eye of Gen. Douglas MacArthur, Commander in the Southwest Pacific and Supreme Commander for the Allied Powers, who also signed.
Photo by Ed Hoffman.

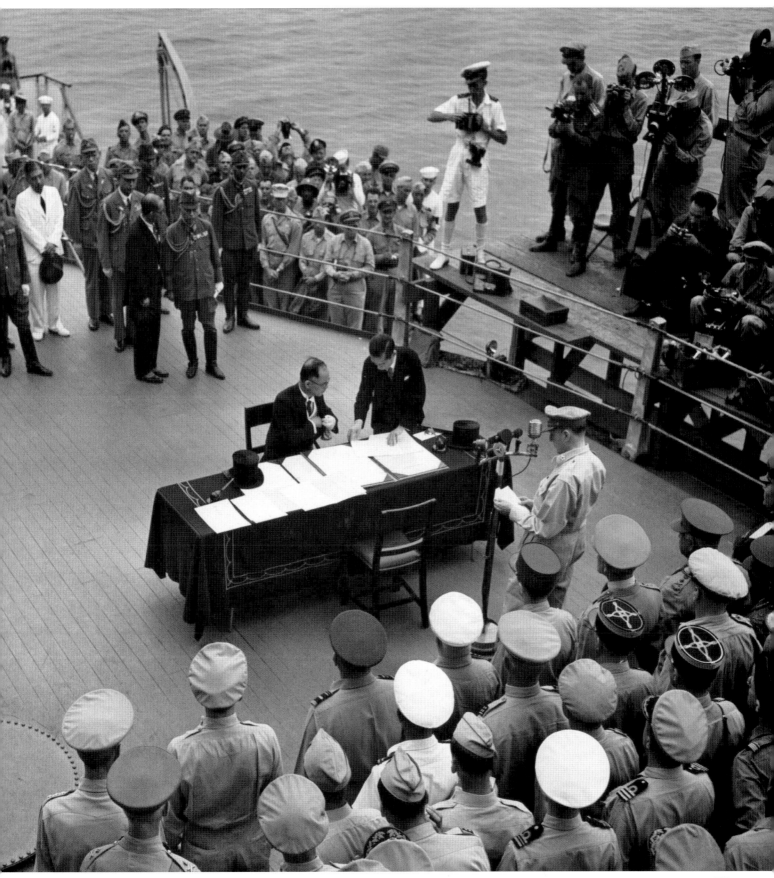

No place like home. For a bomb shelter, that is, such as this one in Garden City, Long Island, New York, in 1954. Government "Civil Defense" gurus scared Americans starting in the 1950s by publicly advocating such shelters to protect against nuclear attack, changing official advice from "duck and cover" to "run like hell," preferably into your own shelter. Several companies still offer prefab shelters, including a "twister resister" for $19,300, and a ribbed paraboloid (egg shaped) nuclear shelter for $24,630.

CANNED FOOD

ATER

WALTER KIDDE NUCLEAR LAB
973 STEWART AVENUE
GARDEN CITY, LONG ISL
NEW YORK
ATTN: MR. JAMES J.

U.S.

Fashion statement. Our government, ever concerned about our well-being, wants us to hoard Saran wrap and duct tape, and for a brief period in 1963, these tasteful masks. Stay safe from nuclear fallout, auto exhaust, smog, or a friend who just ate raw onions at lunch. The original caption does not indicate why or where this photo was made, but the masks seem not to have caught on.

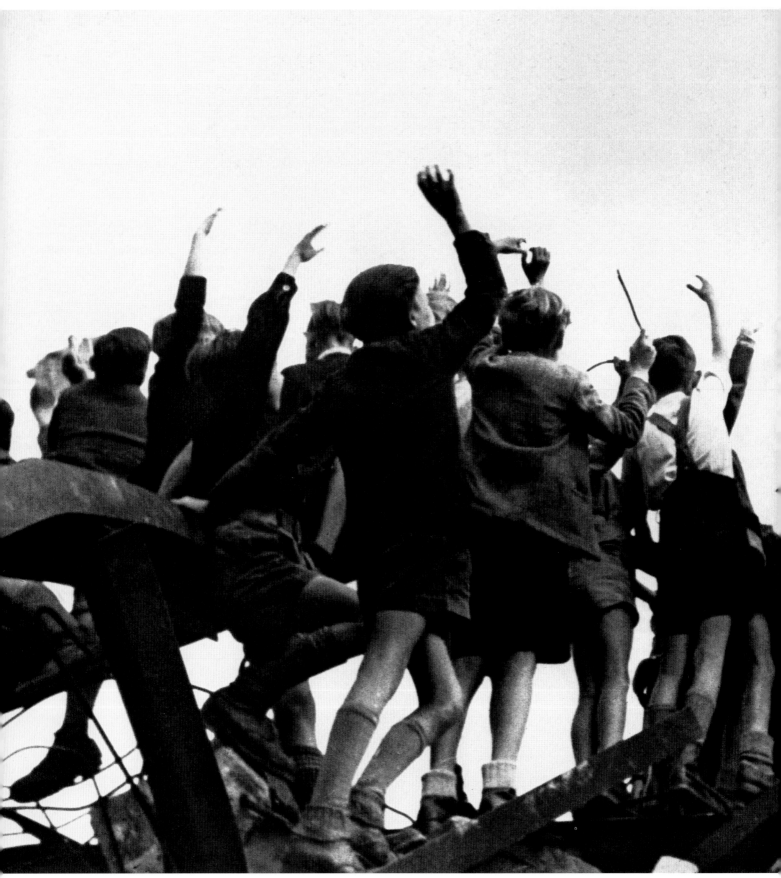

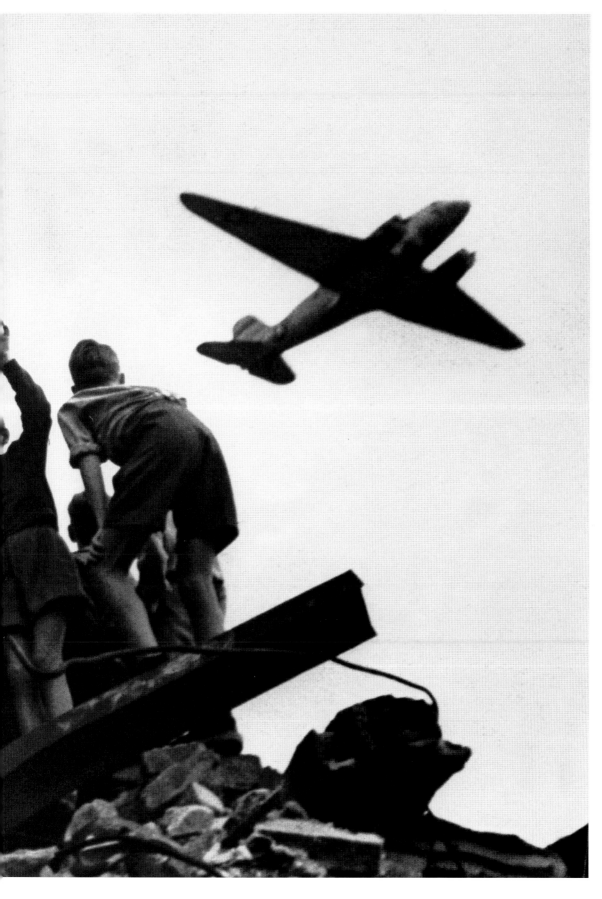

Beating the blockade.
Children of West Berlin wave at an American cargo plane bringing food and supplies, including fuel, to their closed city. In June 1948, the Soviet Union cut off access to the city. America—joined by allies —began an airlift. At its peak a plane was landing or taking off from Berlin's airfields every thirty seconds round the clock, averaging 8,000 tons a day. "The sound of the engines," wrote one Berliner, "is music to our ears." The airlift ended in 1949, a few months after the Russians reopened Berlin.
Photo by Al Cocking.

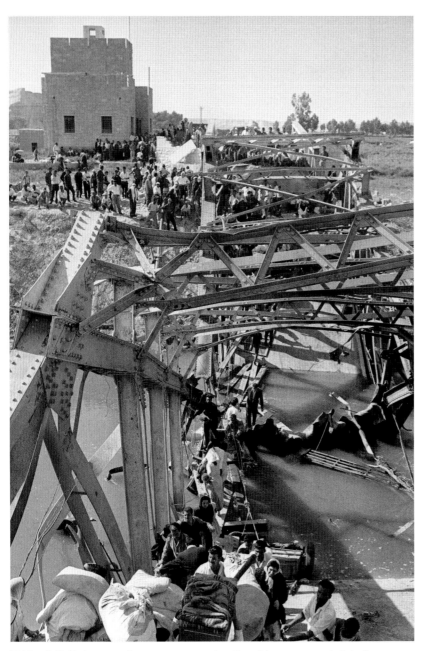

Bridge toll. Refugees of war, some carrying the old, young, and sick, flee across the heavily damaged Allenby Bridge between the now Israeli-occupied West Bank and Jordan in June 1967. Some 320,000 Palestinians fled or were expelled from the West Bank and Gaza in the course of the hostilities or shortly after the Six-Day War. *Photo by Peter Skingley.*

Andrew Lopez
UNITED PRESS INTERNATIONAL

Castro firing squad execution

Fidel Castro and his Barbudos (or "Bearded Ones") guerrillas stormed through Havana in January 1959, celebrating the fall of hated dictator Fulgencio Batista. Photographer Andrew Lopez was assigned to the war crimes trial at San Severino Castle, a former military installation complete with a moat.

Hundreds of Cubans gathered to testify against brutal Batista army corporal Jose Rodriguez, known as "Pepe Caliente" (Hot Pete). "The entire trial took two hours," Lopez recalls, "[but it took only] one minute for three tribunal judges to condemn Pepe to death."

Pepe was taken to a courtyard where he dropped to his knees as a priest administered last rites. The prosecutor, rebel major Willy Galvez, screamed at Lopez to stop taking pictures. "I was standing there arguing with him, and in the background I could see eight or nine Barbudos waiting for all this to end so they could get on with their business and shoot this guy."

The prosecutor demanded that Lopez surrender his film and Lopez handed him a roll. "I kept the one with Pepe on it," he said.

Last rites. Holding a crucifix, Jose Cipriano Rodriguez, a brutal Cuban Army corporal found guilty of the deaths of two brothers, receives last rites in January 1959 from Father Domingo Lorenzo. Shortly after this photo was taken, Rodriguez was shot by a firing squad. *Photo by Andrew Lopez.*

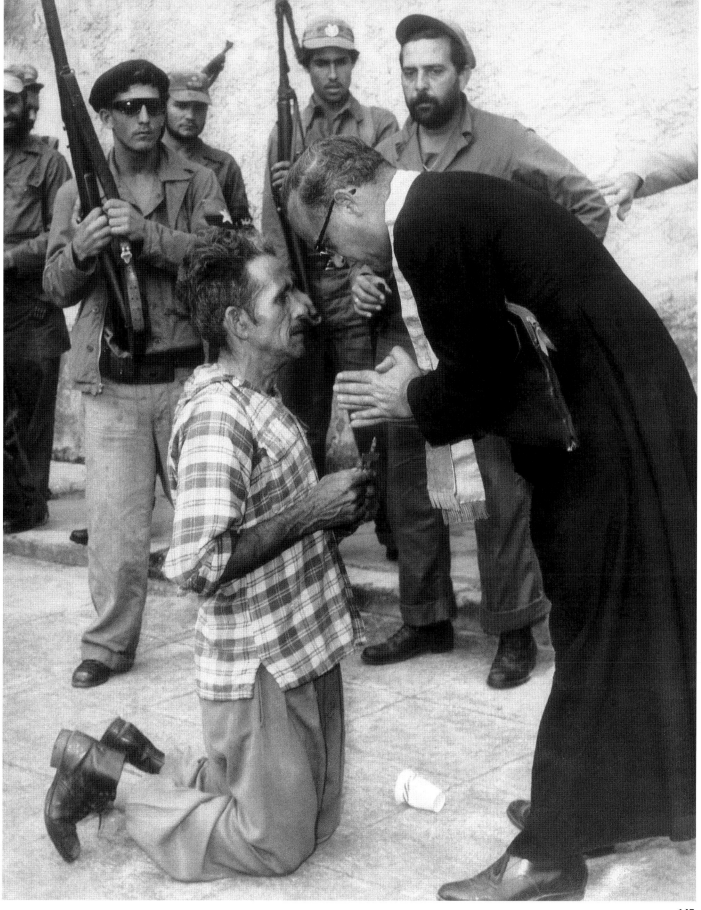

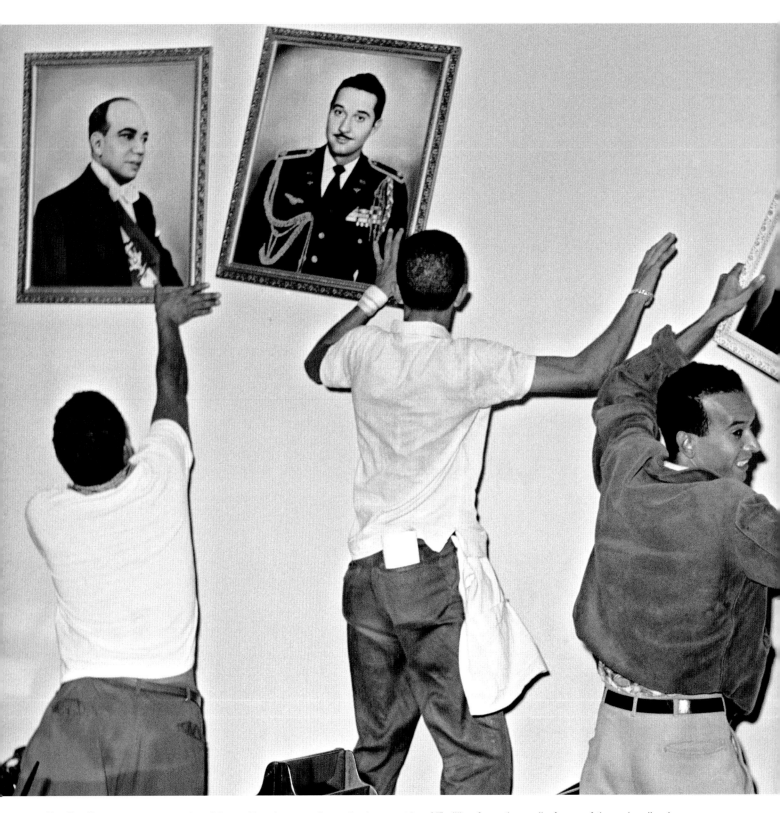

Family album. Angry University of Santo Domingo students rip down a trio of Trujillos from the wall of one of the school's classrooms in October 1967. From left, the images were of Hector, Rafael, and Rhadames Trujillo. *Photo by Martin McReynolds.*

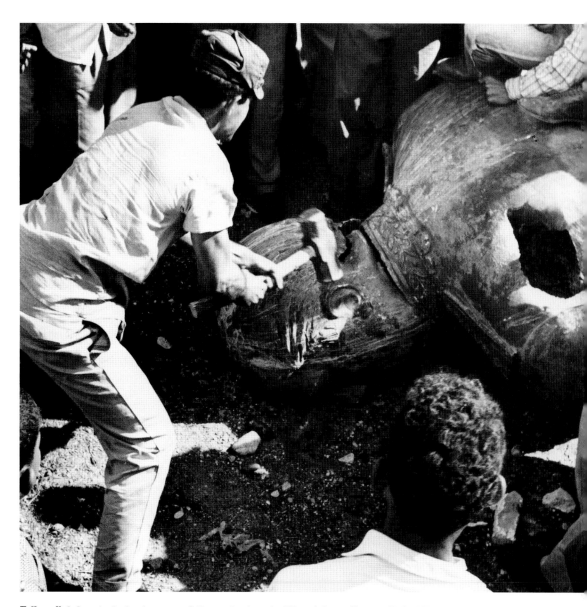

Fallen dictator. A sledgehammer falls on the head of Dominican dictator Rafael Trujillo—his statue, anyway—pulled down by demonstrators in San Cristobal, Trujillo's birthplace, in December 1961. Trujillo, who had ruled the country like a medieval fiefdom since 1930, was assassinated in May 1961, amid rumors of a CIA plot.
Photo by Martin McReynolds.

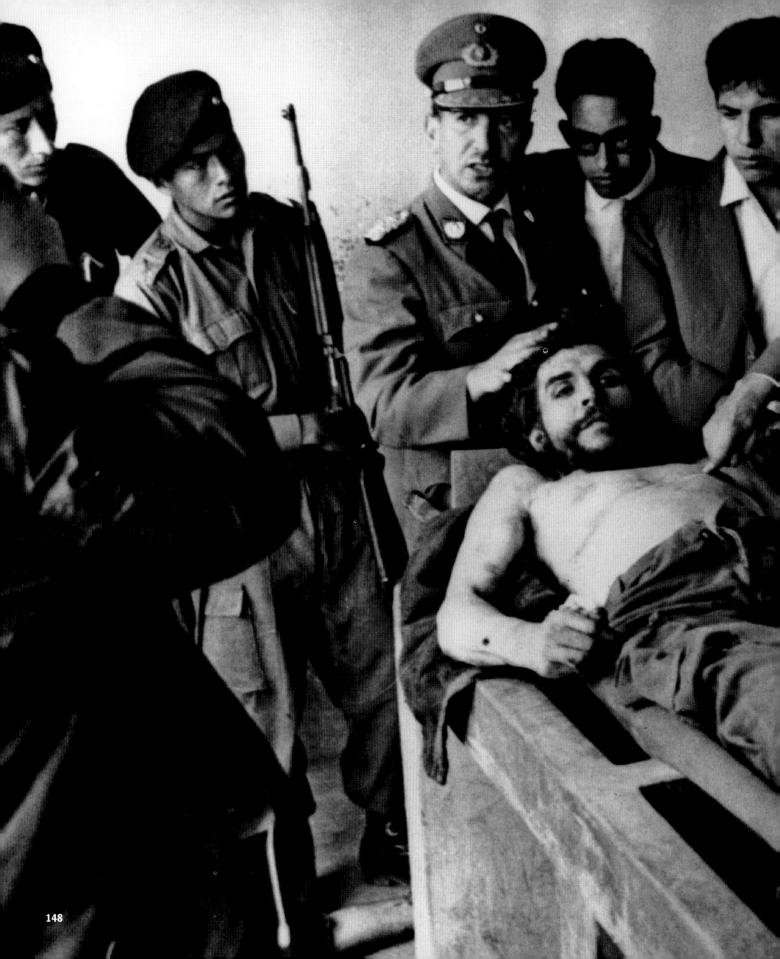

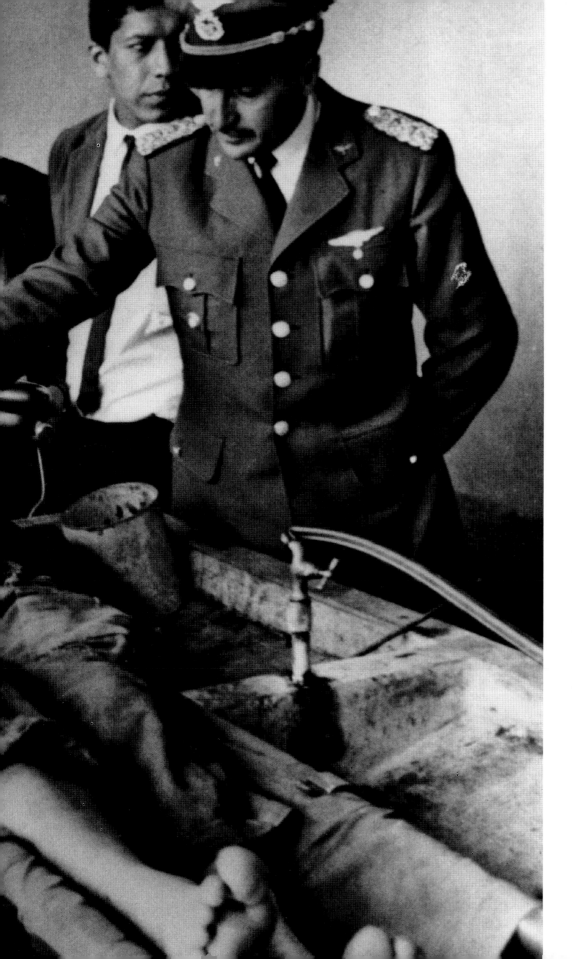

On display.
The body of Ernesto "Che" Guevara, former right-hand man to Cuban prime minister Fidel Castro, is prepared for public display following his capture and execution by Bolivian troops in October 1967. Che's dream of fomenting revolution throughout the hemisphere was a nightmare for U.S. officials, who had trained, equipped, and guided the Bolivian troops. Widely regarded as one of the world's greatest revolutionaries, Che was the best-recognized symbol of guerrilla struggle. After the public viewing his body was put into a secret, unmarked grave with other revolutionaries.
Photo by Freddy Alborta.

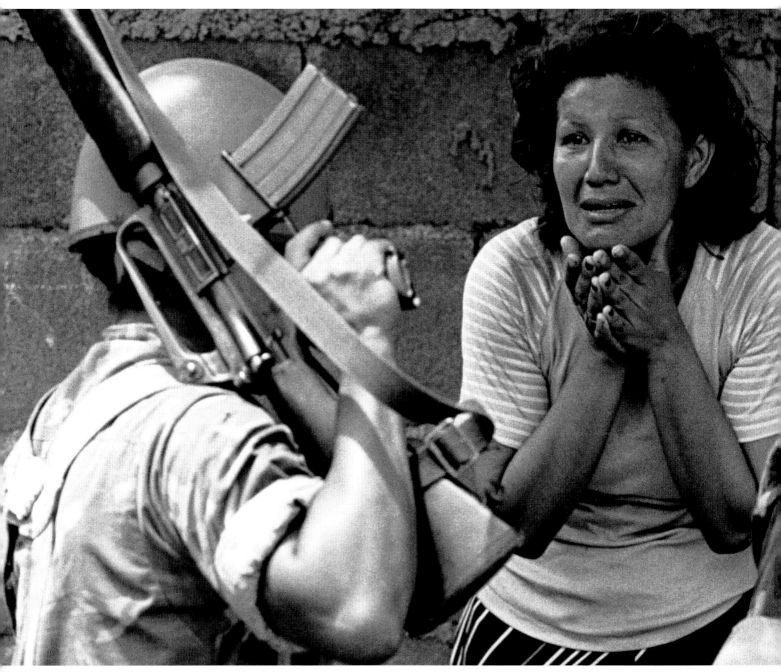

No more bombs. A tearful woman pleads with a Nicaraguan National Guardsman to halt the indiscriminate bombing of her Managua neighborhood in June 1979. Government forces fought Sandinista rebels, and an estimated 30,000 people, many of them civilians, died in the "final offensive" that ousted U.S.-backed President Anastasio Somoza and ushered the Sandinistas into power, a revolution that tested President Jimmy Carter's human rights policy. *Photo by Bill Gentile.*

NOT child's play. Young Sandinistas celebrate their triumph by displaying the tools (those are real guns) they used to achieve it, helping end the 40-year rule of dictator Anastasio Somoza, who fled the country in July 1979, only to be assassinated in Paraguay the next year. Sandinistas entered Managua and huge crowds greeted them as liberators. *Photo by Bill Gentile.*

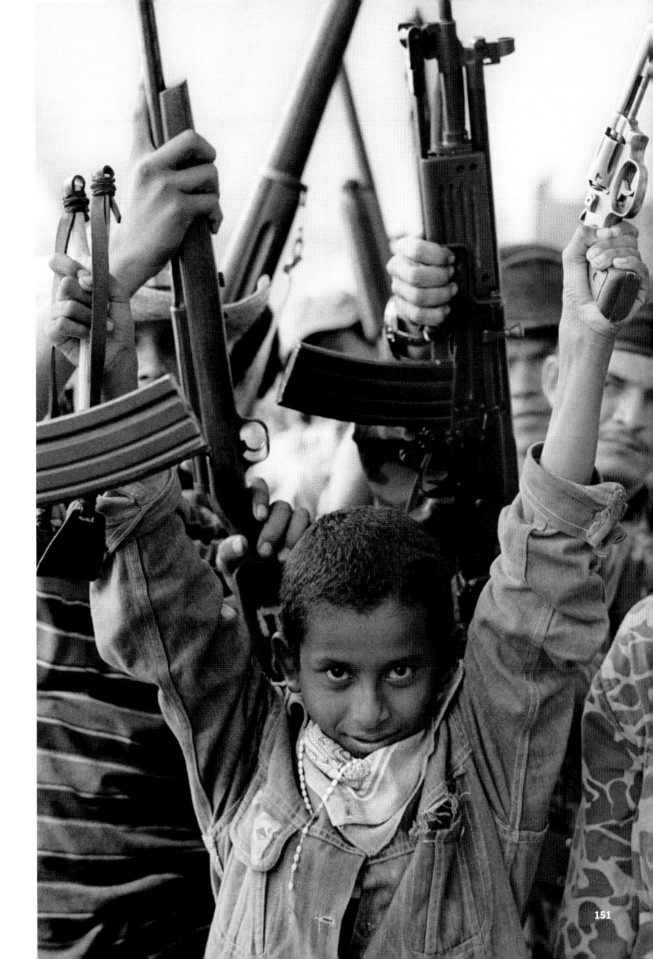

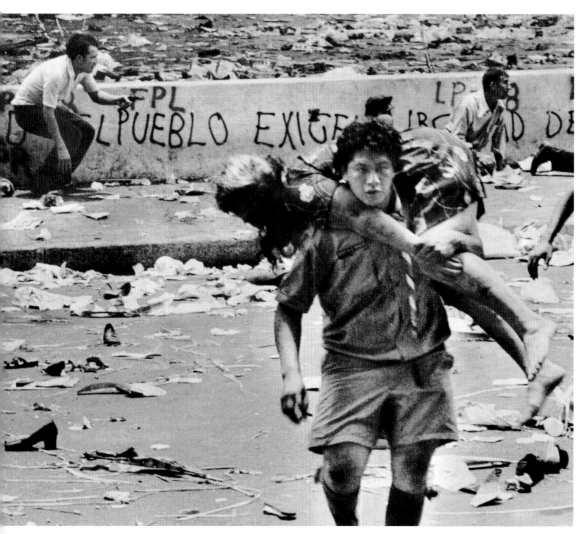

Scout's honor. A Salvadorean Boy Scout carries a wounded woman to safety after sniper fire interrupted a funeral mass for Archbishop Oscar Romero in March 1980. Days before, Romero was assassinated while celebrating mass, focusing world attention on the scale of repression in the small Central American republic. *Photo by Oscar Sabetta.*

We interrupt this session.
Col. Tejero DeMolino announces a coup before Spanish parliament as they voted for a new premier. President Landalino Larilla is at right. King Juan Carlos announced on TV that the rebels' action would not be tolerated, and after 18 hours they surrendered and released their 350 captive politicians. The photographer smuggled his pictures out of the building in his Jockey shorts, knowing no "macho golpiza" would touch another man's pants.
Photo by Hugo Peralta.

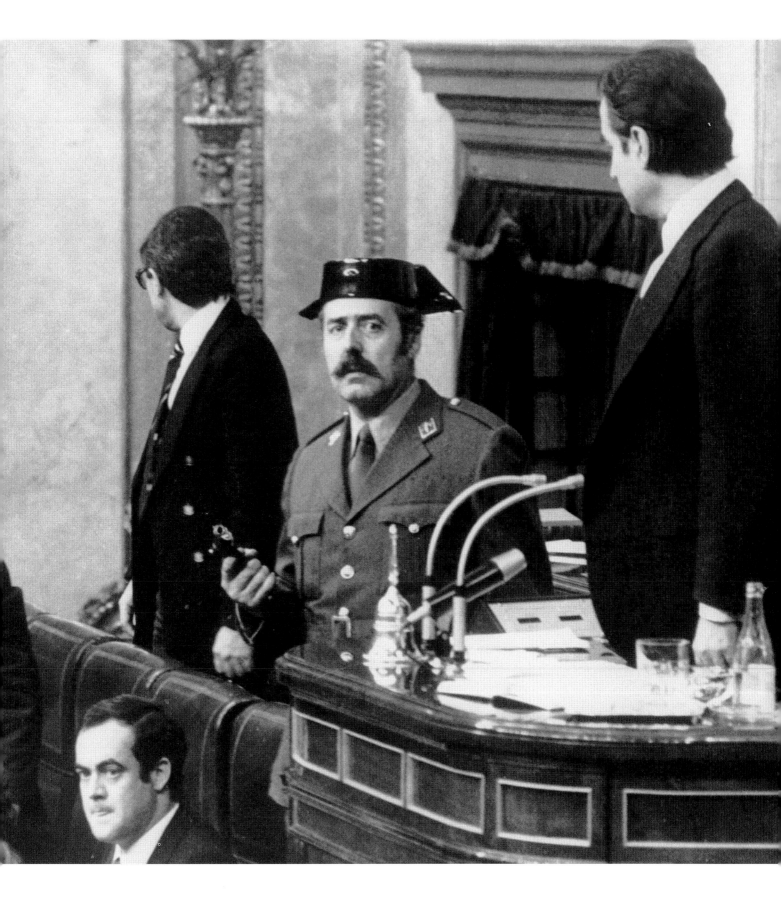

Photographer unknown

UNITED PRESS INTERNATIONAL

Justice and cleansing in Iran

The Islamic Revolution steamrolled through Iran in January 1979. Ayatollah Khomeini imposed his Shiite Muslim beliefs on the entire country and set about to destroy "corrupt Western influences." "From now on it is I," he decreed, "who will name the government."

Four million Kurds didn't like Western influences, either. But they also didn't want to lose their Sunni Muslim faith, and they demanded independence. Khomeini dispatched his Revolutionary Guards to dispense "justice" in mock trials, in the process slaughtering thousands of Kurds.

In August, nine Kurdish rebels and two former police officers of the deposed Shah faced a firing squad in Sanandaj, Iran, after being tried and sentenced to death. An Iranian newspaper photographer recorded the executions in grim detail.

A UPI staffer obtained a copy of the picture and it was transmitted worldwide. The photographer's name was never revealed, the only photo winner in Pulitzer history not to be identified.

"The photographer feared the gunmen might shoot him, so he smuggled the film from the scene in his trouser pocket," the UPI reporter, who also chooses to this day not to be identified, later said. The photo was displayed in UPI's office as a reminder of "the numbing transition from life to death."

Iranian justice.
Khomeini enemies are eliminated by firing squad.

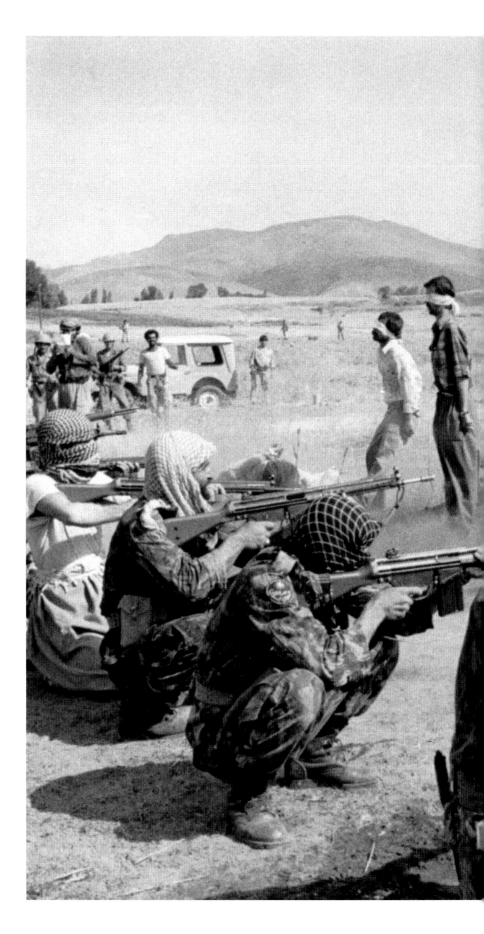

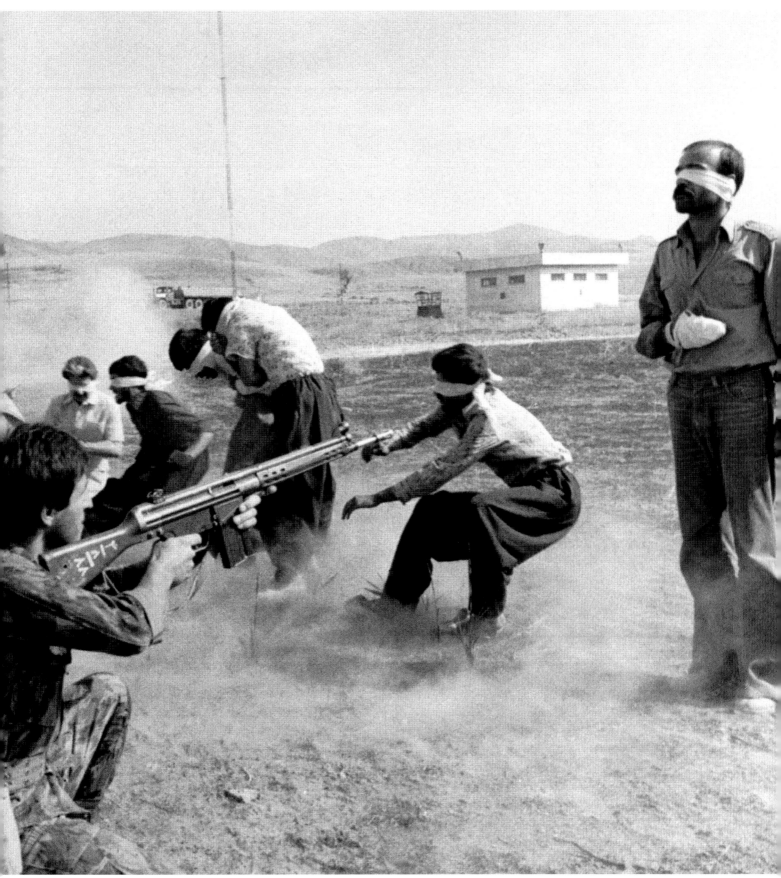

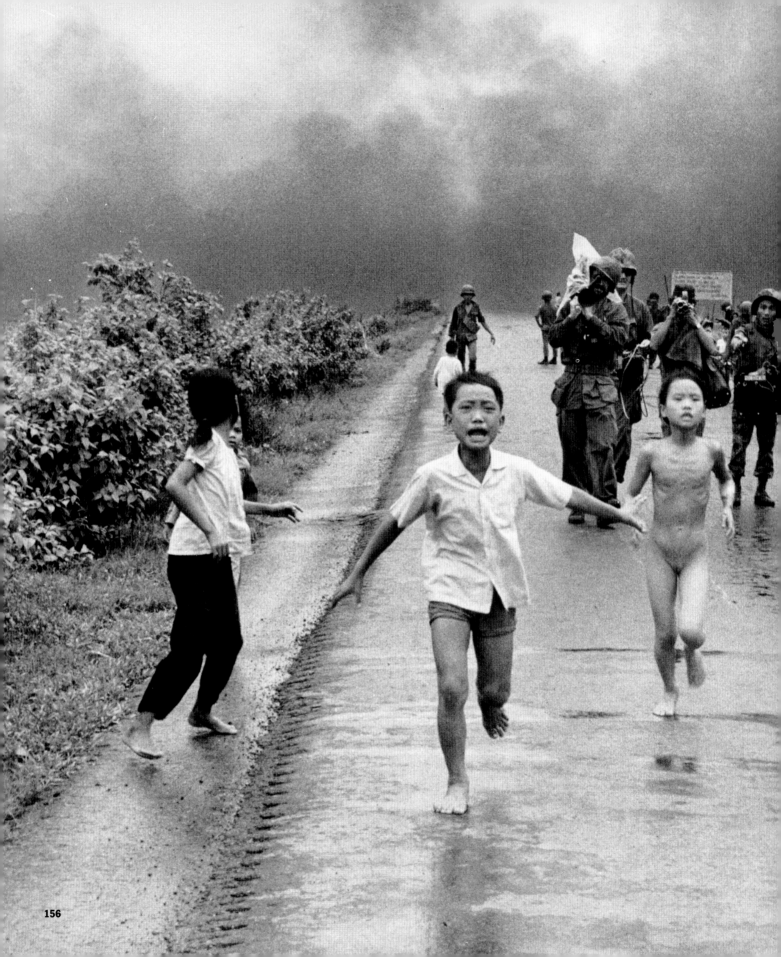

Conflict | 2

"**T**he Vietnam War had to be the most accessible, ongoing trauma in history. From the late 1950s to 1975 literally hundreds of journalists from all over the world poked their heads in at one time or another to check out the war, do a little dance with death and pop out again.

"Vietnam was a photographer's dream. A military ID card let you hitch rides on anything that flew. It was your ticket to combat, GI food, a place to sleep, and PX privileges. The downside was that a lot of people in Vietnam were trying to kill one another. There were no referees to whistle you back to the sidelines or cops telling you to stay behind the yellow tape. You could push fate as far as you wanted. 'Shooters' who got the best pictures played it like a rubber band—and sometimes it snapped."
—Bill Snead, UPI Saigon bureau manager 1967-69

"In today's buttoned-down, litigious corporate world, it seems hard to believe that photographers would still go running off into deadly situations without their lawyers having reviewed every possible consequence and detail. But amazingly, it still happens.

"Some go out of a sense of duty and commitment, others go to enhance their careers—or to start them, and still others go because they love the adrenaline rush, the charge into danger, the intensity of watching and photographing mankind when the starkest realities occur. Then, the equal thrill of escape, the return to sanctuary—the food, the drink, the friends. And perhaps . . . yes, perhaps even the sex, that comes with the sweet aroma of just, still, being alive."
—Dirck Halstead, UPI Saigon bureau manager 1965-66

Three UPI staff photographers—David Kennerly, Kyoichi Sawada, and Toshio Sakai—asked UPI to send them to Vietnam. All three won Pulitzer Prizes. One, Sawada, would not return.

"Too hot, too hot." ["Nong qua, nong qua."] Kim Phuc Phan Thi, 9, screams after a South Vietnamese plane mistakenly dropped napalm on her village in June 1972. She ripped off her burning clothes but was severely burned and not expected to live. She did, thanks to AP photographer Nick Ut, who rushed her to a hospital. Ut won a Pulitzer Prize in 1973 for his version of this photo. *Photo by Hoang Van Danh.*

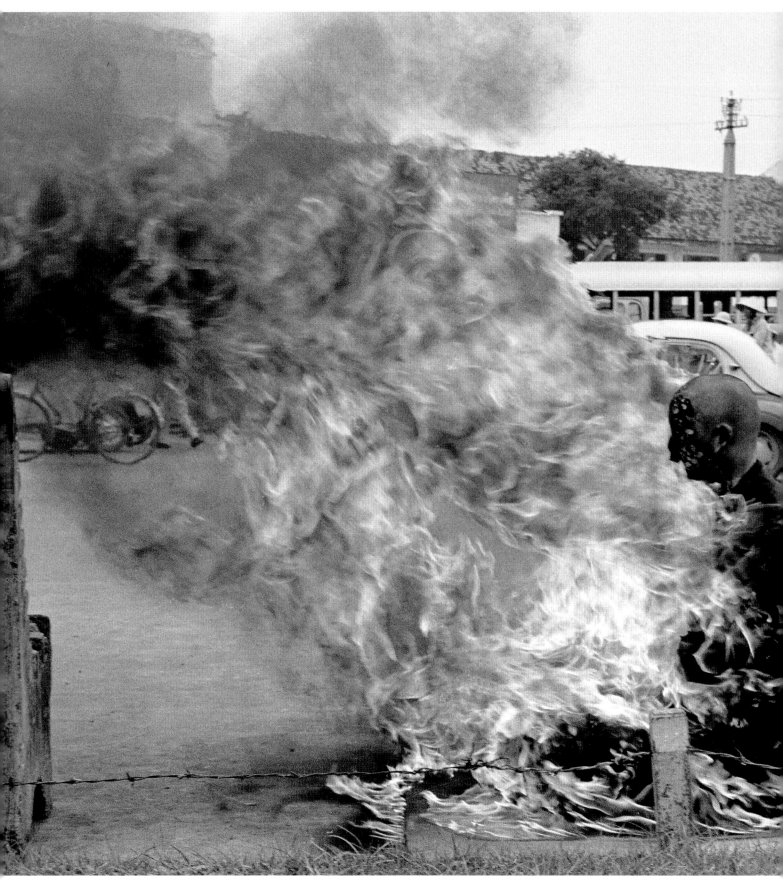

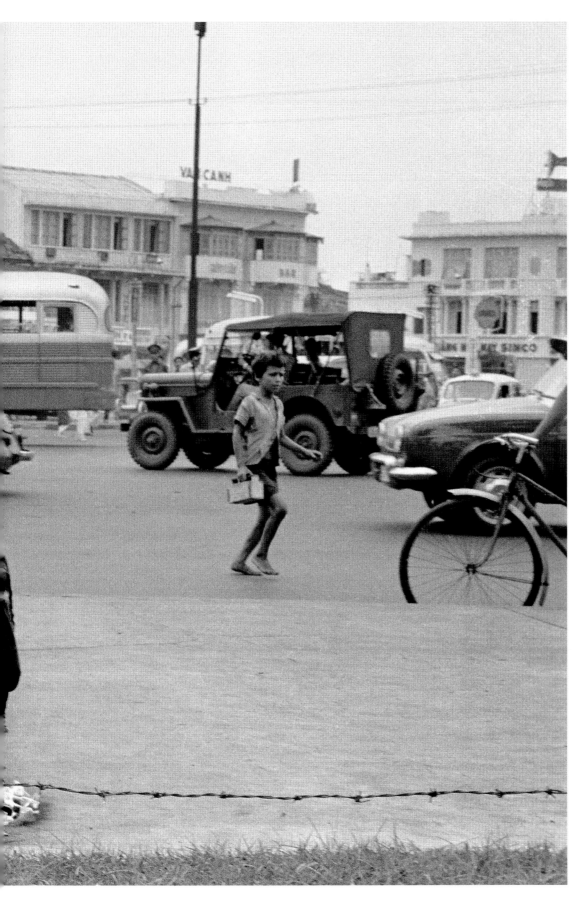

Ritual suicide.
A young Buddhist monk, Thich Quang Duc, sets himself ablaze in a ritual suicide near the central market square in Saigon, October 1963, to protest Ngo Dinh Diem's anti-Buddhist policies. UPI's Asia reporters not only wrote about the news but carried cameras and, as in this case, made some electrifying photos of it, earning an extra $25 for their effort.
Photo by Ray F. Herndon.

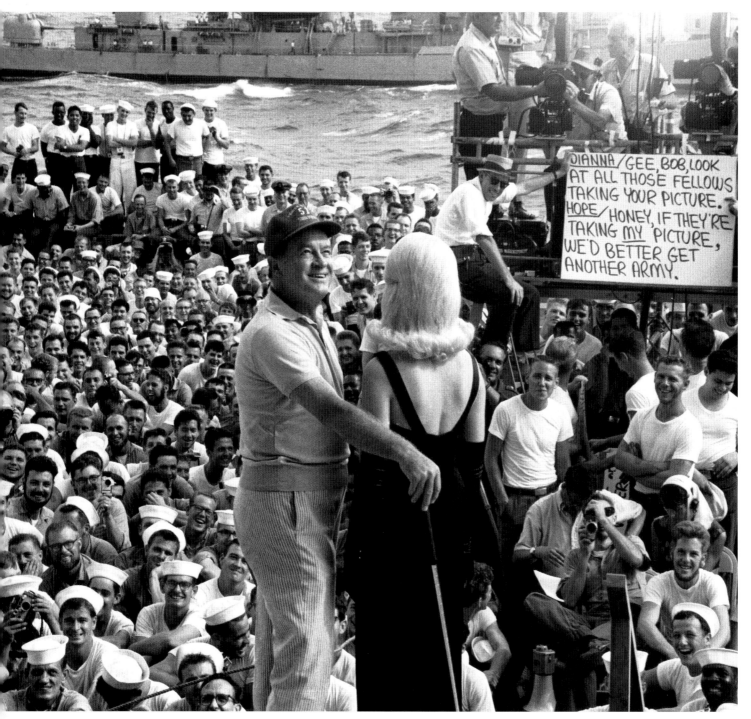

DIANNA/GEE, BOB, LOOK AT ALL THOSE FELLOWS TAKING YOUR PICTURE.
HOPE/HONEY, IF THEY'RE TAKING MY PICTURE, WE'D BETTER GET ANOTHER ARMY.

Hope for the holidays. Comedian Bob Hope brought girls (here, Miss World USA, Dianna Lynn Batts) and gags to American troops for 50 years. Ignoring the risks, he went to Vietnam nine times, including this USO holiday tour in 1965. Hope found laughs in the controversial war, telling the soldiers, "I bring you news from home—the country is behind you 50 percent."
Photo by Dirck Halstead.

American embassy bomb.
A woman lies dead, one of 160 killed or injured by a Viet Cong bomb near the U.S. Embassy in Saigon in March 1965. The U.S. was becoming more involved in the war, increasing troop strength from 25,000 in January 1965 to 185,000 by December, 385,000 in 1966, 485,000 in 1967, and 543,999 in 1968. *Photo by Nguyen Thanh Tai.*

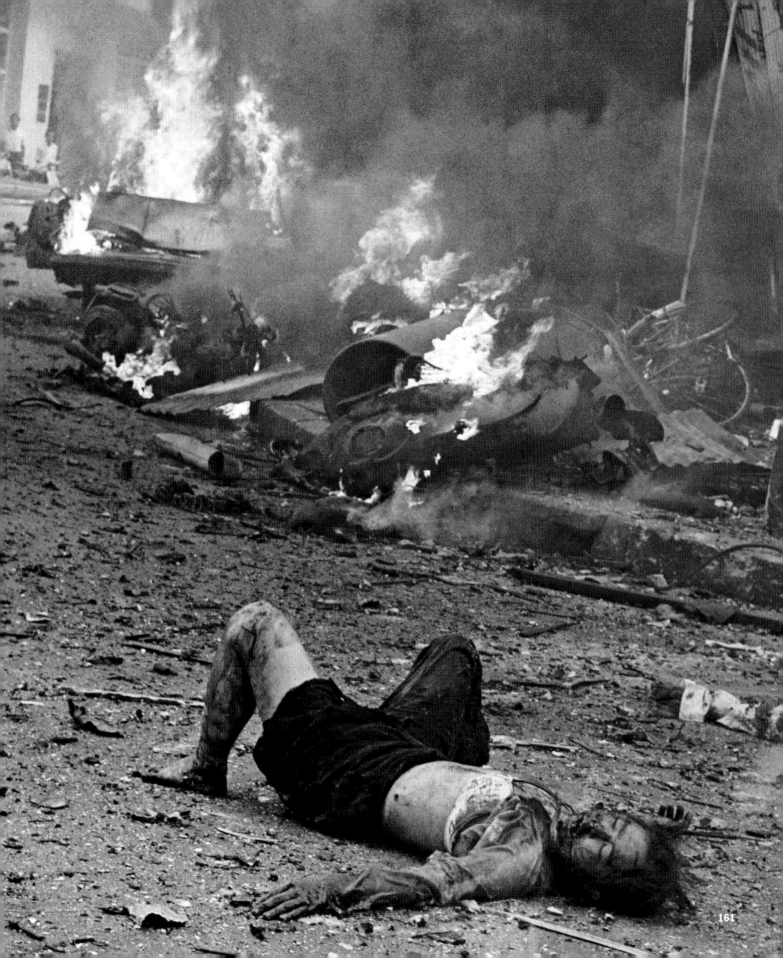

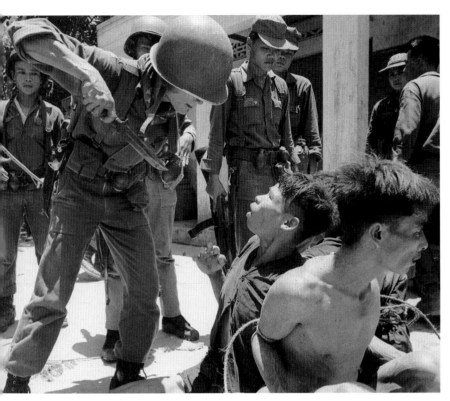

Pointed question. Holding a knife on a Vietnamese prisoner captured in a joint operation with U.S. Marines, a Vietnamese soldier asks the prisoner where his unit is hiding. Thanh Quit Village, April 1966.
Photo by Steve Northup.

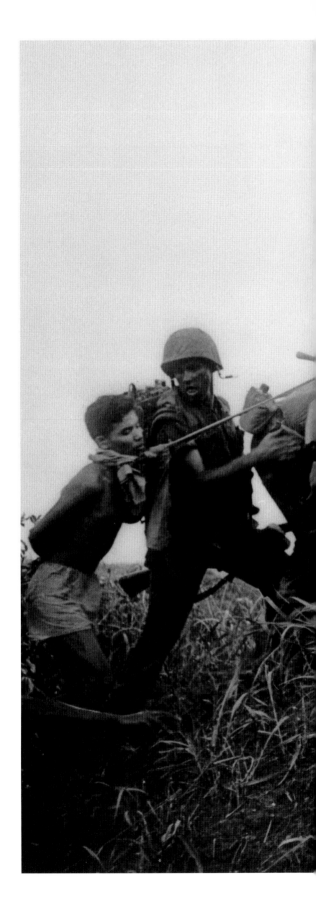

Herding the enemy.
Lashed together with cloth ties, with a halter on the leader, captured Viet Cong soldiers are led to custody by U.S. Marines near Da Nang in November 1965.

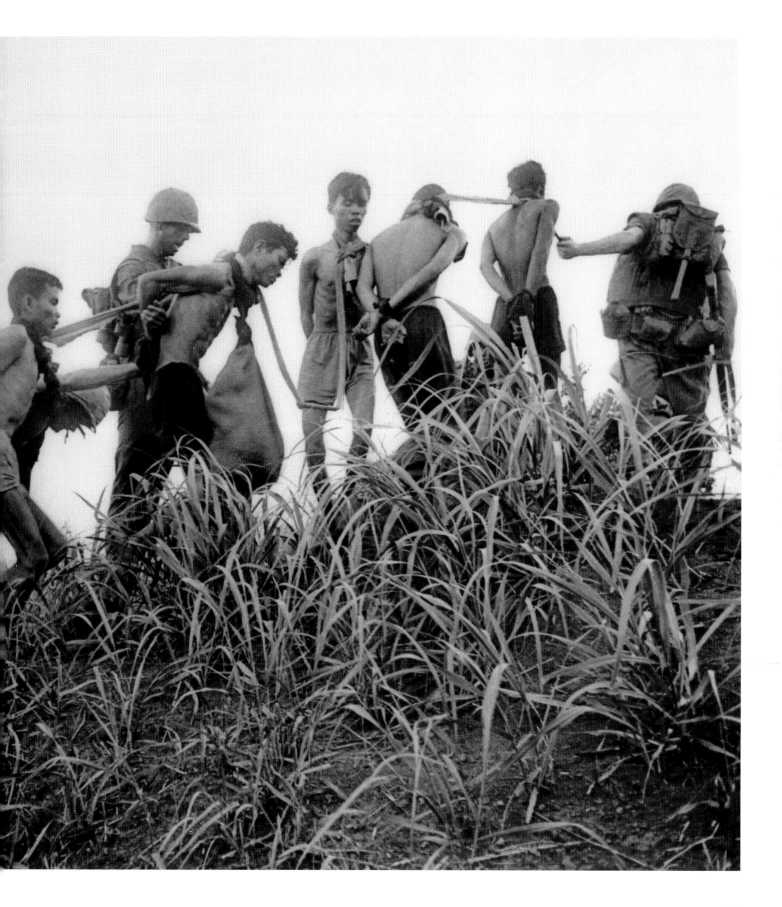

Kyoichi Sawada

UNITED PRESS INTERNATIONAL

A family flees from U.S. bombs

Kyoichi Sawada worked in UPI's Tokyo bureau but wanted to be sent to Vietnam. He even took his vacation there and returned with an impressive set of combat pictures to convince them he was right. In 1965 he was sent to Vietnam, where by then nearly 200,000 American combat troops were trying to dislodge the Viet Cong. Caught up in the struggle were four million men, women, and children forced out of their homes as their crops and villages were destroyed.

Sawada photographed two mothers struggling for their lives as they tried to get their children to safety across a river while American planes dropped bombs and napalm on their hamlet just beyond the other side.

After he was awarded a Pulitzer Prize for a portfolio that included this photo, Sawada searched for the two families, with only his photo as a guide. He found both, and he gave each a copy of the photograph —plus half of his Pulitzer Prize cash award. He kept none of it for himself.

The photo also won the World Press Photo Grand Prize and the Overseas Press Club award. Four years later, in October 1970, Sawada and UPI Phnom Penh bureau manager Frank Frosch, in civilian clothing and unarmed, were ambushed by the Viet Cong and killed south of Phnom Penh.

A mother struggles to keep her baby afloat as a family swims for their lives during U.S. bombing. *Photo by Kyoichi Sawada.*

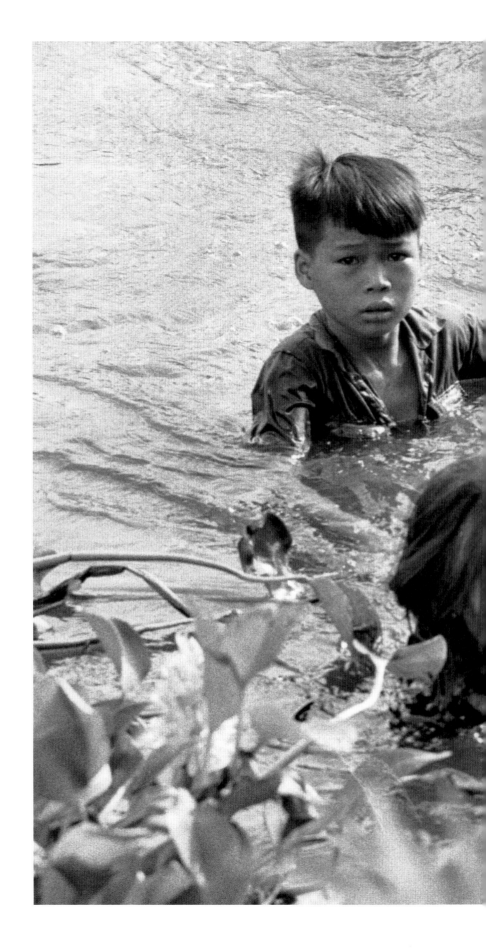

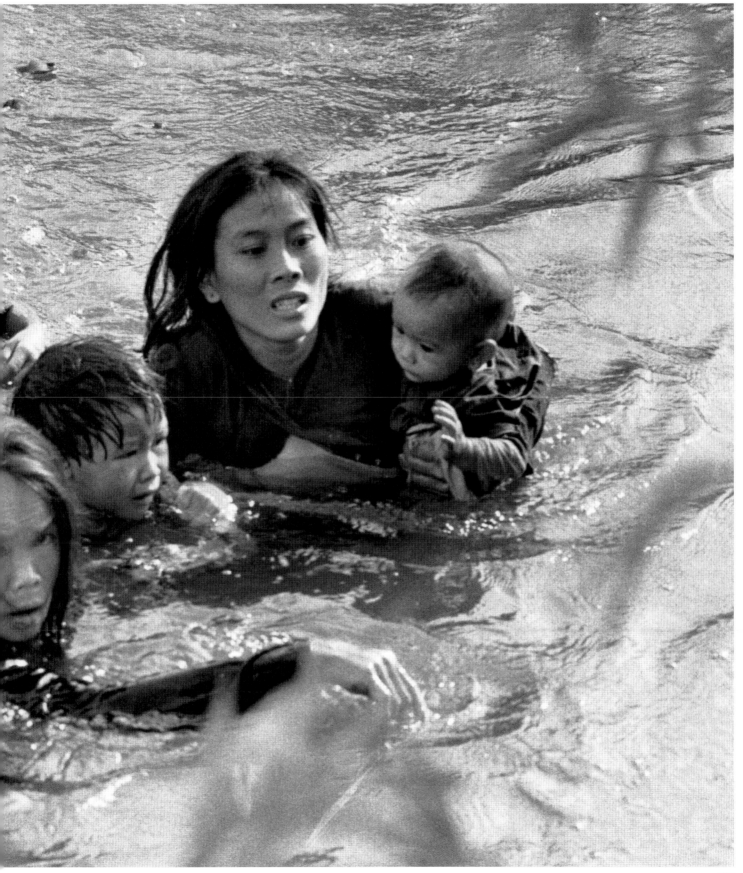

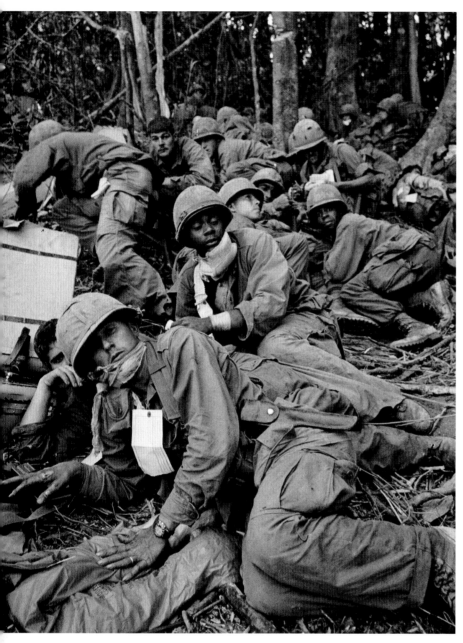

Getting out. Members of the 173rd Airborne Brigade, some wounded during the bitter siege and capture of Hill 875, huddle low as they await evacuation helicopters near Dak To in November 1967. *Photo by Kyoichi Sawada.*

Meanwhile, at home.
In Washington, D.C., thousands of antiwar protesters clash with military police and U.S. marshals on the second day of a "Pentagon March" in October 1967. Earlier that year, President Lyndon Johnson had fired his defense secretary, Robert McNamara, for expressing his own doubts about the moral justifications of the Vietnam War.

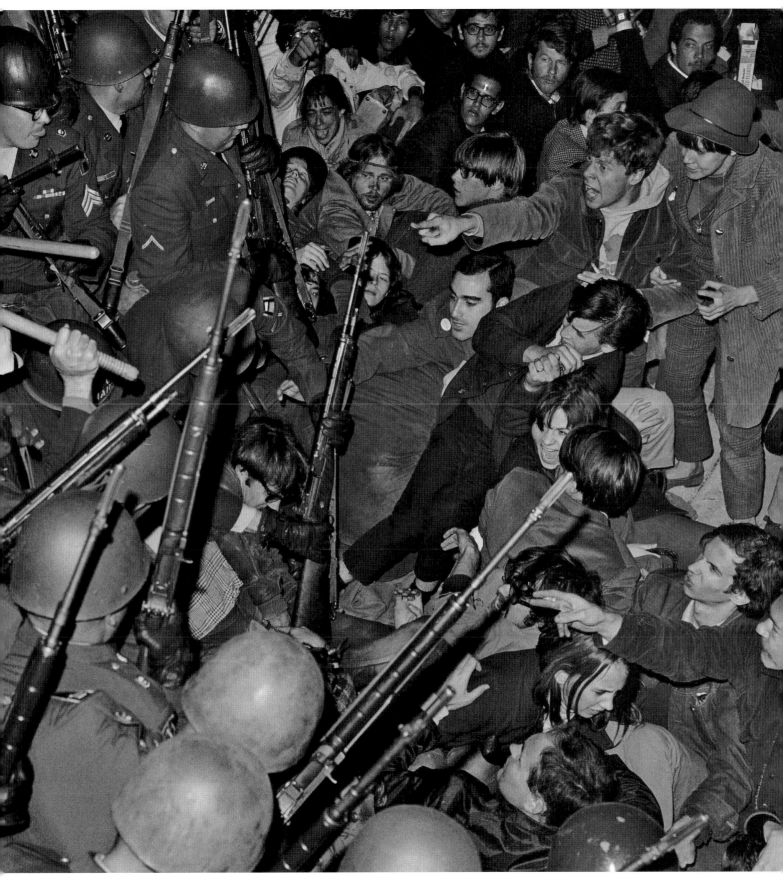

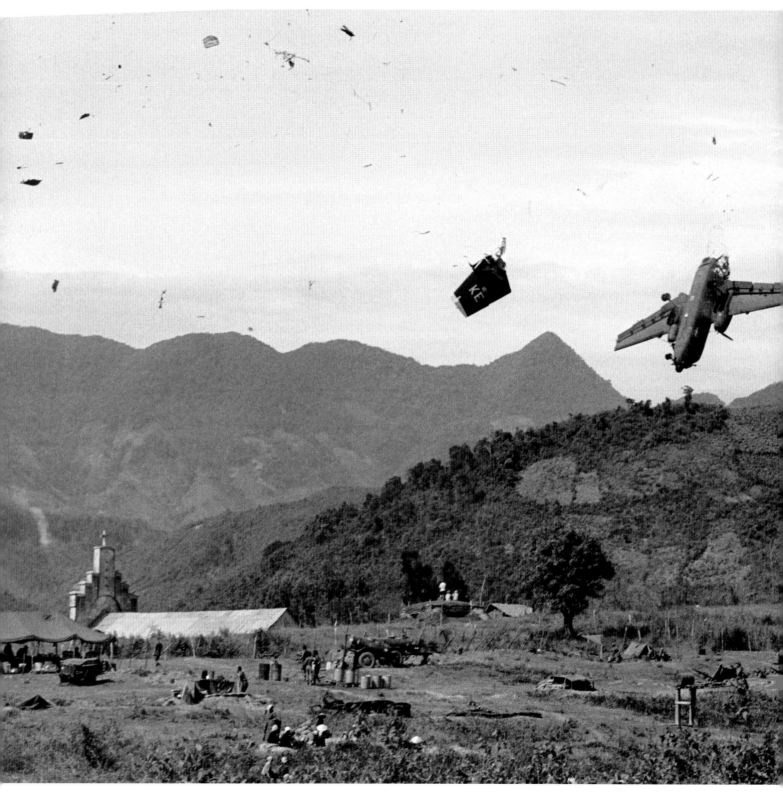

"Friendly fire." A U.S. Caribou transport disintegrates after being hit by U.S. artillery in Ha Phan, Vietnam. The crash killed the crew of three in August 1967. The photographer, covering a normal landing, watched in horror as the American plane was shot out of the sky by Americans. *Photo by Hiromichi Mine.*

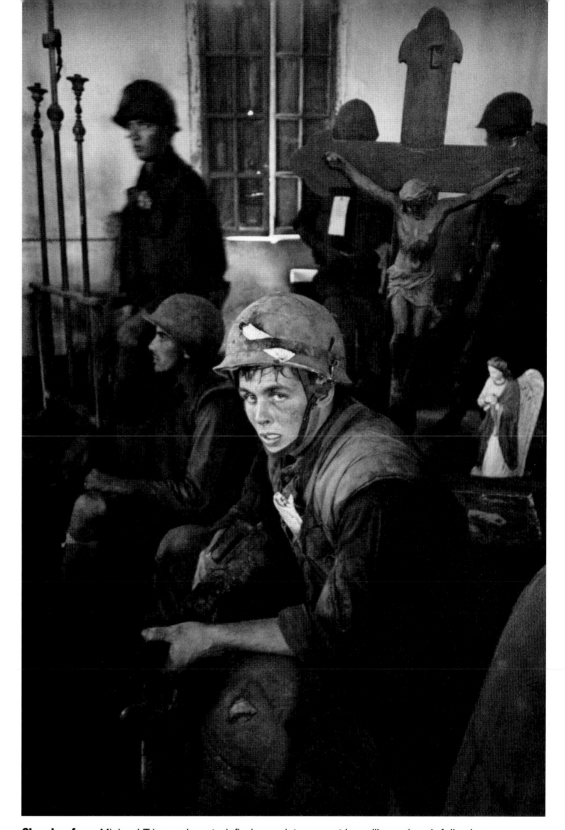

Church refuge. Michael Tripp, exhausted, finds a quiet moment in a village church following a heavy North Vietnamese mortar attack in May 1967. The Marines, forced to use the An Hoa Peace Church as a hospital and morgue, feared they would be overrun. They gave the photographer a .45 automatic and two magazines just in case, but no attack came.
Photo by Frank Johnson.

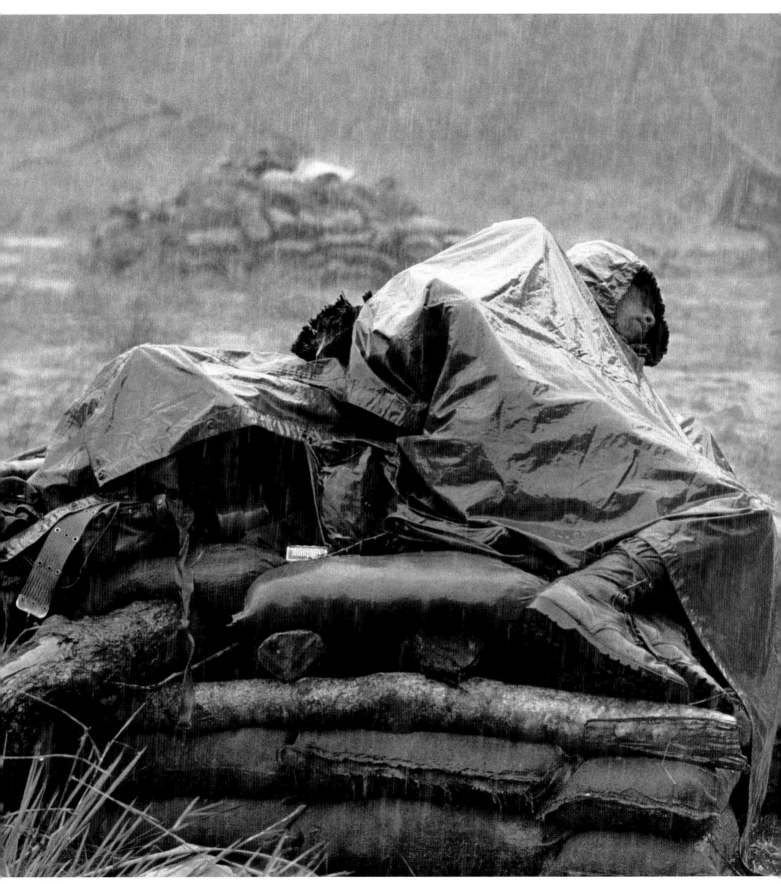

Dreaming of better times

"There was a commotion in the forest," Toshio Sakai remembers, "then all became silent. Birds stopped chirping and insects quieted. My heart was beating fast. A tense atmosphere filled the air."

American soldiers in Vietnam were in an unfamiliar land. They knew that their next step might be their last, on a mine or into a booby trap. They experienced terrifying struggles followed by numbing boredom, but unrelenting anxiety. Unable to lower their guard, they could never really rest.

Suddenly, shells explode overhead, and AK-47s crackle. The Viet Cong attack. The Americans return fire and the jungle is abuzz with bullets.

The furious battle rages until suddenly the heavens open with a monsoon rain so intense that all shooting stops. The forest is again silent—for minutes, then hours. The deluge continues; the firefight is over. Weary soldiers hunker down and try to stay dry as best they can in the rain and the mud.

"I saw a black soldier on the bunker taking a nap," Sakai says. "Behind him I saw another white soldier holding an M-16 rifle, crouching and watching. The sleeping soldier must have dreamt of better times in his homeland. I quietly released the shutter."

A moment of calm. American soldiers rest after sniper and mortar fire near Phuc Vinh, South Vietnam. *Photo by Toshio Sakai.*

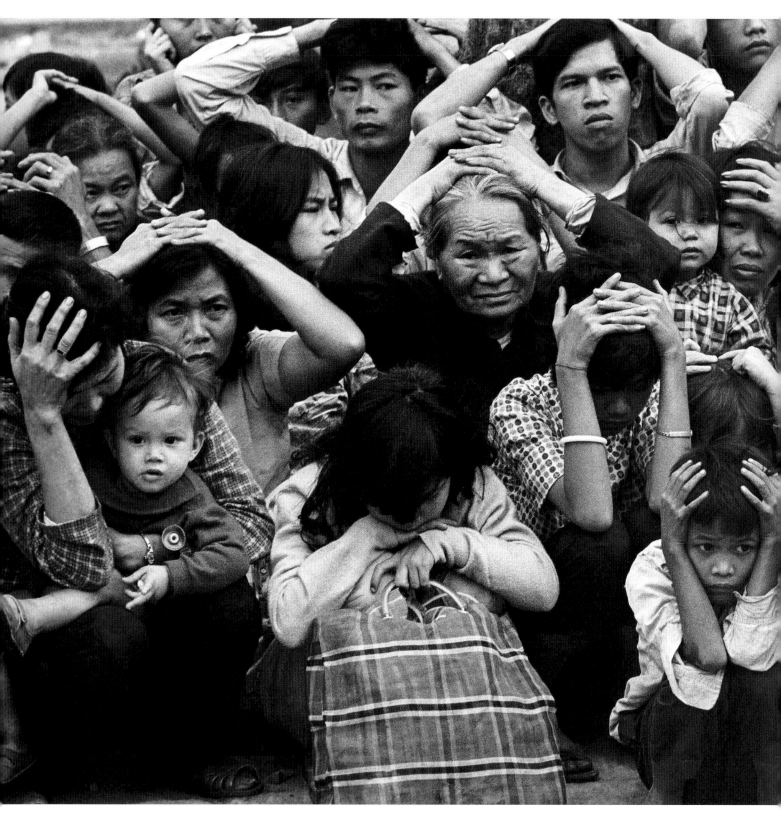

Homeless and scared. Vietnamese civilians, driven from their homes during heavy fighting in Hue, crouch under guard with hands over their heads in February 1968. The North Vietnamese captured the city in January during the lunar new year, or Tet, but after three weeks of fierce fighting the South Vietnamese reclaimed the city. *Photo by Kyoichi Sawada.*

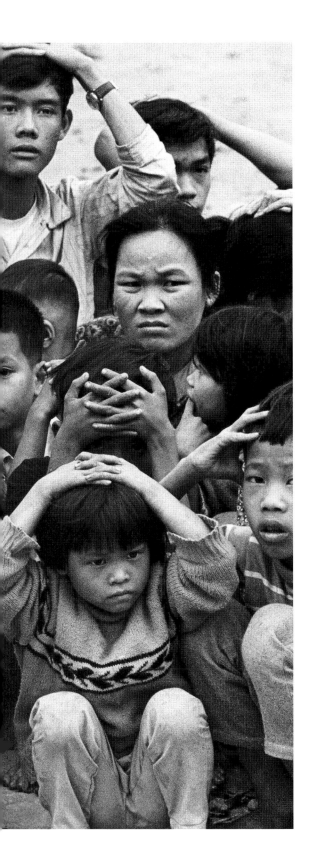

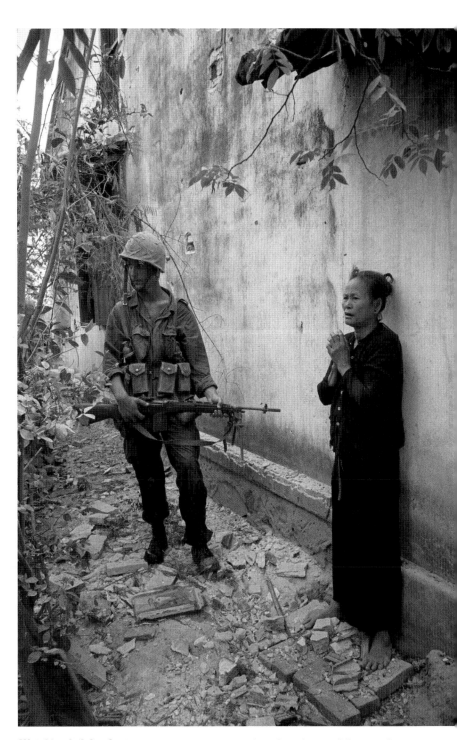

Watching helplessly. A Vietnamese woman and an American soldier watch as American planes bomb her village, Quinhon, and Viet Cong sniper positions. Villagers were evacuated and then watched in horror as much of their village ceased to exist. *Photo by Kyoichi Sawada.*

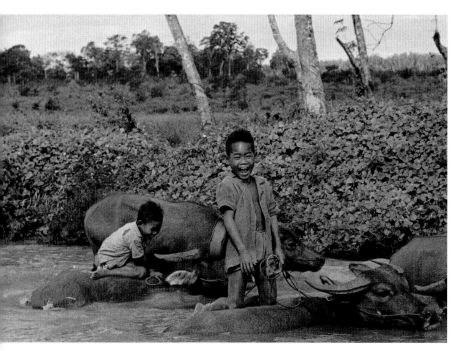

Water ride. Cambodian children play with water buffalo.

David Hume Kennerly

UNITED PRESS INTERNATIONAL

A lonely and desolate war

David Kennerly first had to convince the Pentagon to release him from the Army reserves so he could go to war, the only such request the brass can recall. Next he had to convince UPI to reassign him to Vietnam from Washington, D.C. They granted his request in 1971 but told him that "all the Vietnam pictures have been taken."

Not the best ones, it would turn out. Kennerly brought a fresh eye to the conflict, and his portfolio of pictures showing war's quieter moments earned him the Pulitzer Prize for feature photography.

"I wanted to show the periphery of war and to depict the people who lived there," he says. "I took a lot of pictures of bodies and people dying, but I think the feature side—those are some of the best."

His photo of a soldier and battle-shattered trees summed up the barren devastation of the 10-year war and the debate about getting America out of Vietnam that was raging back home in Washington and on America's streets. "During a lull in the action soldiers grow tense, wondering when the barrage will begin again, and from which direction," Kennerly says. "The gloomy tableau matched the mood of the men. To me, that was more the war I saw, in terms of the day-to-day scene. It captures the loneliness and desolation of war."

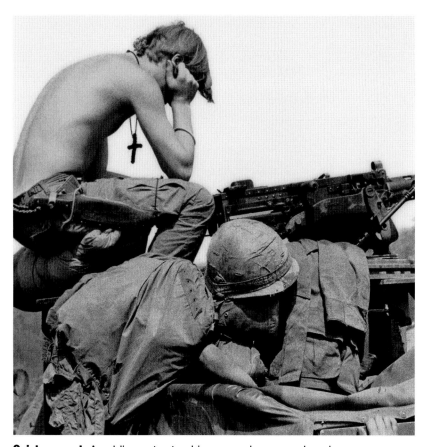

Quiet moment. A soldier rests atop his armored personnel carrier.

An American GI patrols a war-ravaged hill.
Photo by David Hume Kennerly.

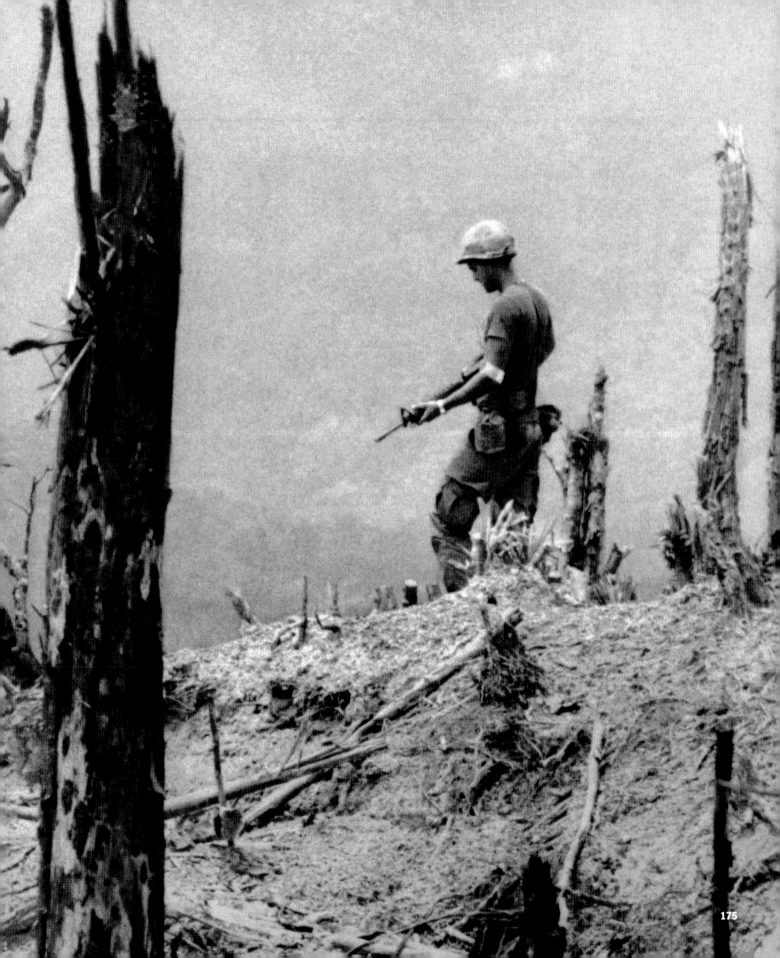

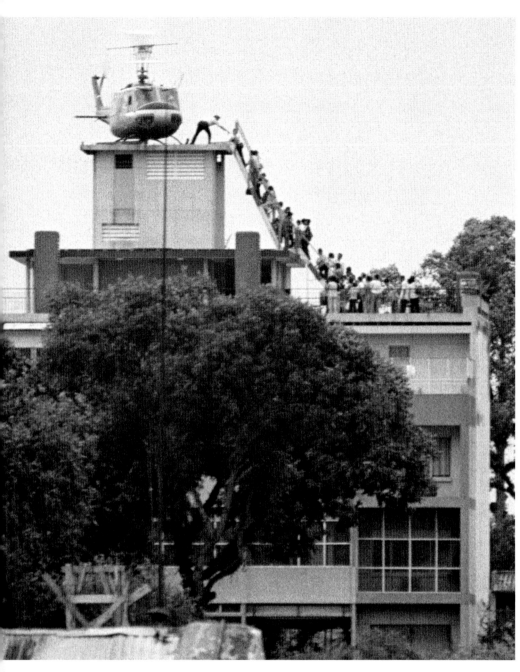

Fall of Saigon. A helicopter atop a Saigon apartment building fills with evacuees as the city falls to the Communists in 1975. Fourteen people took off in the eight-passenger chopper, leaving the others stranded on the stairs. *Photo by Hubert Van Es.*

No boarding pass.
Ed Daly, president of World Airways and a former Golden Gloves boxer, discourages a would-be passenger trying to board his already overloaded plane leaving Saigon in April 1975. Daly took it upon himself to evacuate hundreds of women and children as the Vietnam War ended abruptly, but this mission was nearly scuttled by South Vietnamese soldiers also eager to get out of town. This photo was winner of the 1975 Overseas Press Club Award.
Photo by Thai Khac Chuong.

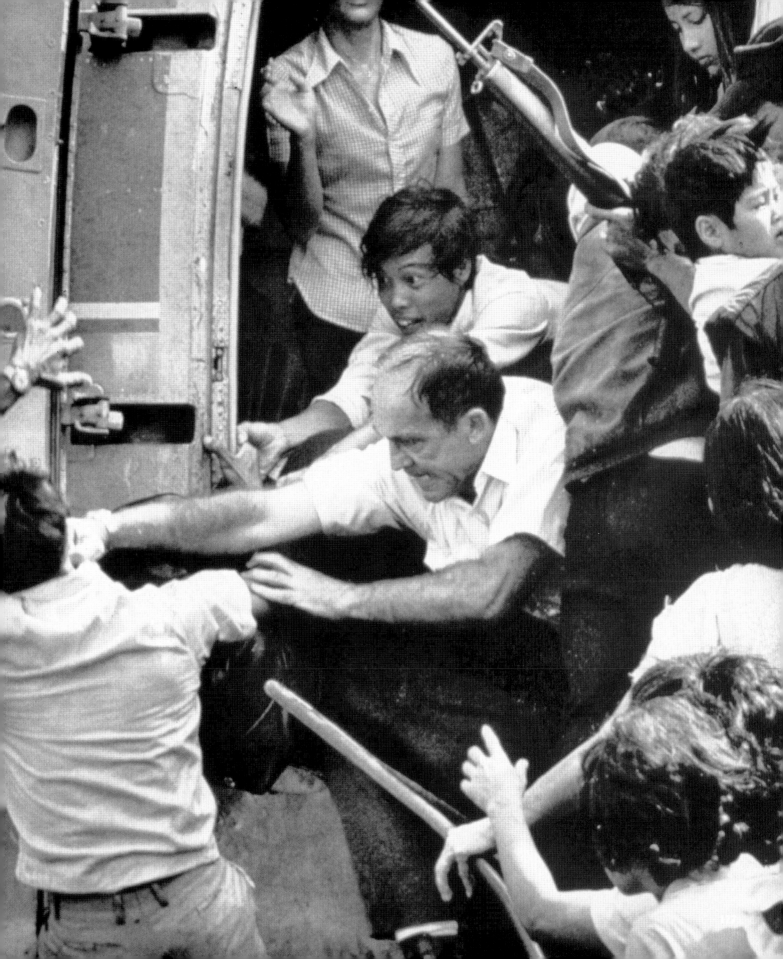

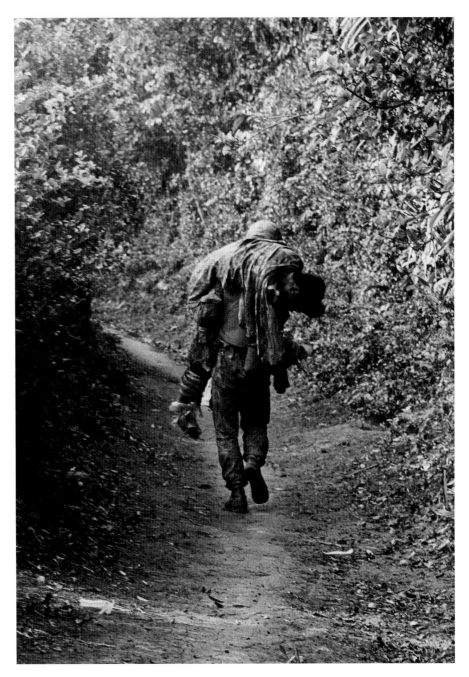

Long walk. A Marine carries a wounded comrade over his shoulder to safety near Cape Batangan, south of Chu Lai, in 1967. No stretchers were available. *Photo by John Schneider.*

He knows sacrifice.
Veteran Fred Strother pays his respects to 58,249 fallen comrades at the Vietnam Veterans Memorial in Washington, D.C., the testament to sacrifice during one of this nation's least popular wars. He lost a leg in that war in 1966. By 2005, the war America lost is but a single paragraph in Vietnamese grade school history books, and two-way trade between Vietnam and the United States had reached $6 billion a year. *Photo by Don Rypka.*

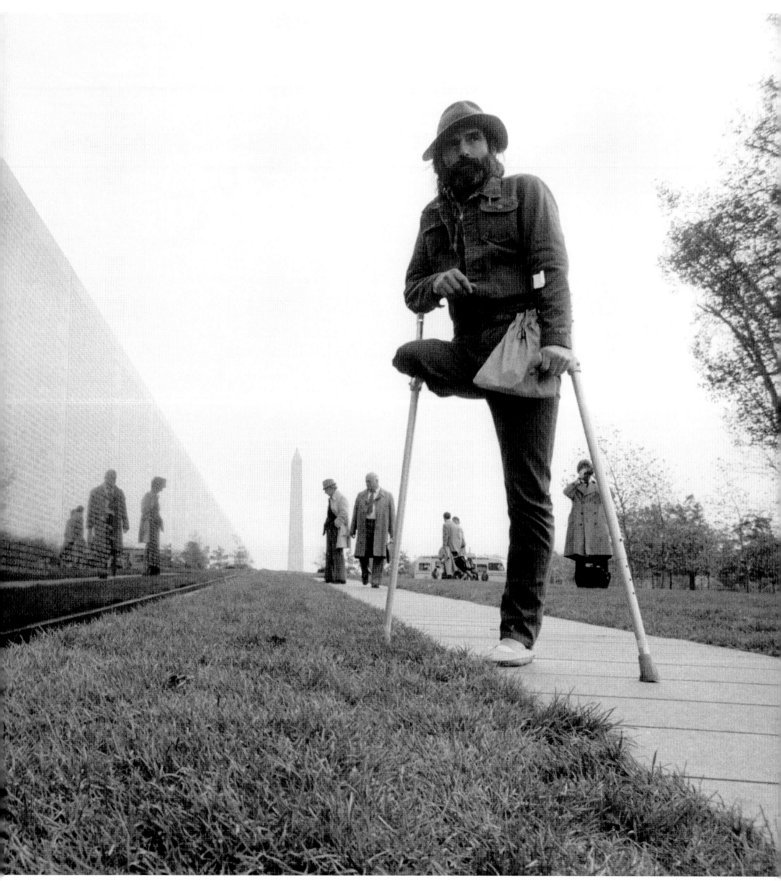

Hiromichi Mine

Willie Vicoy

Sean Flynn

Kyoichi Sawada

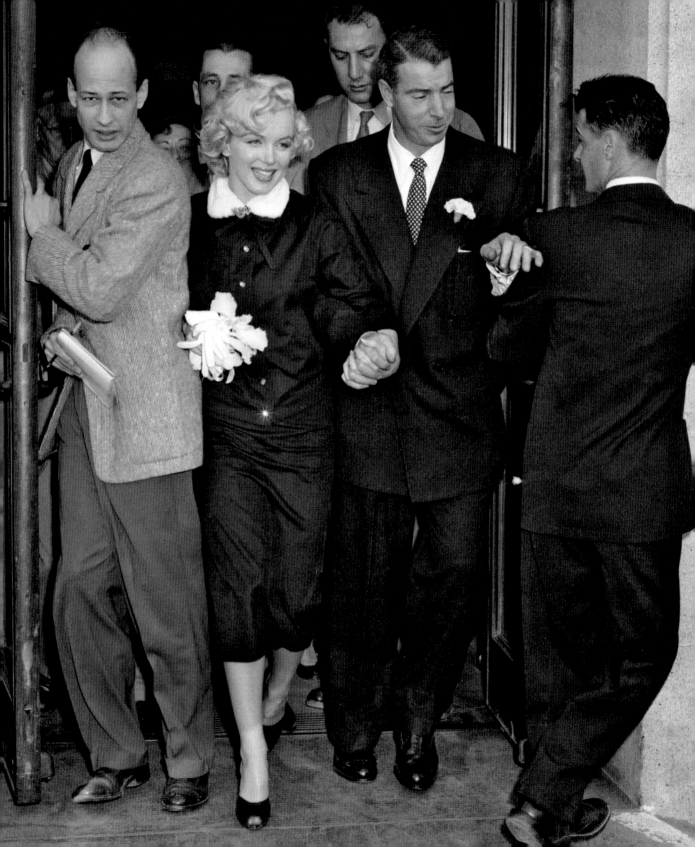

Entertainment

Psychologists tell us that celebrities benefit us emotionally in two ways: They provide a mythical narrative—a story the not-famous rest of us can follow and identify with. And they function as blank screens onto which the not-famous project their dreams, hopes, fears, plans, values, and desires—wish fulfillment.

Film stars and sports heroes and even Depression-era gangsters have fascinated both the public and the press, more than most of our leaders, thinkers, and captains of industry. One of the most popular photographs in the National Archives shows Elvis Presley meeting President Richard M. Nixon in the Oval Office in December 1970.

Andy Warhol, a pioneer of celebrity journalism (whose *Interview* magazine contained only celebrity interviews) said, "In the future, everyone will be world famous for 15 minutes." Reality television elevates its contestants to that brief celebrity status.

Popular magazines are filled with celebrity tidbits: divorce, scandals, awards, and film trivia. Weekly newsmagazines, claiming that they are only following our gossip-centric culture, often contain more entertainment news than news of the week. Paparazzi photographers stalk celebrities and are paid enormous sums for sometimes bad but exclusive candid photos. Their subjects claim to hate paparazzi (the word means "buzzing insects") but pursuit by the swarm revalidates their celebrity status.

The paparazzi thrive because almost all "official" photos of the celebrity du jour are released only after the celebrity approves, a process that virtually guarantees photos without spontaneity.

It wasn't always that way. UPI pioneered a Hollywood "photo beat" in 1964. Photographer Charles Heckman became a fixture among the glitterati, welcomed at studios and A-list parties and on film sets. He favored a dapper Jazz Age look so authentic that on the set of *Thoroughly Modern Millie* in 1967, director George Roy Hill mistook Heckman for one of his actors. Though some tried, no celebrity was ever allowed to "help" UPI select pictures.

Newlyweds. Movie star Marilyn Monroe and baseball legend Joe DiMaggio joined forces in San Francisco in January 1954—just nine months later, she filed for divorce. Many said DiMaggio was the father she never knew. They remained close until her tragic death in 1962.

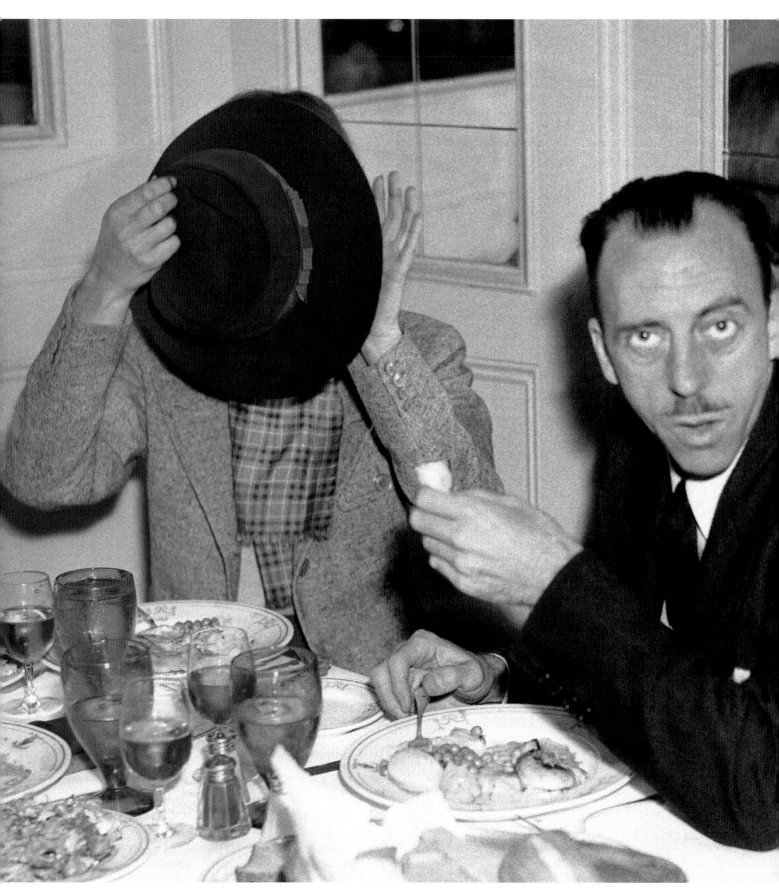

Multitalents. Fred Astaire, on accordion, was famous for his dancing. Irving Berlin, on piano, was famous for his music. There is also Astaire the singer, which, as *Time* magazine put it, "takes some getting used to," though in the '30s, eight Astaire recordings went to number 1 on the pop charts, several of them Berlin compositions. Astaire and Berlin take a music break while working together on *Top Hat* in 1935.

Garbo. Greta, notorious for her mystery. The more she avoided publicity, the more she got. Photographers stalked her and she blocked her face in this photo with her hat. Well, not quite. Check out the mirror image of Greta behind her friend, Rubert Rued, at a New York restaurant in 1936.

Rock 'n' roll. Calm policemen monitor excited teens waiting to see an Alan Freed show, Moondog's Rock 'n' Roll Party, in New York's Times Square in 1957. Freed coined the term "rock 'n' roll" in 1951, so whites would more readily accept "race music," rhythm and blues. He became the first disc jockey and concert producer to feature the music, and he appeared in several rock 'n' roll films. In 1952 a sold-out Freed concert in Cleveland seated 10,000 fans before another 6,000 crashed the gates.

Twisters.
Anna Maria Alberghetti tries the newest noncontact dance, the Twist, with Rudy Vallee, at Mamma Leone's in New York in March 1962.

Familiar face(s). President Harry Truman tickled the keys at the National Press Club in 1945, entertaining American troops, but what tickled their fancy was actress Lauren Bacall, draped atop the piano. All eyes were on Bacall, and a biographer later revealed that a pair of those eyes belonged to Truman's wife, Bess, who didn't much like what they saw.
Photo by Frank Cancellare.

Chums. President John F. Kennedy liked to pal around with singer Frank Sinatra, a Democrat who had campaigned for Franklin D. Roosevelt. They enjoyed this $400-a-plate dinner on the eve of the Democratic National Convention in Chicago in 1960. They schmoozed together until 1962, when Bobby Kennedy, the attorney general, convinced his brother to cut ties with Sinatra because of the singer's mob connections. Sinatra was devastated—but from then on it was Frank Sinatra, Republican.

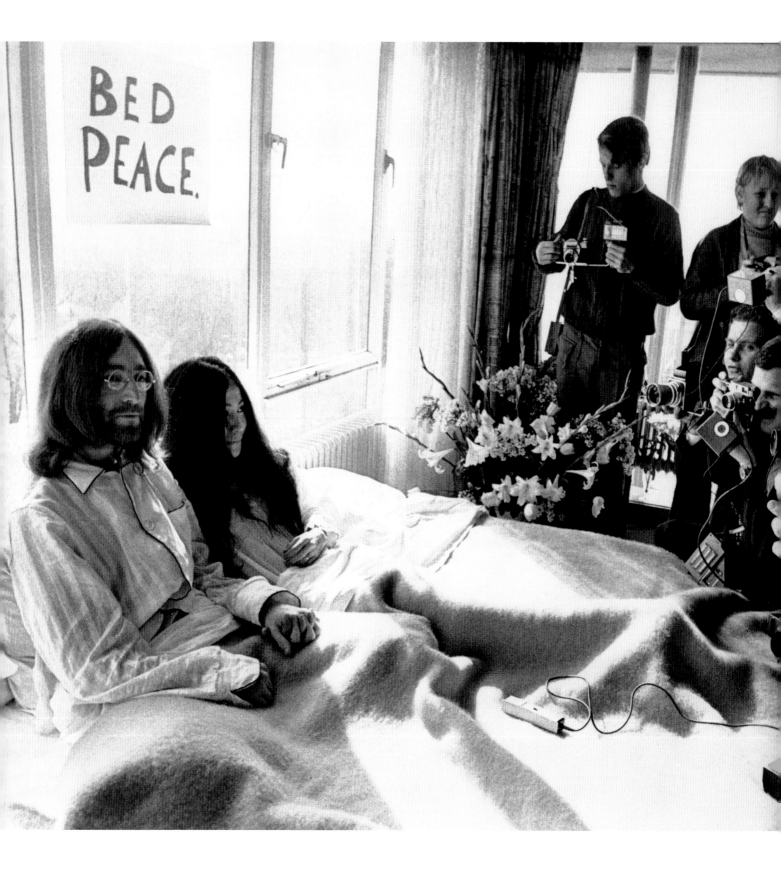

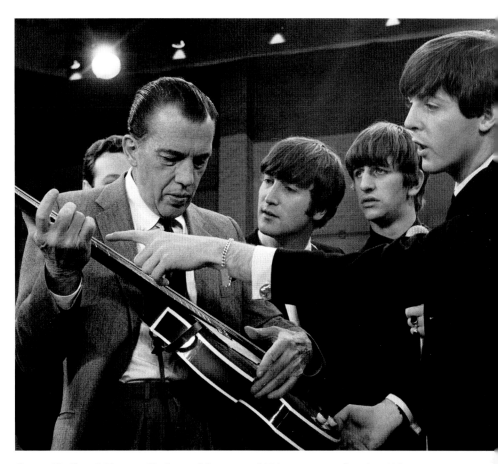

8 p.m. Be there! Clumped in front of those small TV screens on Sunday, February 9, 1964, Americans saw the debut of the Beatles on *The Ed Sullivan Show,* a date that shall live in—well—the history of rock music. Paul McCartney shows Sullivan the business end of a guitar during a rehearsal; John Lennon and Ringo Starr doubt he'll ever catch on.

Bed-in? After their March 1969 wedding in Gibraltar, master media manipulators John Lennon and his new bride, Yoko Ono, staged a "bed-in for peace" in the presidential suite of the Amsterdam Hilton for the first week and the Queen Elizabeth Hotel in Montreal for week two. Hoping for nudity, photographers got only pajamas, and a performance art honeymoon protesting the Vietnam War.

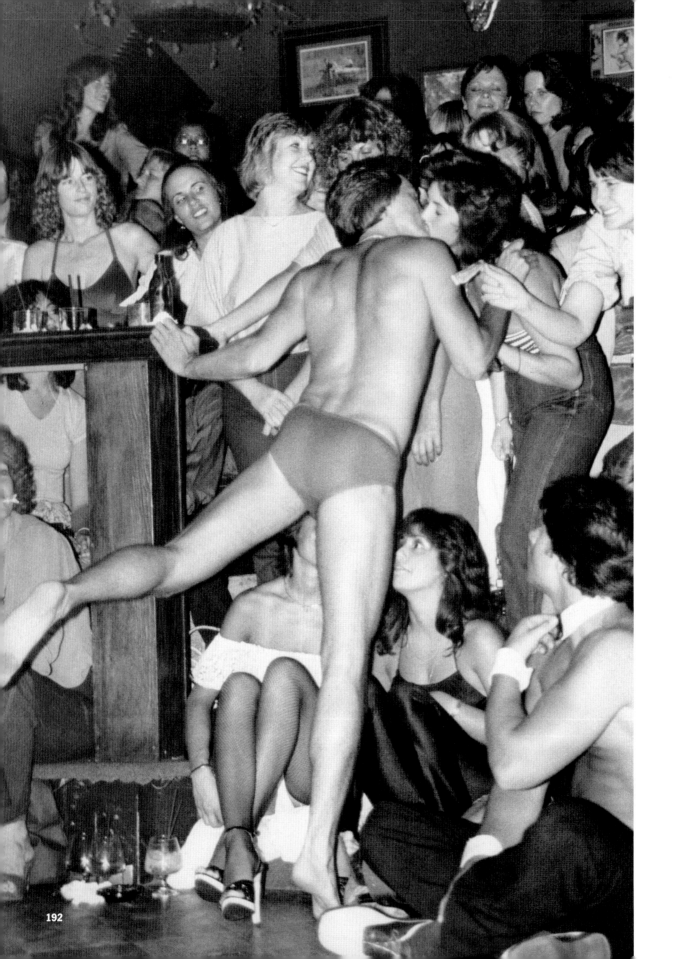

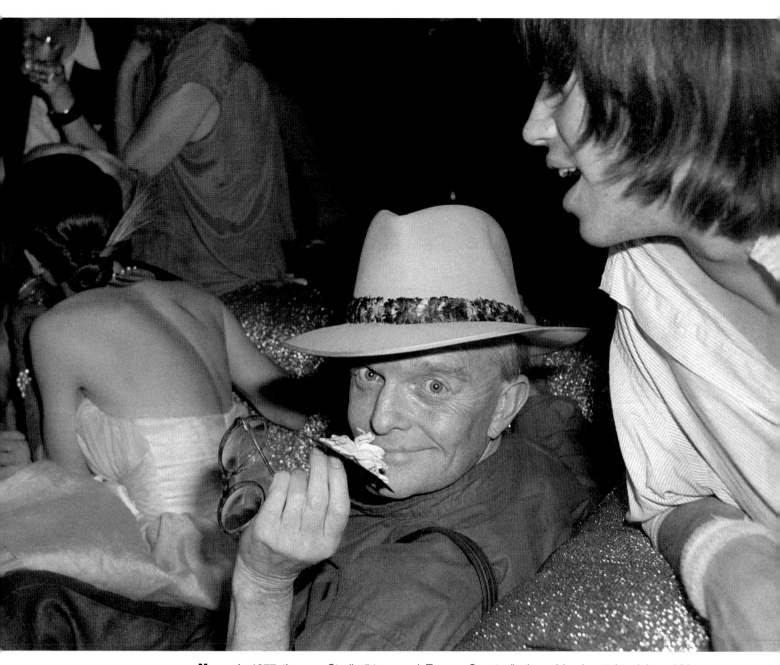

Moses. In 1977, the year Studio 54 opened, Truman Capote (hat) would arrive at the club and "the seas would part." Other celebrities sometimes had trouble getting in. The club became famous for drugs and debauchery and as the place to see A-list celebrities. In December 1978 the Feds raided the place. The owners would do some prison time, and Studio 54 eventually closed its doors. *Photo by Andy Lopez.*

Hunkshow. A male stripper gets a kiss, a dollar tip, and a closeup inspection during a performance at Chippendales, a hit nightclub act exclusively for female audiences. This crowd was standing room only in September 1979, the Chippendales' first year.

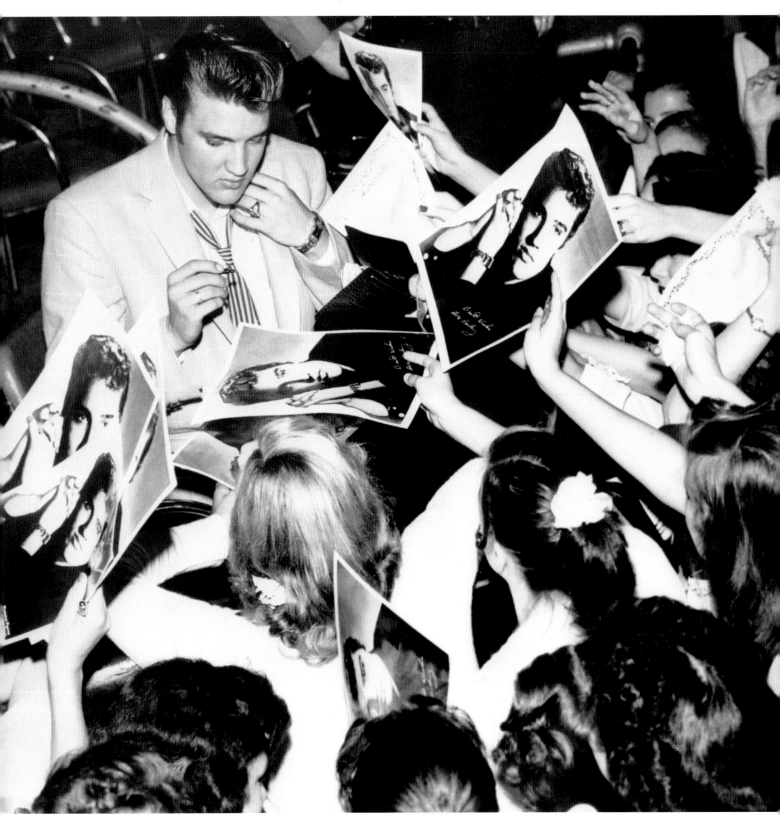

Heartthrob. Just two days after his 21st birthday in January 1956, Elvis Presley recorded "Heartbreak Hotel" for RCA in Nashville—his first track for a major record label. It quickly topped the charts and made Elvis the focus of teen screamers seeking autographs.

Soldier home. In 1958, Elvis was inducted into the U.S. forces, and he ended his tour, flashing a sunny smile, in this March 1960 snowstorm. He was reported to be a model soldier during two years in Germany. There he met Priscilla Beaulieu, 14, the daughter of a military man also stationed in Germany at exactly the right moment for her to meet Elvis. They were married in 1967. *Photo by Joel Landau.*

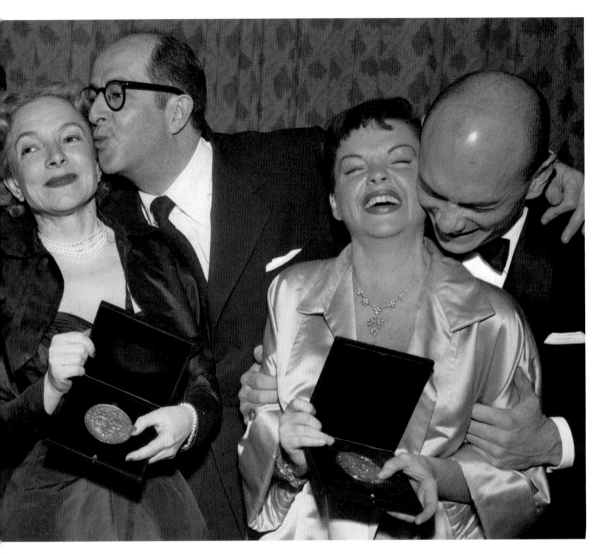

Smug and kisses. Tony Awards clutched tightly, Helen Hayes, host of the 1952 Tony Awards ceremony, tolerates a smooch from Phil Silvers; Judy Garland seems to enjoy the attention of Yul Brynner. Garland received an honorary Tony for her work in vaudeville.

Sphinx serenade.
During a visit to Egypt in 1961, American music legend Louis Armstrong entertains his wife, Lillian, and the Sphinx, as he unburdens himself of some jazz.

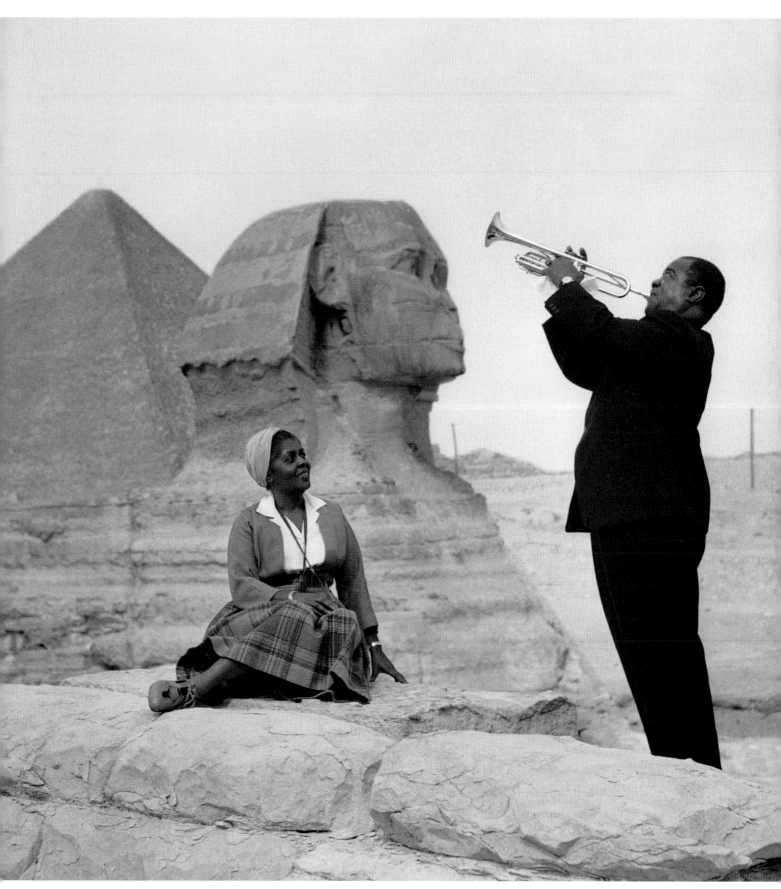

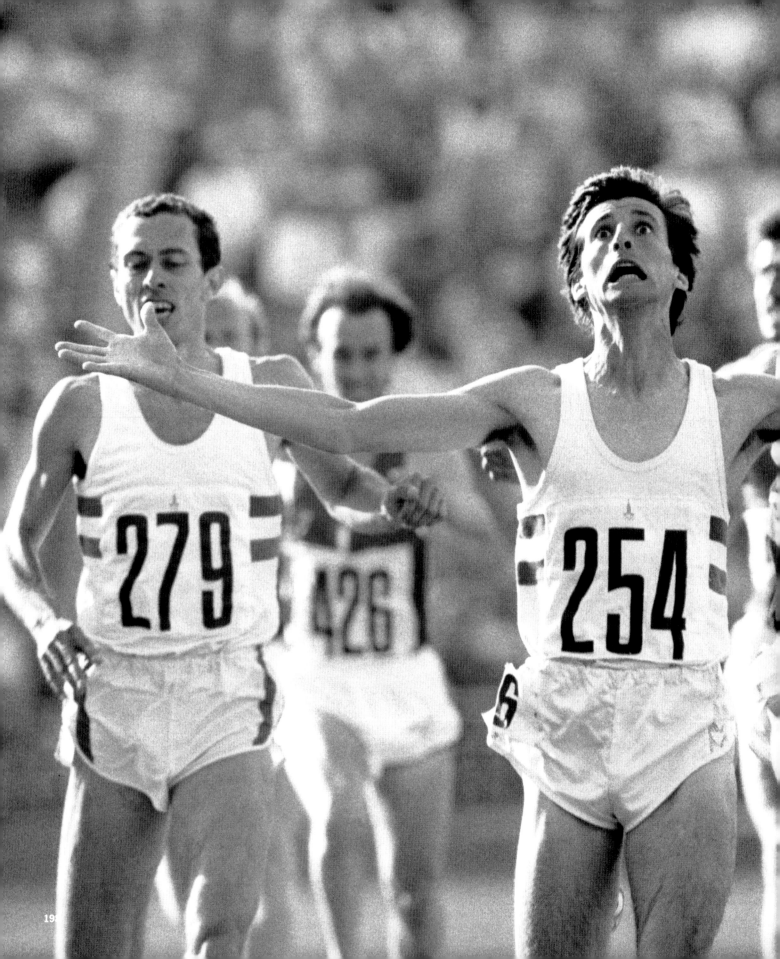

Sports

The arena is defined. Your subjects rarely venture outside it. The rest is up to the sports photographer, armed with telephoto lenses because most times, there's no way to get closer to the action.

Unlike sportswriters and television viewers, still photographers don't have the luxury of instant replay. At its best, great sports photography captures not only the tremendous skills and abilities of the world's greatest athletes in action, but also their passions.

The best sports shooters produce action photos that even the spectators in the front-row seats—or multiple TV cameras—didn't see. The camera doesn't "see" the way the eye does, and keeping the subject in focus while trying to catch the action requires great skill and lightning reflexes. The longer the lens, the more challenging it is.

Some photographers seem content just to prove that they attended a sports event by shooting "safe" but forgettable pictures.

The very best practitioners, such as former UPI photographers Joe Marquette, Jerry Lodriguss and Darryl Heikes, almost miraculously keep the action sharp using 300mm and even 600mm lenses in fast-break situations that most shooters struggle to follow focus using far shorter lenses.

The "best" sports pictures aren't always peak action. Dodger shortstop Maury Wills held the major-league record of 104 stolen bases, and once stole second with such force that he dislodged the base. UPI's Ernie Schwork strolled briskly onto the playing field, past umpires reattaching second base, as radio announcer Vin Scully did a play-by-play.

The startled umps asked Schwork what he thought he was doing. "It makes a better picture with the stands in the background," he replied.

Sweet revenge. Sebastian Coe of Great Britain grabs the gold in the 1500 meters at the 1980 Olympics in Moscow. Fellow countryman Steve Ovett (279), took bronze, and Jurgen Straub of East Germany (338), silver. It was a sweet moment avenging Ovett's gold in the 800 meters, a race Coe had been favored to win. *Photo by Joe Marquette.*

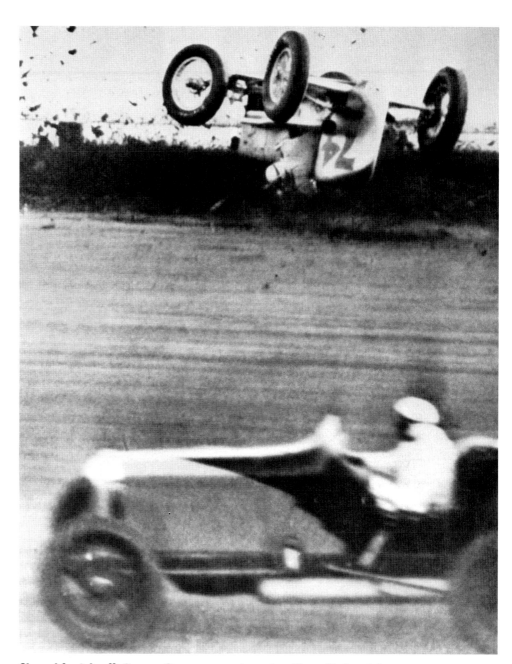

Cleared for takeoff. George Connors speeds past as Pierce Bertrand does a fancy aerial spin during the Los Angeles Legion Ascot Speedway race in 1937. Bertrand suffered only minor bruises.

Babe Ruth cigars? He pitched 29⅔ scoreless innings in the 1916 World Series. He was sold in 1919 to the New York Yankees and batted .847 in 1920. He hit more homers in 1920 and 1927 than any entire team in the American League. He had a cigar factory making Babe Ruth stogies, which he's selling here in a Boston shop. Told in 1931 that his $80,000 a year was more than President Hoover made, Ruth quipped, "I had a better year than he did."

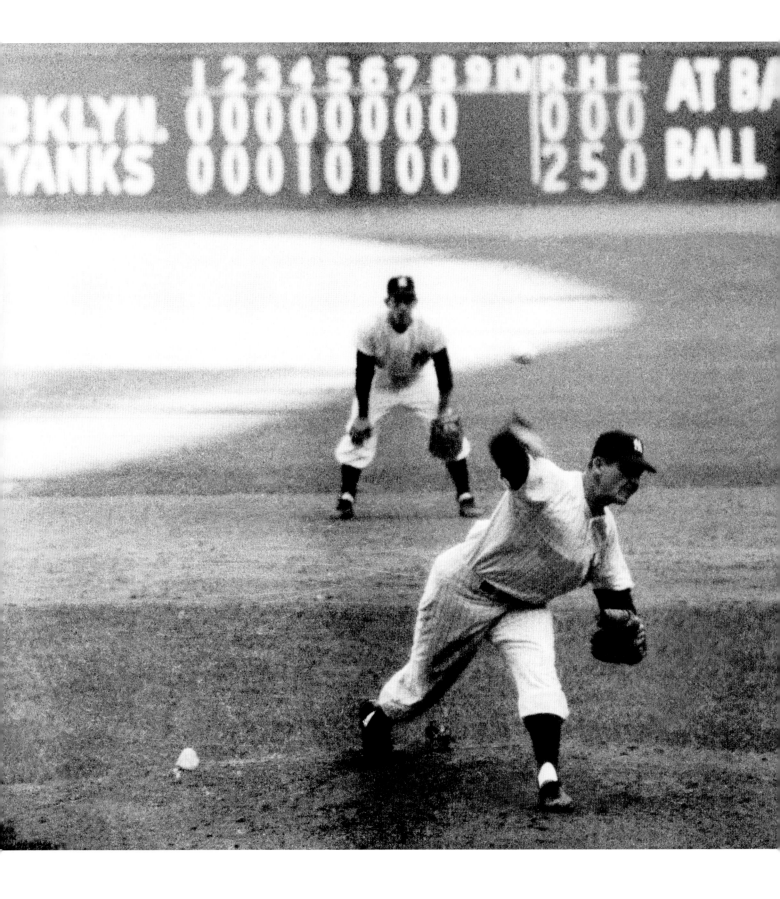

Perfect pitch. Don Larsen of the New York Yankees pumps a final pitch to the plate, and the scoreboard tells the tale. In October 1956 he pitched the first and only perfect game in World Series history, retiring 27 Brooklyn Dodgers in a row. One sportswriter described the rest of Larsen's career as "unbroken mediocrity punctuated with flashes of competence." *Photo by Art Rickerby.*

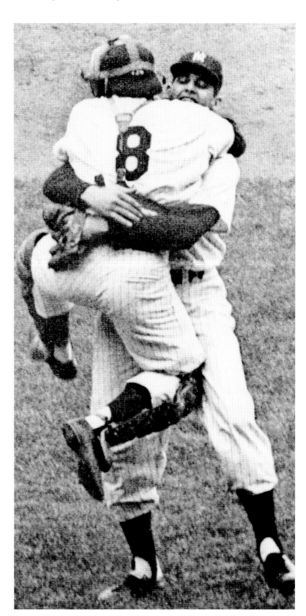

Berra hug. Catcher Yogi Berra hops aboard Don Larsen after Larsen's perfect game. *Photo by Art Rickerby.*

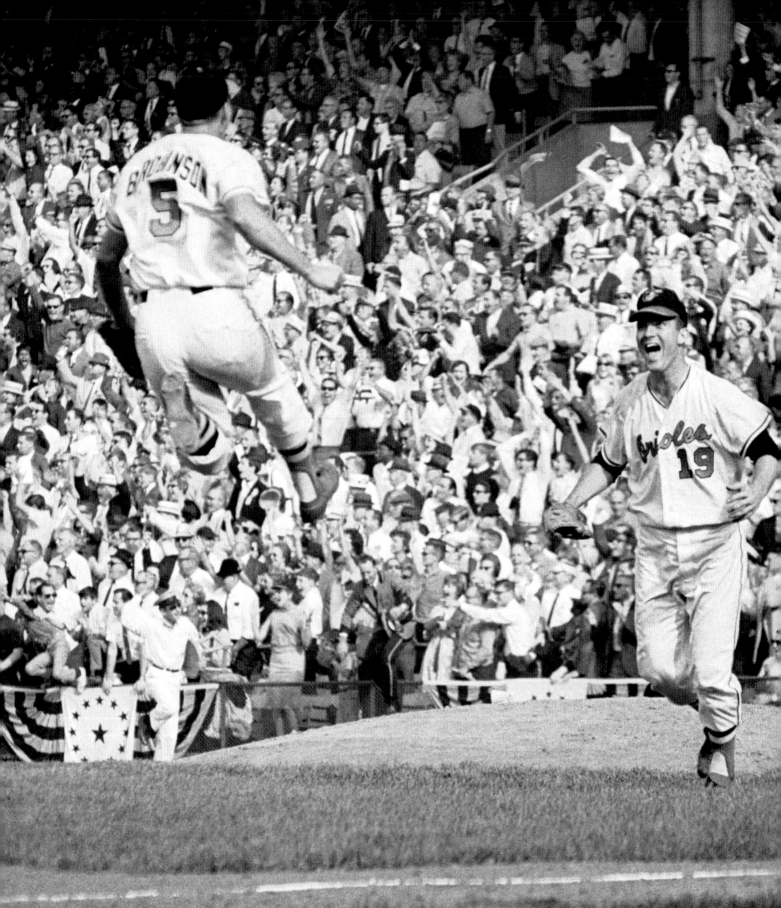

Baseball ballet.
Baltimore Orioles third baseman Brooks Robinson does some high-stepping toward pitcher Dave McNally after the final out at the top of the ninth. The Orioles had just swept the World Series against the Los Angeles Dodgers 4–0 in 1966.
Photo by Darryl Heikes.

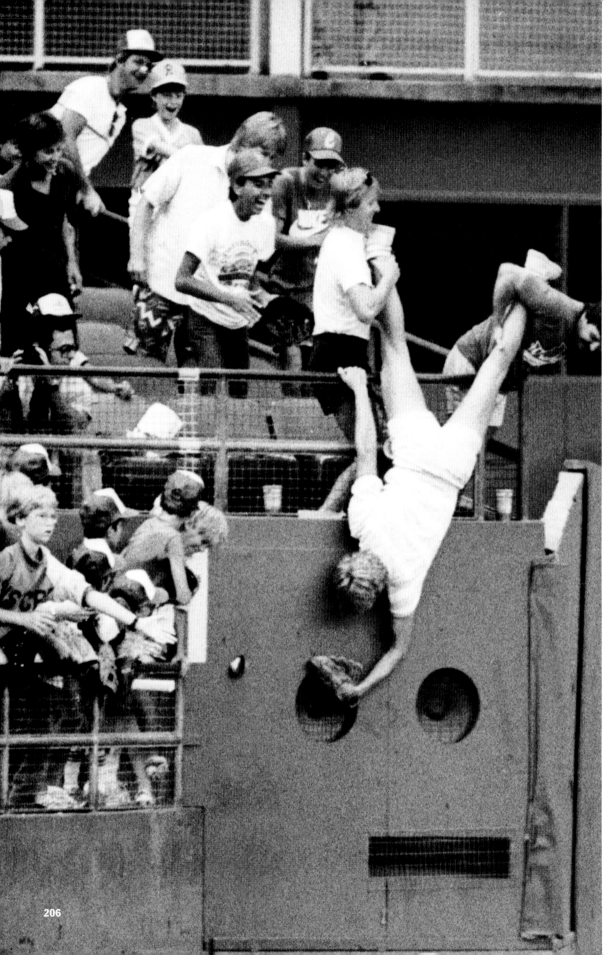

Nice catch.
As a fan, Mark Krpec, dived for a foul baseball, other fans dived to catch him, probably the greatest catch of the day. The great save occurred during a workout before the July 1986 All-Star game at the Houston Astrodome.
Photo by Kevin Plevka.

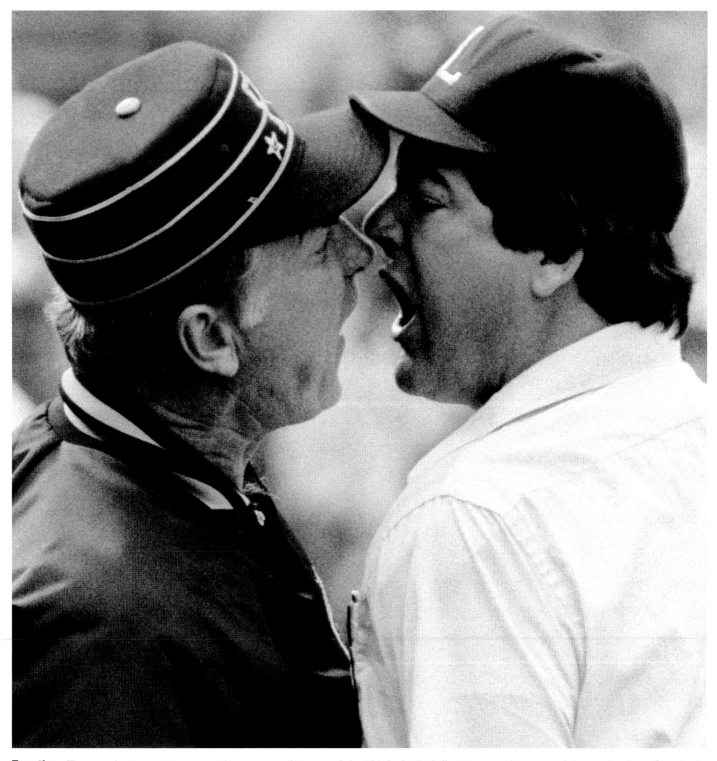

Face time. They can't see eye to eye, so they go mouth to mouth in a high-decibel disagreement between plate umpire Jerry Crawford and Pittsburgh Pirates manager Chuck Tanner, unhappy about Crawford's calls during a 1960 game won by the Chicago Cubs. *Photo by Jim Smestad.*

Fans, fog, and frostbite. It was 13 below zero when the Green Bay Packers faced the Dallas Cowboys outdoors on Lambeau Field in the 1967 "Ice Bowl" championship game in December 1967. For those fans who couldn't see through the clouds of breath hanging over the stands, Green Bay won, 21–17. *Photo by Ralph Schauer.*

Ka-boinggg!
Tony Adamie has a close encounter with the goalpost, allowing Walter Clay to dive in for a touchdown in a December 1948 football game. Goalposts actually *on* the goal line were dangerous and an impediment to traffic. They were relocated *off* the actual goal line in 1966.

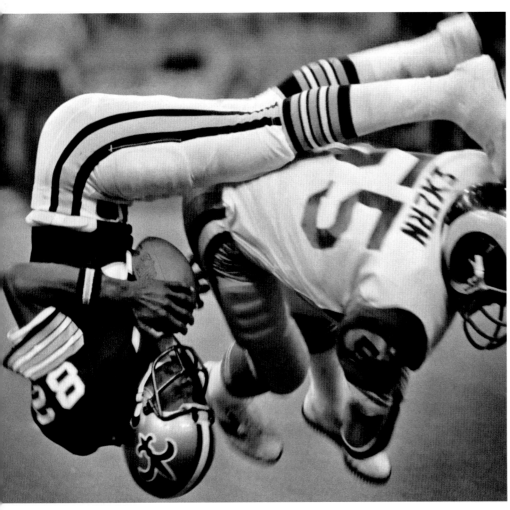

Topsy-turvy TD. Ike Harris of the New Orleans Saints flips past a defender, still in control after Carl Ekern sent him spinning in the fourth quarter of a Saints–Los Angeles Rams game in 1980, which the Rams won, 27–7. This photo won Pro Football Photograph of the Year in the NFL Hall of Fame contest. *Photo by Jerry Lodriguss.*

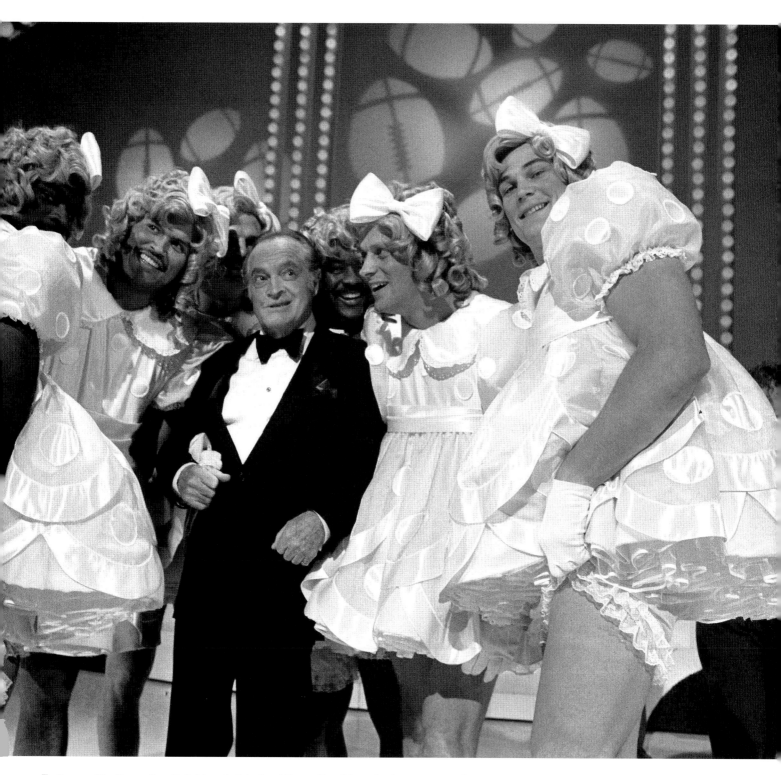

Feeling pretty. Comedian Bob Hope's televised *Super Bowl Party* in January 1983 featured football hulks each dressed as Shirley Temple. They sang "Good Ship Lollipop," and to be on the safe side nobody teased them. From left: Lawrence Taylor, New York Giants; Anthony Munoz, Cincinnati Bengals; Ted Hendricks, Los Angeles Raiders; Bob Hope; Dan Hampton, Chicago Bears; Doug Wilkerson, San Diego Chargers; and Randy Gradishar, Denver Broncos.
Photo by Glen Waggner.

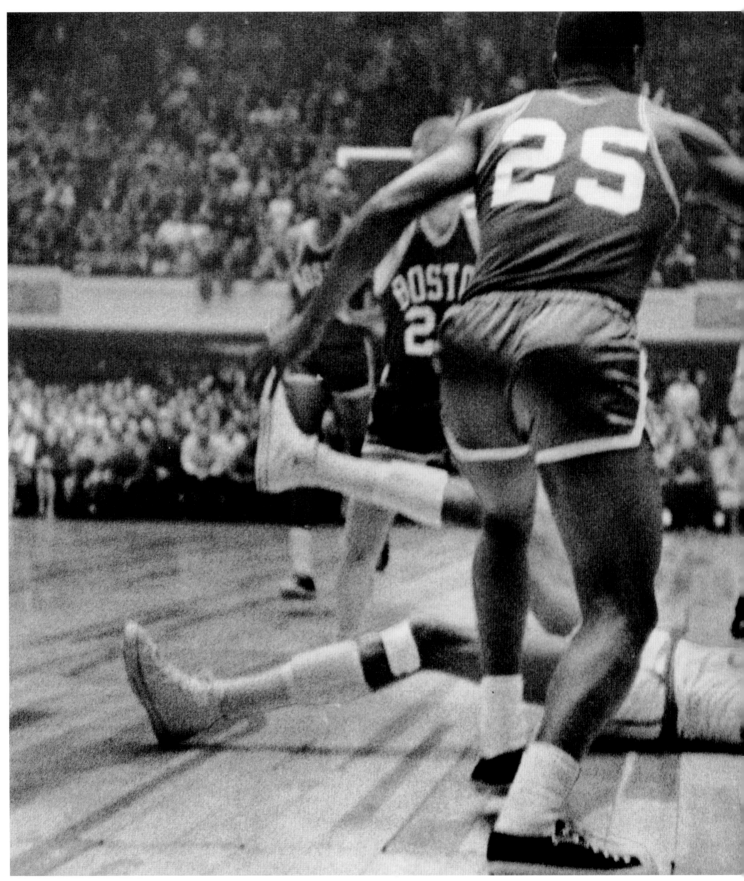

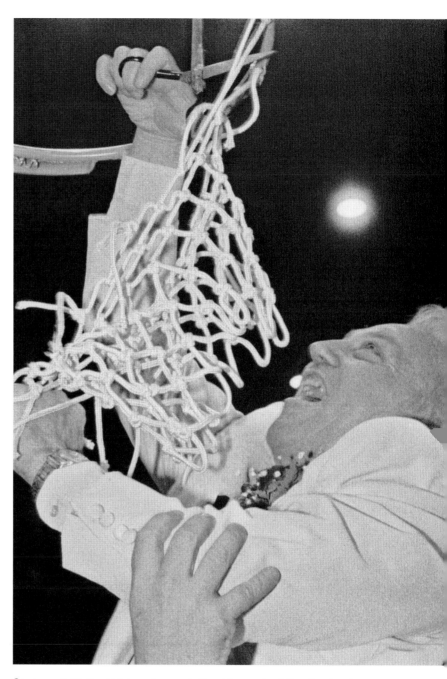

Career cut. DePaul University coach Ray Meyer gleefully whacks at the net after his final game as head coach in 1984, after 724 victories in 42 seasons. He was elected to the Basketball Hall of Fame in 1979. *Photo by Jim Smestad.*

Horizontal threat. Even lying down, Wilt Chamberlain is in control during a Philadelphia Warriors game with the Boston Celtics in 1962. "Wilt the Stilt," 7 foot 1, was an offensive force second to none. That year he scored in the NBA's only 100-point game and is one of only two players who scored more than 30,000 points during an NBA career. *Photo by Gary Haynes.*

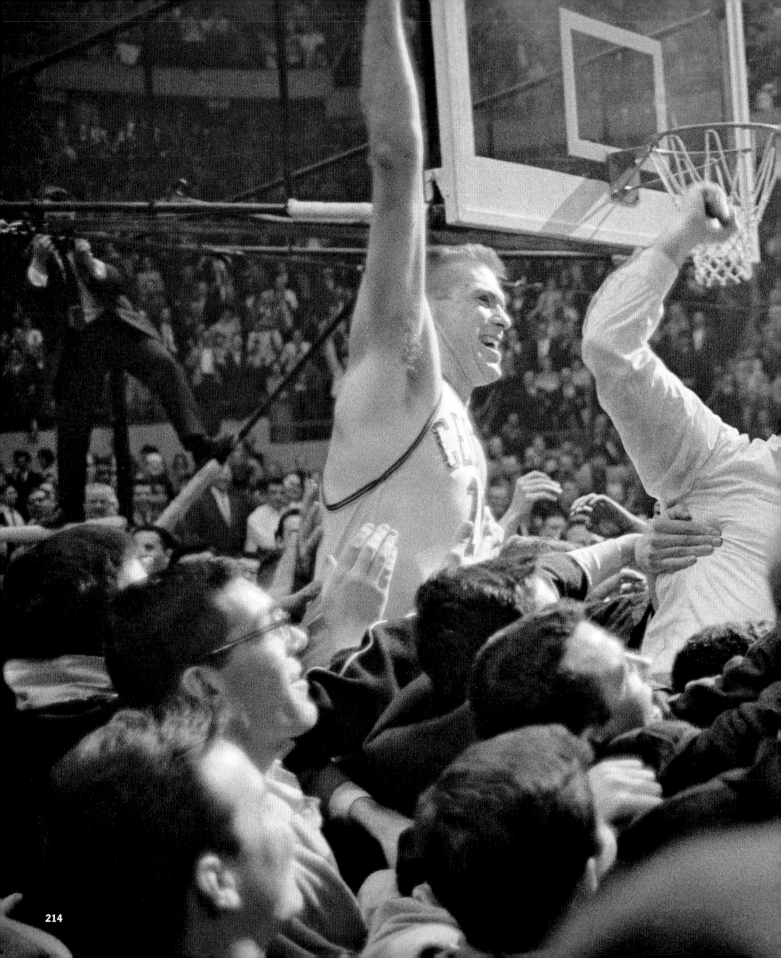

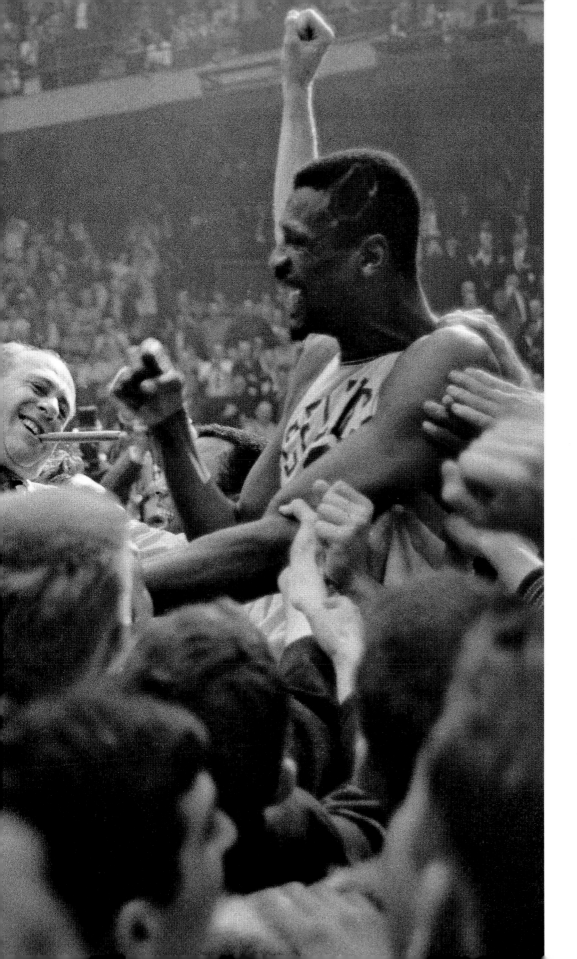

How sweet it is!
Tommy Heinsohn, coach Arnold "Red" Auerbach (with victory cigar), and Bill Russell are joined in celebratory excess after the Boston Celtics won a sixth consecutive world championship in April 1964. The team continued their streak through 1966, and made it an unprecedented eight in a row.

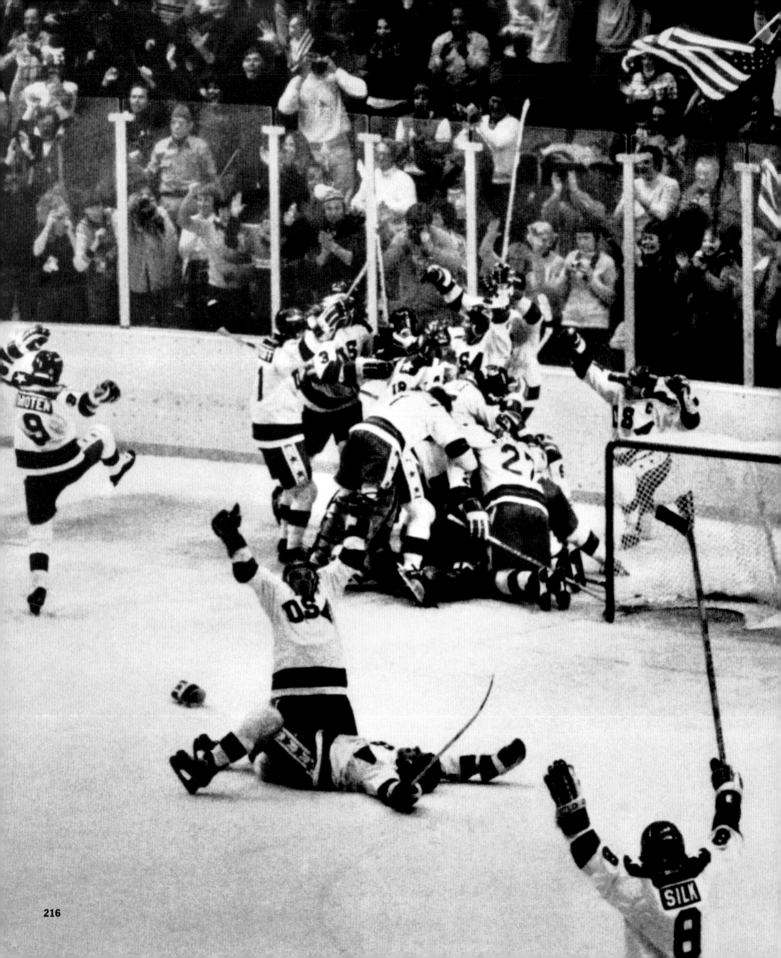

Mission possible! Lake Placid Olympics, 1980: The Russians were the Olympics' only unbeaten, untied, and unmerciful hockey team. They were 16–0 over Japan, 17–4 over the Netherlands, and 8–1 over Poland. Then came the Americans, and when it was over, the mighty Soviets were defeated 4–3 in the semifinal, one of the biggest upsets in international sports ever. The U.S. team mobs goalie Jim Craig, who stopped 36 of 39 Soviet shots. Virtually unknown coach Herb Brooks and a collection of college kids had pulled off a "Miracle on Ice," a monumental victory both athletic and political. They then defeated Finland, 4–2, and won the gold.

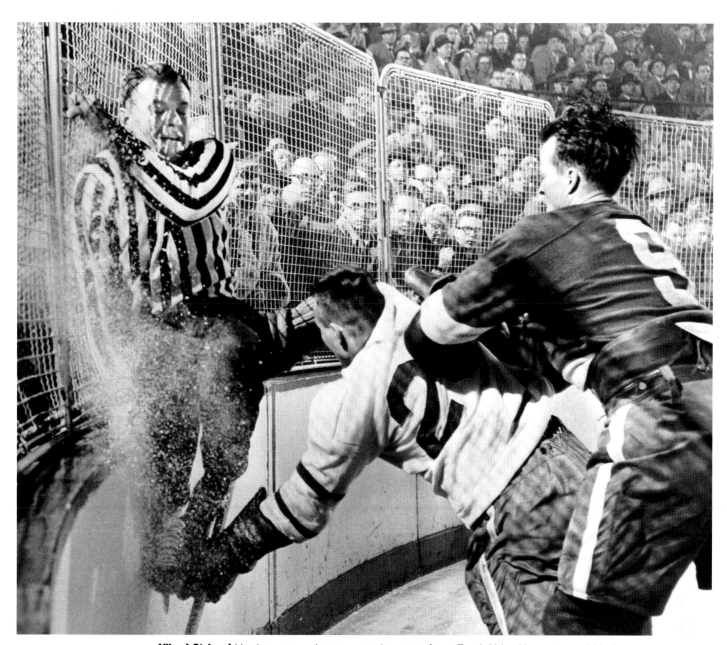

Yikes! Stripes! Hoping to remain a noncombatant, referee Frank Udvari leaps to avoid being at the boards when Toronto's Gordie Hannigan and Detroit's Gordie Howe get there during a Stanley Cup Contest in 1956. Udvari was unharmed and Detroit won, 3–2. *Photo by Art Chernecki.*

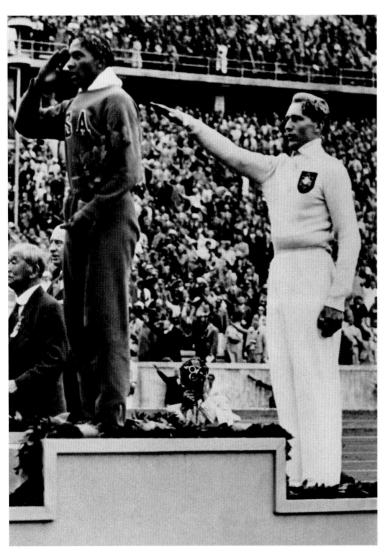

Owens salutes. A black American, Jesse Owens, 22, embarrassed Hitler and Nazi Germany by winning four gold medals in the 1936 Berlin Olympics. Germany's Luz Long gives the Nazi salute. Germans clamored for Owens's autograph. "I came back to my native country," Owens said later, "and I couldn't ride in the front of the bus."
He returned home to ticker-tape parades in New York and Cleveland, but President Franklin D. Roosevelt never publicly acknowledged his achievements. He was later honored by presidents Dwight Eisenhower in 1955, Gerald Ford in 1976, and Jimmy Carter in 1979.

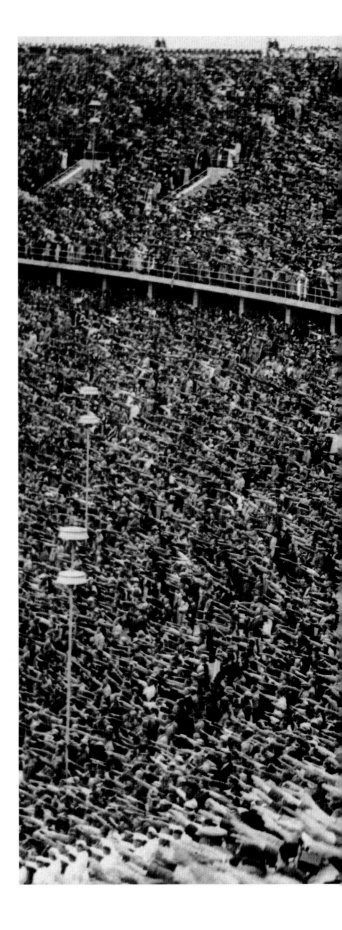

Heil, Hitler.
A sea of salutes greets Adolf Hitler's arrival at the 1936 Olympic Games in Berlin. German athletes performed well but the results failed to prove Hitler's theories of Aryan racial superiority.

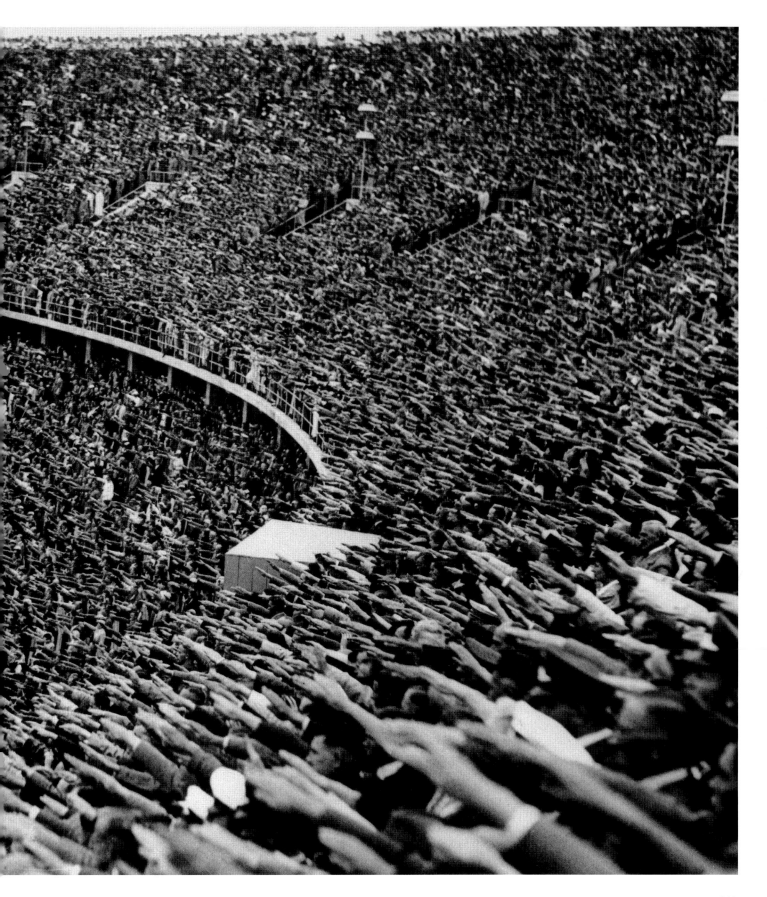

Frequent flyer.
Bob Beamon is aloft and about to shatter the world long jump record with a jump of 29 feet, 2½ inches at the 1968 Olympics in Mexico City. From 1935 to 1968, the world long jump record increased by only eight and one-half inches. Beamon, who had barely qualified for the finals, bested the old world record decisively—by almost two feet: 21¾ inches.
Photo by Darryl Heikes.

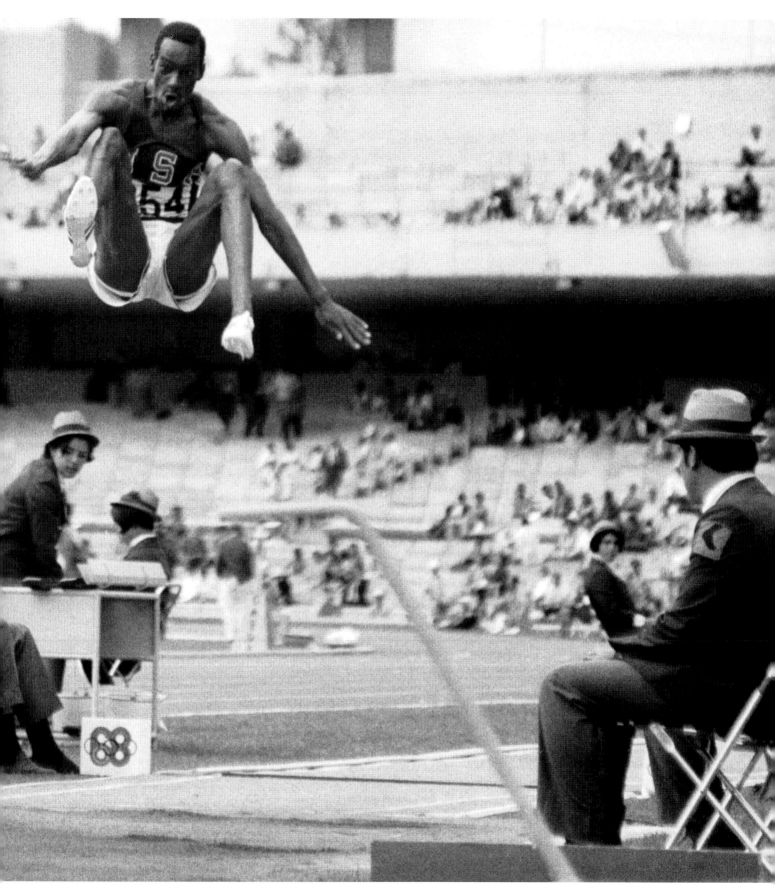

Olympics held hostage.
Armed police drop to a terrace where the Palestinian "Black September" group seized Israeli athletes inside the Olympic Village in Munich in 1972. They demanded that Israel release Palestinian prisoners held there; the Israelis balked. Germans talked the group out of the Olympic Village to a small airport but the rescue plan went awry and all the hostages, a German policeman, and five of the eight terrorists died in a shootout.
Photo by Darryl Heikes.

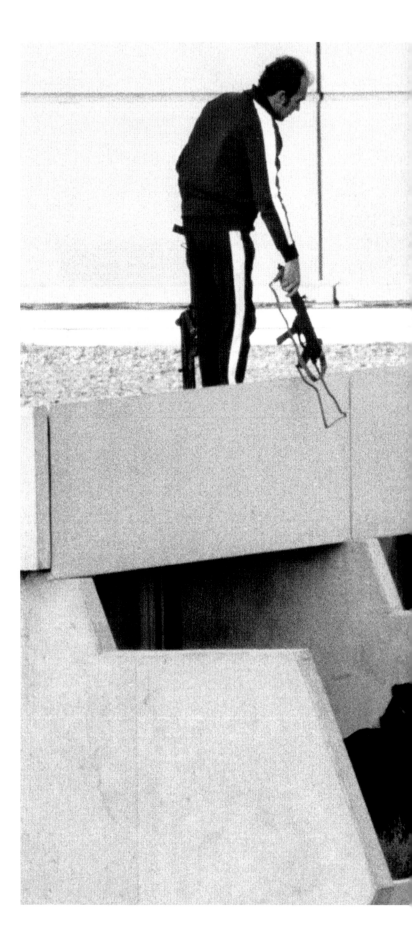

Stalling for time.
Negotiations take place with anti-Israel terrorists at the Olympic Village.
Photo by Darryl Heikes.

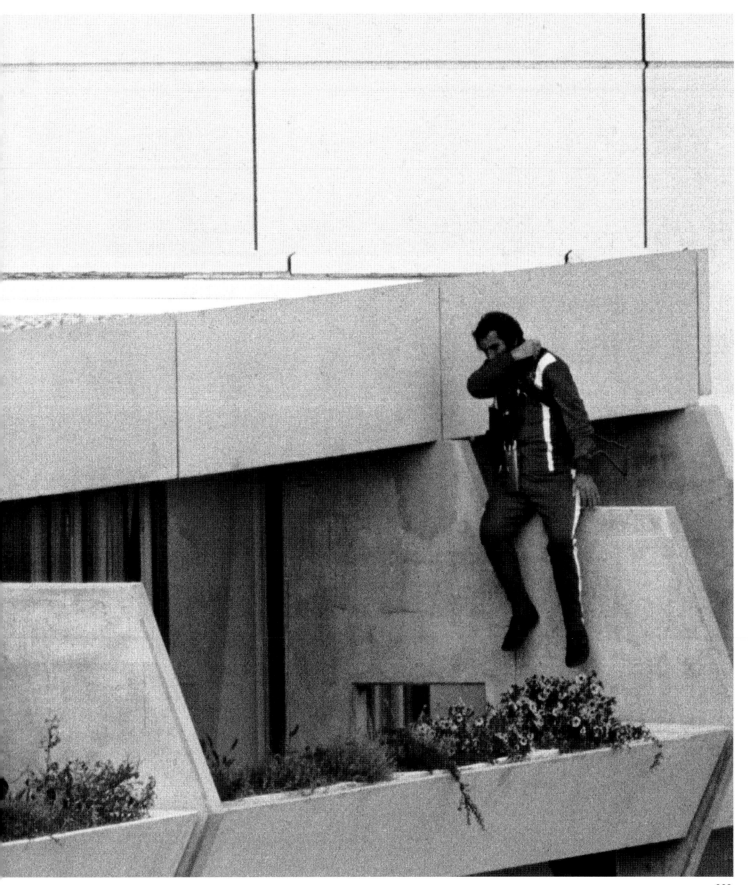

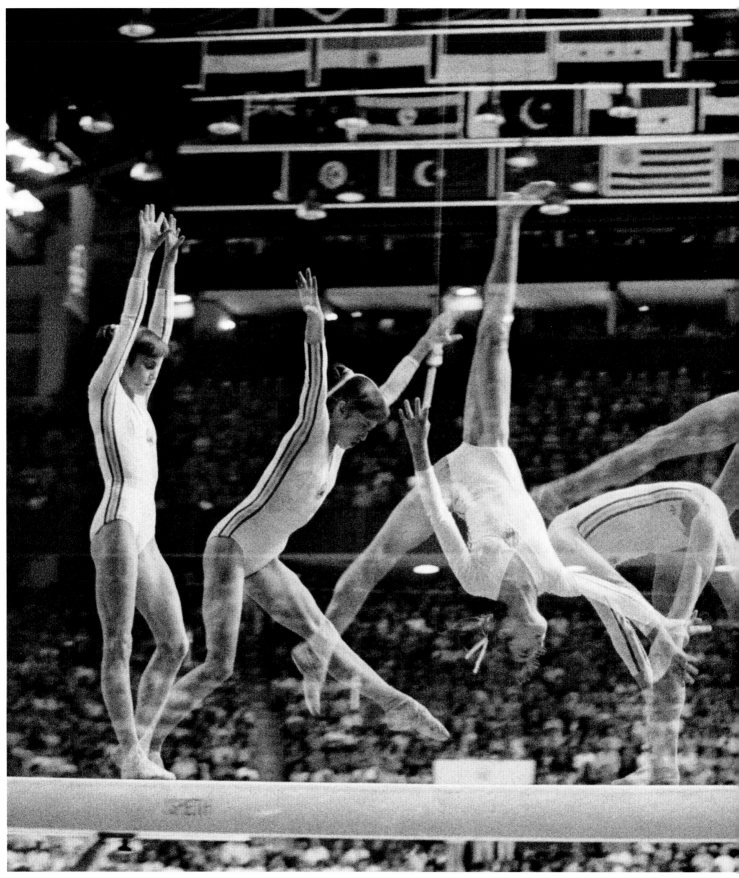

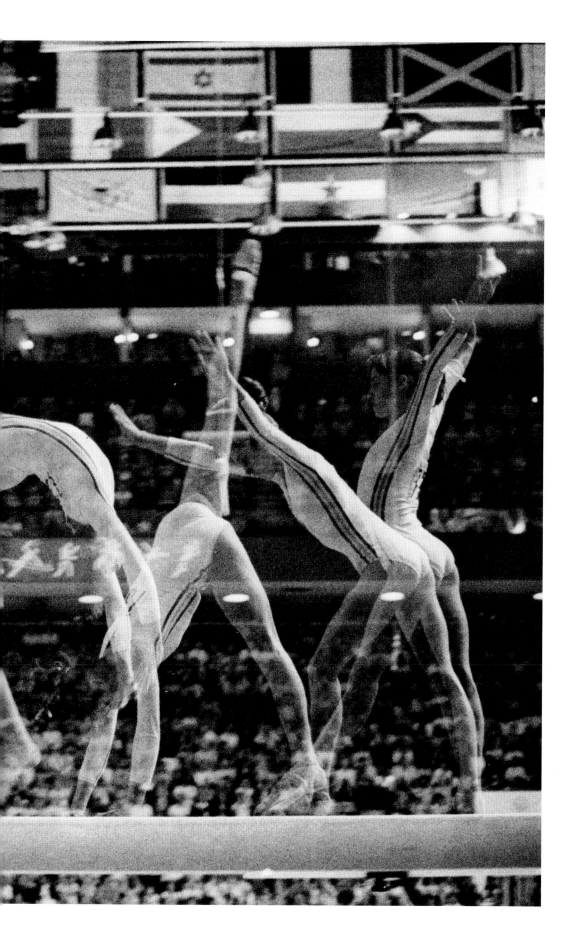

Golden balance.
Romania's Nadia Comaneci, 14, became an international sensation at the Montreal Olympics in 1976, winning three gold medals and seven perfect scores—the first ever for an Olympic gymnast. This multiple exposure records her gold medal performance on the balance beam. She fled Romania in 1989 for America and became a citizen in 2001. *Photo by Darryl Heikes.*

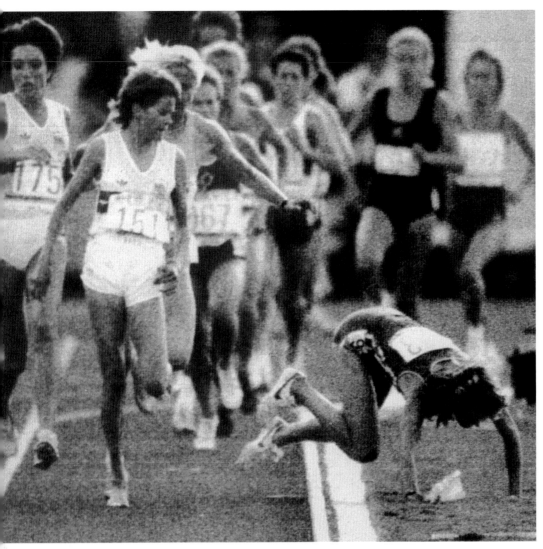

Collision course. Believed to be the best female middle-distance runner of her generation, Mary Decker saw her Olympic dreams end with a collision in midrace with Zola Budd, running barefoot for Britain. The two bumped twice in the 3000 meters and Decker tripped on Budd's right leg. Trying not to fall, she grabbed Budd's number—151—and ripped it off her back, her spikes injuring Budd's heel. Budd limped to finish in seventh place, and tried to apologize to Decker, who, in tears, told her to go away. *Photo by Ron Kuntz.*

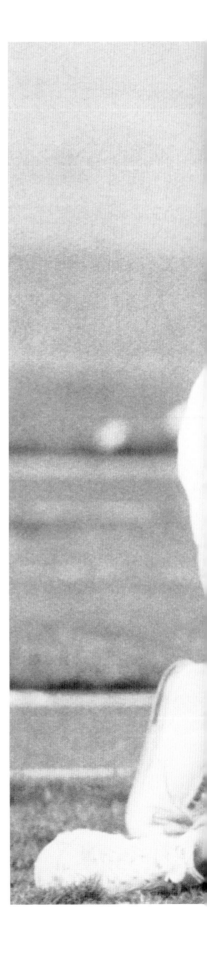

Dashed hopes.
An official tries to help Mary Decker after her fall during the Olympic 3000 meters ruined her chance for a medal at the Summer Olympics in Los Angeles in August 1984. She had torn a muscle in her left hip. *Photo by Ron Kuntz.*

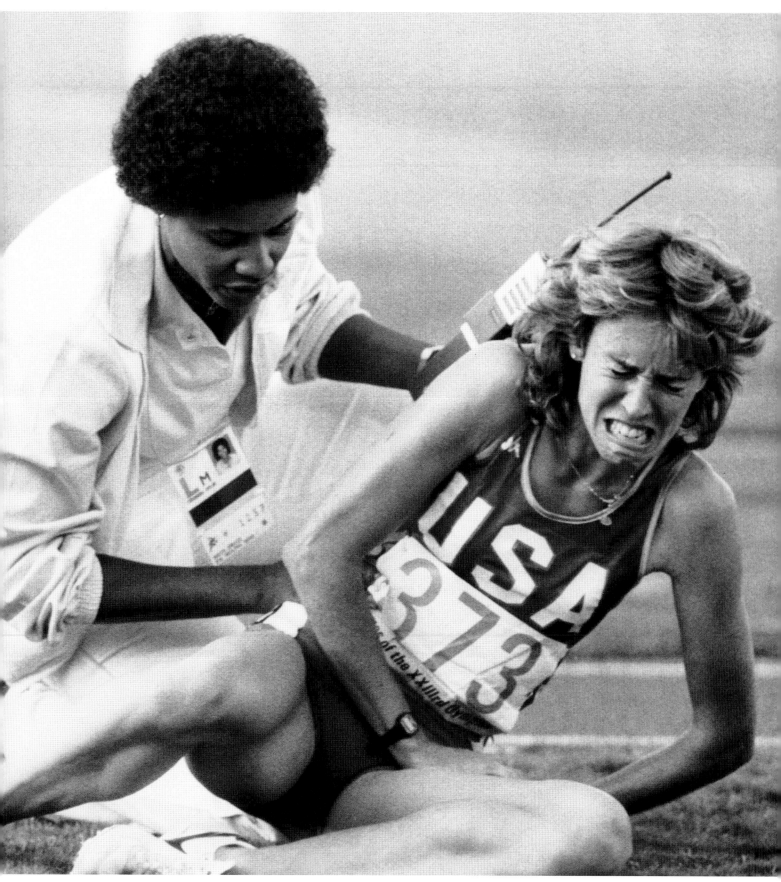

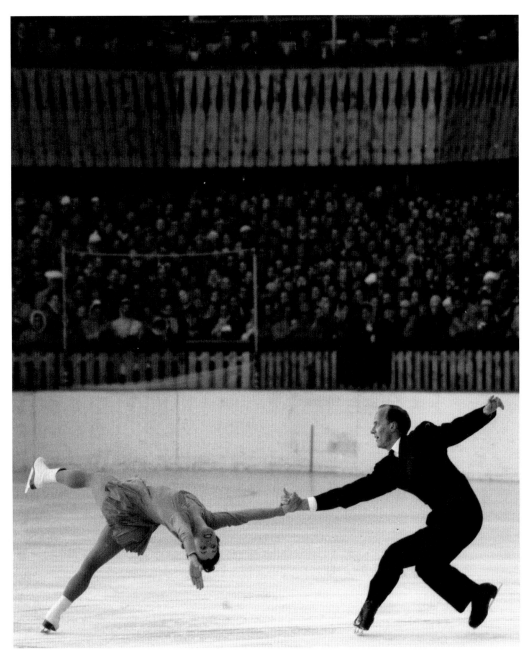

Ice dance. Giving the judges a whirl, Norris Bowden and Frances Dafoe of Canada perform in the Olympic figure skating competition in Cortina d'Ampezzo, Italy, 1956. The Canadians, who had been world champions for two years, won a silver medal. The gold went to an Austrian couple who won by the narrowest point margin in Olympic history.

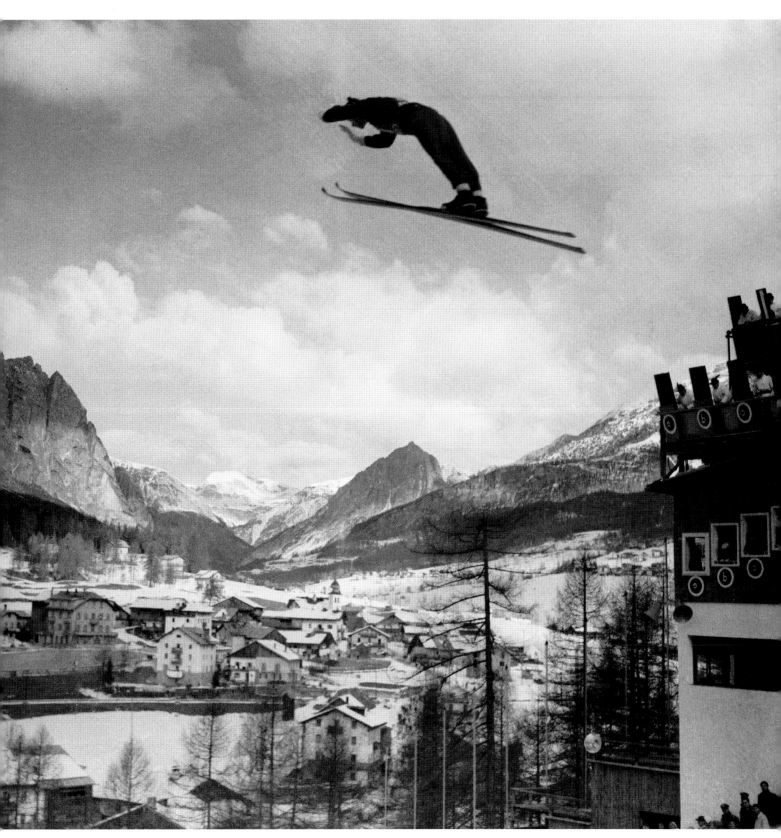

High flyer. A Finnish contestant soars away from the Olympic ski jump, 177 feet tall, near Zuel, Italy, during the 1956 Winter Olympics, probably too distracted to note the spectacular view of the village and mountains—the Dolomiti, Italy's Alps. *Photo by Rene Jarland.*

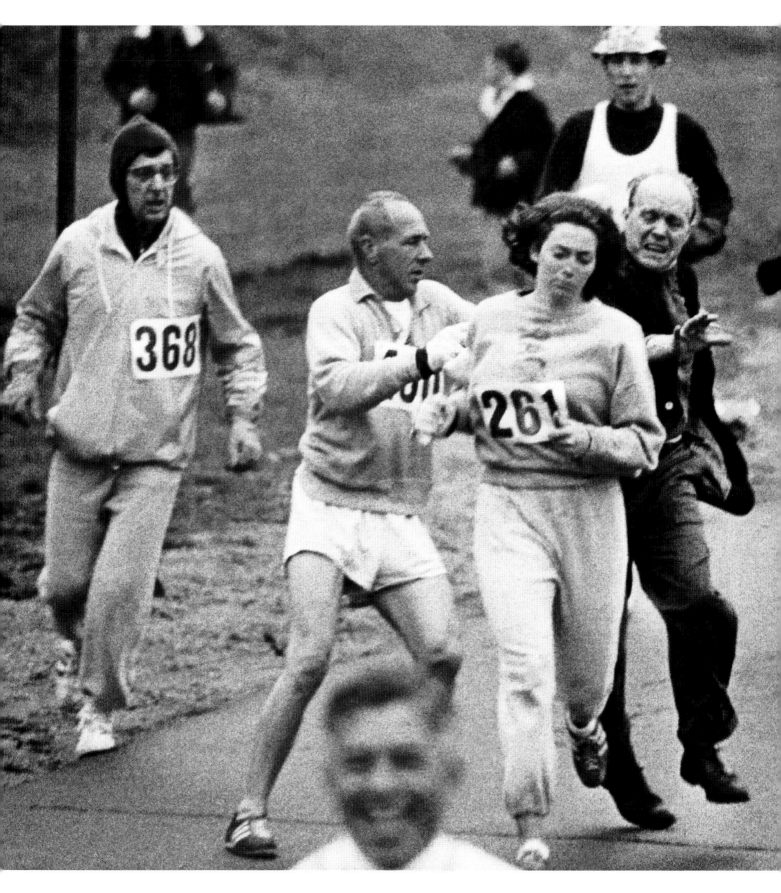

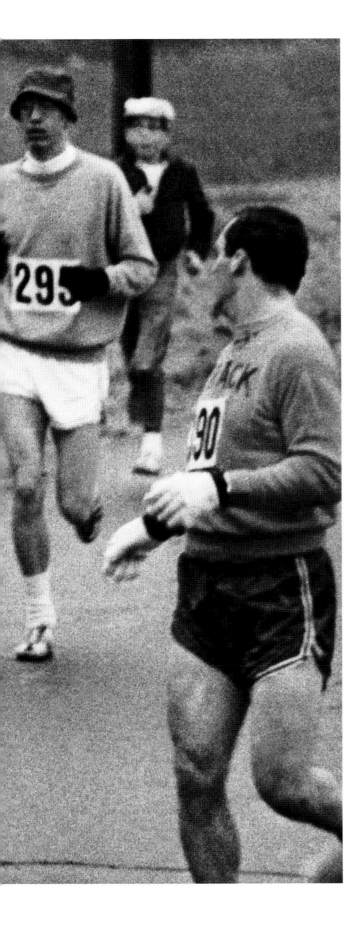

Outing women. In 1967 women weren't allowed to run in the Boston Marathon, but Kathy Switzer had other ideas. Race official Jock Semple, in street clothes, ran out to stop her personally but encountered turbulence—male runners who thought she had a right to complete the race. She had registered by mail as "K. V. Switzer." Women were finally welcomed in 1971.
Photo by Donald L. Robinson.

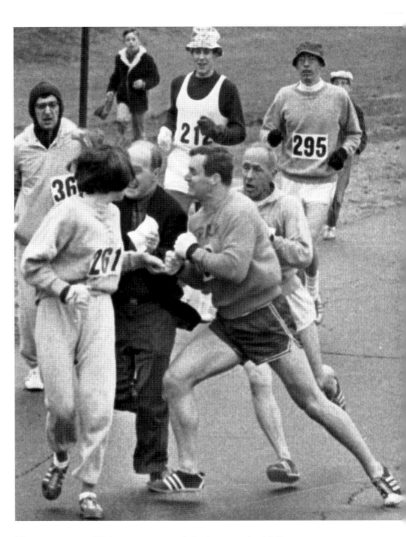

Runner rescue. Male runners run interference for Kathy Switzer, the first woman to run with an official number in the "no-women" Boston Marathon, 1967. Semple managed to rip off Switzer's number (261) before being knocked down. Switzer finished the race.
Photo by Donald L. Robinson.

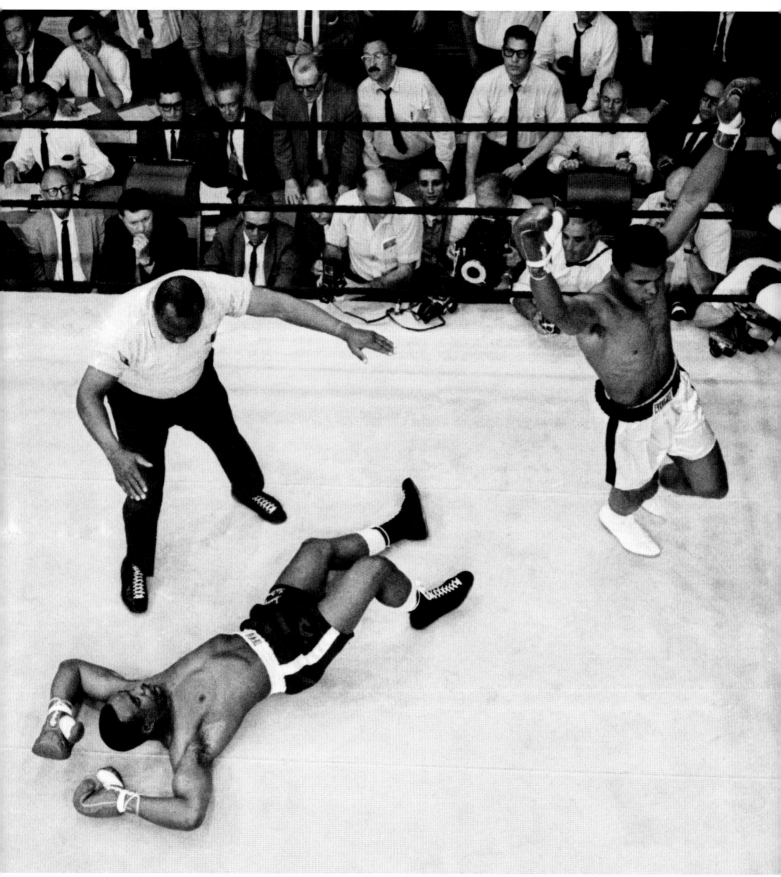

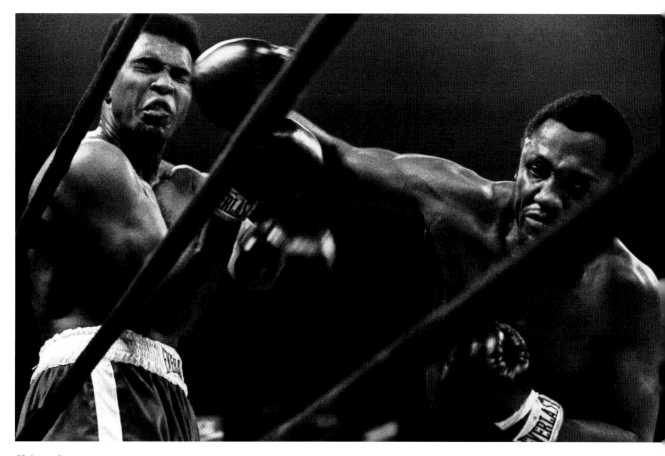

Kaboom! Joe Frazier gets Muhammad Ali's attention at Madison Square Garden in 1971. Frazier had become heavyweight champion after Ali was stripped of his title for refusing, on religious grounds, to serve in the armed forces. The Supreme Court ruled in Ali's favor and he returned to the ring in the "Fight of the Century" with Frazier, who won a decision. They met twice more, and Ali prevailed both times, including the "Thrilla in Manila," in the Phillippines, considered to be one of the greatest fights ever.
Photo by David Hume Kennerly.

Wait a minute. Sonny Liston is down and Cassius Clay (Ali's birth name until he became a Black Muslim in 1964) exults after the fastest knockout in boxing history in Lewiston, Maine, in 1965. Clay won in the first minute of the first round. The referee is former champion Jersey Joe Wolcott. Fans who arrived a few minutes late to claim $200 seats weren't happy to have missed what little action there was. There were calls for an investigation and federal control over boxing. *Photo by Harry Leder.*

Snake 'n' shake. Golfer Lee Trevino comes out of the rough with a snake on his club—a rubber snake that never failed to startle spectators and establish him as a first-rank golf comedian. He pulled this trick at Merion Golf Club in June 1971. *Photo by Ron Kuntz.*

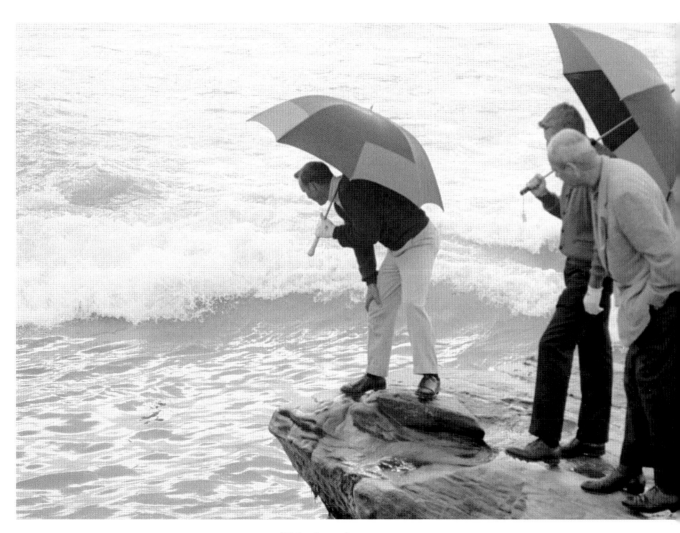

Water hazard.
Arnold Palmer peers into the Pacific Ocean on the off-chance he can find and play the ball he hit into the surf at the Bing Crosby Pro-Am tournament in Pebble Beach, Calif., January 1964. *Photo by Charles Blagdon.*

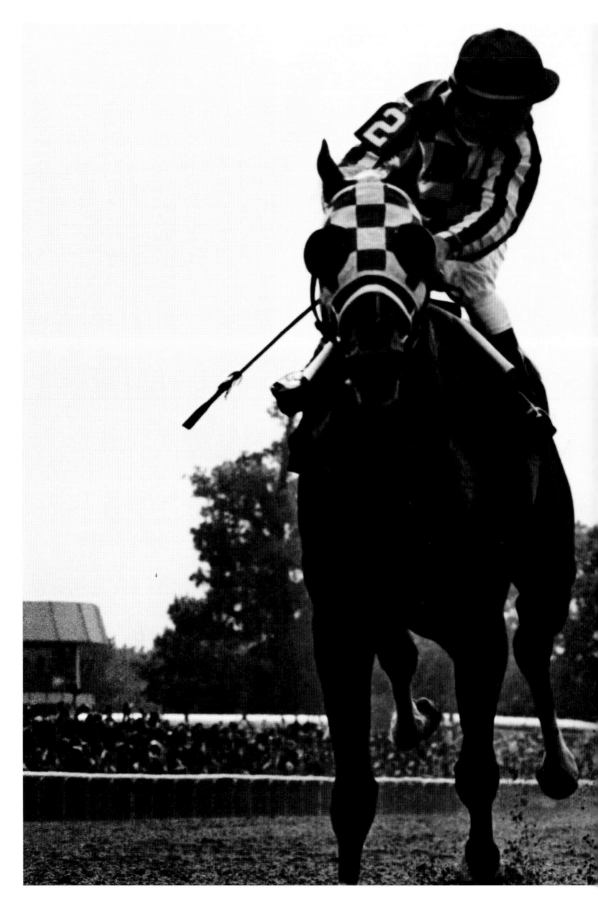

Where *is* everybody?
Secretariat forges ahead,
31 lengths ahead of the
field as jockey Ron
Turcotte turns to see
where everybody went.
Secretariat won this 1973
Belmont Stakes and the
first Triple Crown since
Citation in 1948, and set
a new world record time
for the 1½ miles —
2 minutes, 24 seconds.
Photo by Bill Lyon.

Extra point. Jimmy Connors, playing doubles at Forest Hills, N.Y., with Ilie Nastase of Romania at the U.S. Open in September 1975, pretends to kick a linesman adjusting the net.
Photo by Jerry Solloway.

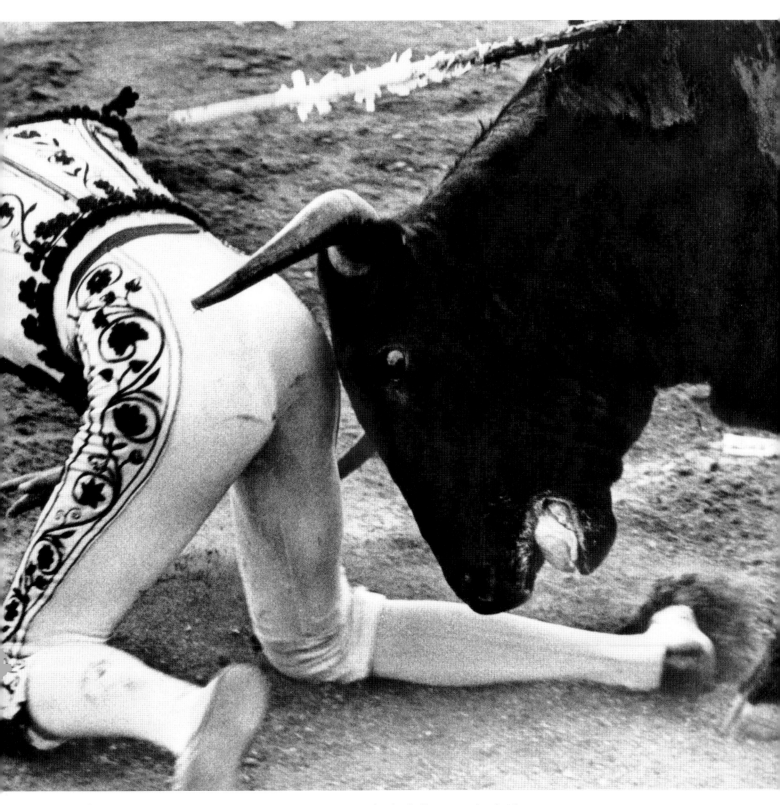

Horns of a dilemma. Bullfighting 101 should teach you never to let the bull see your backside.
In Spain in August 1972, a bullfighter who skipped that class is about to get a pointed reminder,
learning the hard way. *Photo by Hugo Peralta.*

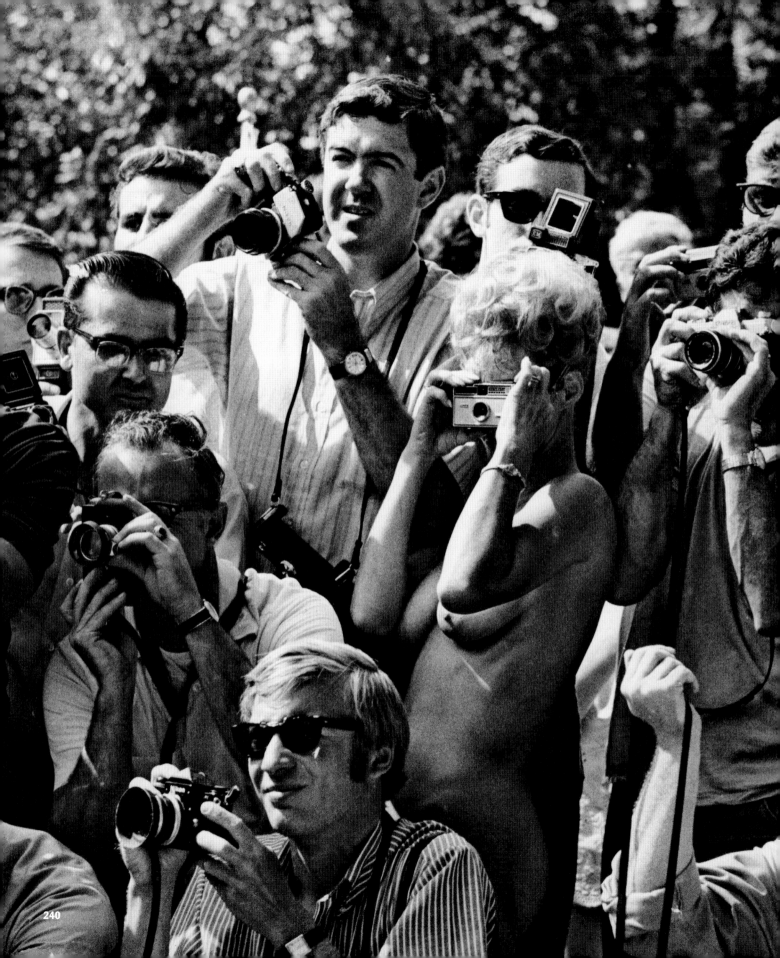

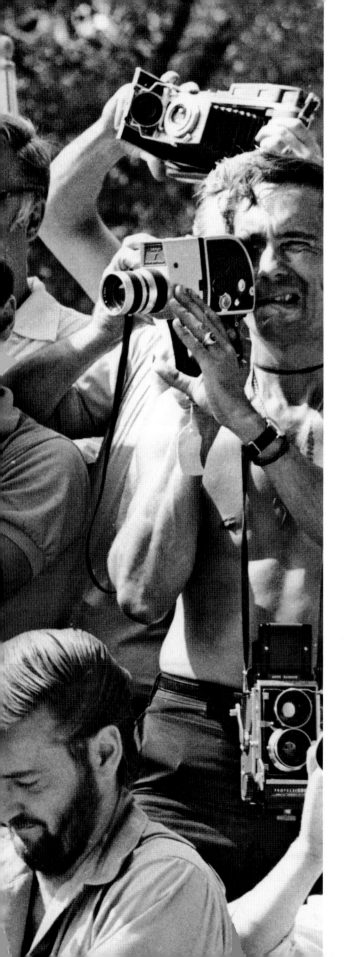

Shooters and Their Tales

Great news photography starts between the ears, and evolves through a blend of talent, patience, preparation, and sacrifice. The best photographers seem always to be in the right spot, not through luck but because they are always thinking ahead. Two shoulder-to-shoulder photographers at the same event do not necessarily shoot duplicate pictures. The photographer who thinks harder can work smarter and outshoot the other.

A skilled reporter can arrive minutes after something happens, interview people who saw it happen, and write a story as compelling as if the reporter had been been there. The world's best photographer, arriving late, has missed the event forever. Most "spot news" photos are taken after the fact.

A photo is also more fragile than words. If a photo editor misses the best picture, no one ever sees it. A great photo cropped poorly or used too small, as happens at too many newspapers to this day, becomes almost irrelevant, failing its mission to inform readers.

Photography is powerful because it gives us the truth, or something close to it, that makes it harder to deny reality. Photographs can dispel myths and right wrongs.

Abraham Lincoln credited Matthew Brady for helping him become president. Brady had portrait studios in Washington and New York, and he set about making portraits of his generation's leading figures, including a little-known, publicity-hungry presidential candidate from Illinois who was in New York for a speech at Cooper Union. Abe's portrait appeared in publications throughout the country. After he was elected, Abe said, "Brady and Cooper Union made me president."

Sometimes the story behind a picture is as good as or better than the photo itself, as the following accounts from UPI's photographers will attest.

Uh—guys! Professional photographers are so focused on the winner of the "Miss Nude America" pageant in Indiana in 1967 that they fail to notice the female nudist who has joined them, wearing only her Kodak Instamatic. *Photo by Bill Snead.*

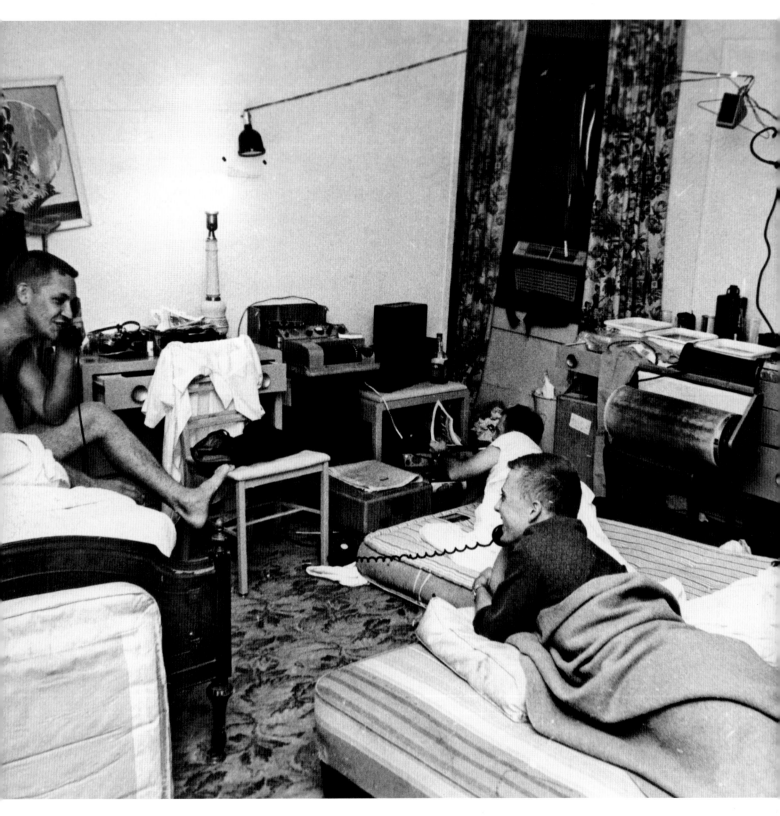

Sleeping *at* the job. UPI photographers, covering the tumult over the enrollment of James Meredith at the University of Mississippi in Oxford in 1962, shared a room—not only with each other, but with UPI's transmitter, print dryer, and darkroom. From left: Jerry Huff, Jerry McNeill, Gary Haynes (on phone), and Pete Fisher. *Photo by Jerry Huff.*

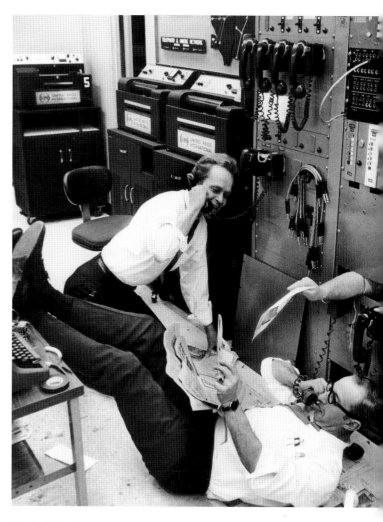

Control freaks.
John Rech (left) and Ray Foli clown as a UPI technician
tries to perform genuine maintenance on the bureau's
telephoto control panel.

Nobody said it would be easy

The public sees the pictures but rarely gets a look at what photographers endure to get them. News photographers are easy targets for good and bad guys alike, and occasionally other photographers record the travails.

Grrrrrr.
"Johnny Dio," John Dioguardi, angry after being ordered out of a Senate hearing room, takes it out on UPI's Stanley Tretick in 1957.

Move along. Chinese officials get clingy with David Kennerly, trying to work near the Ming tombs in 1972, telling him to "move along."

Hands-on judge. A *Miami News* photographer just took his picture in the courthouse hallway, and Judge Steve Weaver asks if he can get some prints.

More fireworks. UPI exclusive of Mackinac Bridge, 1958.

Bridge opening, take two

Photographer Art Chernecki and his boss, Carl Kramer, covered the 1958 dedication of the Mackinac Bridge, a five-mile engineering miracle that linked Michigan's upper and lower peninsulas.

There would be speeches and fireworks. Chernecki gave Kramer, who had never been a photographer, a camera. They would shoot from opposite ends of the bridge. "Just shoot when the fireworks start," Chernecki told his boss.

The fireworks were spectacular and Kramer had the best angle—until Chernecki took the camera and discovered that there had been no film in it. Chernecki transmitted his off-angle photo and the pair retired to a bar to exchange blame.

More than a few drinks later Kramer made clear to Chernecki and others in the bar that he was a boss, not a photographer. If Chernecki wanted film in the damned camera, he should have put some there. An odd-looking fellow walked over to their table and said he could help. "Mind your own business," Kramer snapped. The guy said that fireworks *were* his business. He'd set off the official batch but had some left over if UPI wanted to try again.

It was after 1 a.m. when they were back at the bridge. Chernecki and the fireworks placed carefully, the sky lit up and the bridge was "rededicated," a UPI photo AP of course never matched. Chernecki liked to say, "They left too early."

Behind the lens

Photographers' tales of what it took to get the picture.

Bird watch

The prior day's check of camera setups for a Saturn launch at Cape Kennedy made the photographer wish aloud that seagulls flying about would be on hand at launch time. Ralph Morse, a *LIFE* magazine photographer, suggested "chumming" the beach before the launch. In the morning UPI's $18 worth of shrimp drew a beachful of gulls and when Saturn flew, they did too. This UPI picture—one bird watching the other—ran vertically across two full pages of *LIFE*. It also won several contests.
Photo by Gary Haynes.

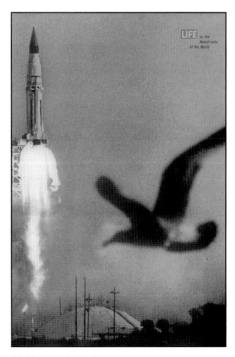

Bird's-eye view. Saturn 1 launch, 1961.

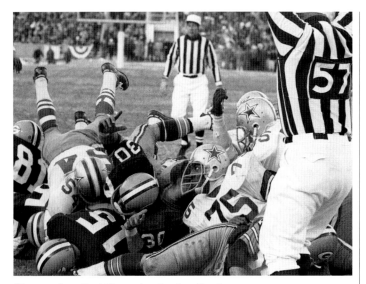

Starr on ice. Bart Starr wins the Ice Bowl.

Ice Bowl football

It may have been warmer atop Mount Everest on December 31, 1967, than at Lambeau Field in Green Bay, Wis., where two professional teams took the outdoor field at 13 degrees below zero to play football. The wind made it feel like minus 46.

Not all 50,861 fans had a consistently clear view of the playing field because fans' breath condensed in clouds above the stands. The Green Bay Packers beat both the elements and the Dallas Cowboys, 21-17, winning in the final 13 seconds when Bart Starr skidded in for a touchdown.

Coach Vince Lombardi later said that he didn't "figure all those people up there in the stands could take the cold for an overtime game," so he gambled on a quarterback sneak.

Fans wore ski gear and masks, hunting coats, double parkas and multiple pairs of gloves. Photography under such conditions is a nightmare. Cameras are mostly metal and chill quickly. Motor drives become useless. Lenses fog up and are slow to focus. Misery, start to finish.

UPI operated out of a boiler room, and delivered warmed cameras to the shooters (Ralph Schauer, Les Sintay, and Dennis Cook) after every two plays, in exchange for the iced camera returned to the boiler room before it was unloaded. At halftime photographers came in to thaw out and suddenly all began bleeding over the eyes. Warmed cameras froze to their cold skin as they focused; when pulled away, a bit of skin came along. The Arctic cold numbed the feeling and delayed bleeding until they got indoors to warm up. Schauer had the only good photo of the winning touchdown.
Photo by Ralph Schauer.

Triumph to tragedy

Laurence Owen, 16, won judges, press, every spectator's heart, and the North American Figure Skating Championship in Philadelphia in 1961. *Sports Illustrated* called her "America's most exciting girl skater." Two days later she died—in a plane crash en route to Europe, along with her sister, mother, and the entire 18-member team and 11 others—coaches, friends of the skaters, the team manager, and two skating officials. The World Championships were canceled. *Photo by Gary Haynes.*

Laurence Owen. Gone too soon.

Life-and-death cab ride

Carlos Schiebeck was in Mexico to photograph French President Valéry Giscard d'Estaing, and was rushing to catch a plane home when his taxi stopped. A little girl, hit by a car, lay broken and bleeding on the Mexican road, miles from help. "People pleaded for us to take her to a hospital, 20 miles away," he says. "This is routine in this part of the world." The girl's grandfather carried her to the cab and climbed in. Carlos, in a rear-view mirror self-portrait, recorded the drama. The girl died just blocks from the hospital, but Carlos didn't have the heart to tell her grandpa. He managed to reach his plane with five minutes to spare. He never even knew her name.
Photo by Carlos Schiebeck.

Dying girl. Schiebeck en route to hospital.

UPI takes an Oscar

In 1968, to jazz up pictures of Academy Award winners posing with their prize, two UPI photographers snagged an Oscar.

Oscar winners leave the stage clutching their statues and are ushered into a succession of three smallish rooms just offstage—the "deadline room," then the "magazine room" next door, and then the "everybody else room." The visit to each of the rooms is carefully timed.

In the "deadline room" were only UPI, AP, and the *Los Angeles Times* photographers. The room was unadorned, with no decoration or anything that says "Oscar." The "magazine room," where photographers shot color, had carpet, potted palms, and two seven-foot wooden Oscar statues painted gold, making for more interesting pictures.

Months before the 1968 awards, UPI petitioned Gregory Peck, then president of the Academy of Motion Picture Arts and Sciences, to move one Oscar statue into the barren deadline room. UPI sent clippings showing that 90 percent of published magazine room photos had been cropped to include only one of the two Oscars behind the winners.

Weeks before the ceremony, Peck said, "Sorry."

Photographers have varying degrees of respect

Big Oscar. Back in the picture.

for authority; UPI's Ernie Schwork had less than most. He was helping with UPI's Oscar setup in a kitchen just offstage at the Santa Monica Civic Auditorium when he learned that the Academy had denied him an Oscar.

He grabbed fellow photographer Craig Mailloux, marched into the magazine room, and came out with an Oscar. They had the statue almost into the deadline room when a security guard appeared to ask what was going on. "Wrong room," Schwork explained, shaking his head. ". . . mind grabbing one of those palms?"

From that year on, Oscar winners photographed in the deadline room had big Oscar peering over their shoulders.

Monroe double exposure

AP photographer Harry Harris shot a world exclusive photo of Marilyn Monroe after she showed up with former husband Joe DiMaggio at the New York Yankees' Florida spring training camp in 1961. The actress was reportedly on the verge of emotional collapse and DiMaggio brought her to Florida for rest and support.

Both UPI and AP had asked for time with "Miss Monroe," as DiMaggio called her. He set a time and called both Harrys, but UPI's Harry Leder didn't get the call.

Florida in February can be chilly, so AP's exclusive was heavy on bundling, light on Marilyn. But it was enough to get UPI's Harry in hot water. AP's picture was getting worldwide play while UPI was getting flak from its Monroe-less clients. UPI's Harry knew DiMaggio personally and pleaded for another chance with "Miss Monroe." DiMaggio agreed, but to be fair he'd have to tell AP's Harry, who reportedly told him: "I got mine."

Fortune, and the warming sun, shone on UPI next morning. UPI's photo revealed far more of "Miss Monroe" than AP's picture had, and papers that published AP's found excuses to run UPI's more exciting version. UPI's Harry and AP's Harry had to exchange places in the doghouse.

MMmmm. Film and baseball stars in Florida.

Mistaken identity

One of UPI's finest photographers always had caption troubles. Joseph Holloway Jr. was such a ghastly speller he couldn't even locate the word he needed help with in a dictionary. Holloway, the Raleigh, N.C., newspictures manager, received a journalism degree from the University of Alabama, after promising never to go into "written journalism."

Easily as important as religion to the South is Southeast Conference football, and one Saturday Holloway, as always, transmitted sensational football pictures. The captions, as usual, misspelled almost every other word.

Southern Division manager Wayne Sargent, his boss, checking the photos in Atlanta, admired them until he got to the captions. Agitated, he typed a single-spaced, full-page diatribe to Holloway, essentially warning Holloway that while his pictures were wonderful, bad spelling could harm a UPI career. And to do something about his spelling. Quick.

A day or two later, Sargent, in high humor, came into the Atlanta photo bureau, brandishing his original letter that Holloway had sent back with a note penned in one corner. "Dear Wayne: Some lunatic got aholt of your personal stationary and is writing me crank letters on it! Thought you aught to know. JHJR"

Measuring up? Miss America contestants in the surf.

Miss America "statistics"

The Miss America pageant wasn't an unpleasant gig for UPI's young male photographers: beautiful women cavorting in swimsuits and four-inch heels, though a formidable pageant chaperone hovered to head off any nonphotographic funny business.

In the mid-1960s the candidates still volunteered their "vital statistics" to pageant officials and the press, but on an honor system. Betty Laesker, wife of an *Atlantic City Press* photographer, worked in an upscale dress shop where many candidates shopped. Not infrequently, she told her husband, Herman, a significant part of a candidate's statistics "came with the dress."

Photo by Herman Laesker.

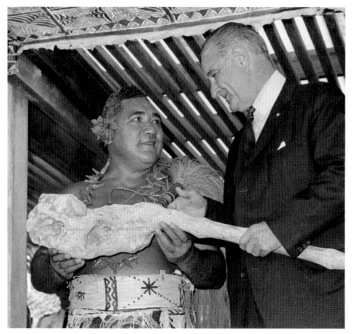

"Hava kava." Transmitted from Pago Pago in 1968.

Rooting for you

A Samoan chief presents a ceremonial kava root to Lyndon B. Johnson during the president's 115-minute refueling stop in American Samoa in 1965, en route to Australia. Almost a fourth of the 22,000 people who live there turned out, including 50 bare-chested chiefs who draped the president and Mrs. Johnson with ulas— Samoan leis—made of shells. Kava juice has ceremonial as well as medicinal properties, and is said to "numb the mouth and calm the mind." Lady Bird Johnson accepted a sip from a chief with a hibiscus tucked behind his ear. She diplomatically reported a "medicinal taste." The islanders believed that kava kava preserved the goodwill of kings and chiefs, and they often used it when reconciling with an enemy.

This root presentation photo was among the first four pictures ever transmitted direct from Samoa by radio-photo, using a transmitter and darkroom gear that photographer Gary Haynes hauled in for the occasion from Los Angeles.

First Super Bowl

The first one wasn't even called the Super Bowl. On January 15, 1967, Vince Lombardi's Green Bay Packers met Hank Stram's Kansas City Chiefs in the first "AFL-NFL World Championship Game Bowl" in Los Angeles Memorial Coliseum. Green Bay won, 35–10, before only 61,946 fans in the 100,000-seat stadium. (In 1969 the championship game became the Super Bowl, numbered from 1967.)

AP and UPI were offered lab space under the Coliseum; UPI declined. In January Los Angeles temperatures drop to 45–50 degrees at night, and the rooms beneath the cement and steel stadium stayed cold all day. UPI worked out of its picture bureau, about seven minutes from the stadium by Mickey Shaffer, UPI's almost mythic motorcycle messenger.

Sure enough, on game day AP's chemicals were chilly, slowing film developing time. Schaffer zipped back to UPI with two rolls and moments later they had been developed in a newly invented, full-range film developer, "Microcopy," field-tested the week before. Normal film processing took six minutes; Microcopy did it in 40 seconds, with perfect negatives. Better yet, those first two rolls yielded three excellent pictures.

The film was printed wet out of the wash, and UPI beat AP with the first picture of that first Super Bowl by almost six minutes. And for the rest of the game, UPI swept the photo play in two-service papers.

Since the game played before nearly 40,000 empty seats, TV was blacked out in L.A. But you can't edit game film without seeing how the game is going, so UPI asked NBC for a dish on the office roof. New York headquarters gave the staff rave reviews start to finish until NBC billed $800 for the dish. They had stationed a technician atop the building to watch the game on a small TV and keep the dish aimed. UPI groused, and NBC cut the bill in half.

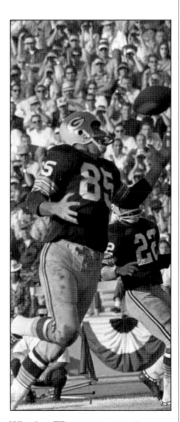

Winning TD. By Max McGee.

PM's wife and UPI photo school

Margaret Trudeau, then 25, called the Ottawa newspictures bureau in 1974. She'd heard that UPI could teach her photography.

On UPI's end of the line was Rod MacIvor, 28, the bureau manager. He would make an exception for the prime minister's wife. Soon he was at 24 Sussex, the Trudeau home.

Ushered to a room on the third floor, he and Margaret Trudeau had begun the first of a series of photo lessons—starting with basics—when his pager summoned him to a "photo opportunity" at nearby Government House.

Margaret wanted to tag along. Wait for her in the library downstairs, she said. MacIvor found the library, and Canadian senator Keith Daveys on the phone. He tried to be inconspicuous, but his worst fears were realized when Pierre Trudeau appeared, wondering who MacIvor was. Told that UPI had just given his wife a photo lesson, Trudeau ushered MacIvor into the kitchen, thanked him, and left.

Mrs. Trudeau soon was ready to go in a bandana, blue jeans, and boots. With borrowed UPI cameras, the unlikely pair walked to Government House. She told MacIvor to introduce her only as a "friend learning photography," and the Royal Canadian Mounted Police guards failed to recognize her.

Margaret shot pictures, but next day she was the one

Mrs. PM. Margaret Trudeau, dressed and ready to shoot.

in the papers, in pictures of her taking pictures.

She learned to process and print her own photos in UPI's lab, and the Trudeaus invited MacIvor to take the family Christmas card picture—not the normal UPI assignment. UPI enjoyed a Trudeau edge over AP, especially in access to the Trudeau children. The Trudeaus separated in 1977 and divorced in 1984. Pierre got full custody of the children.

Watts riots motorcycle run

On Friday, August 13, 1965, Watts, a Los Angeles neighborhood, erupted in chaos after a routine arrest of a drunk driver. The riots lasted six days and left 32 dead, 1,000 injured, 4,000 arrested, and 200 buildings destroyed. It took thousands of police and soldiers, including an entire infantry division supported by tanks, to confine the riot to the Watts area, and several more days of street fighting to finally bring things under control.

On the first night, UPI's Bob Flora wanted to get into Watts to photograph the random looters and shooters. If you could believe the reports, rioters were targeting white policemen, not white journalists. Bob proposed a "drive-through shooting," a high-speed auto trip through Watts, Bob and camera on the passenger side while a colleague drove. Nobody else volunteered themselves or their car.

Mickey Schaffer, UPI's non-staff motorcycle courier, was smart and aggressive without being completely reckless. He was willing to try "just one swing" though Watts.

The sight of two white guys on a motorcycle in a black and Hispanic neighborhood in utter chaos would itself have been worth a picture. Schaffer told Flora to hang on as if his life depended on it—as it well may have. The UPI duo whizzed past startled rioters and looters, and Flora had pictures before they could react and throw anything.

AP never matched those UPI photos of rioters frozen in time, shocked as a motorcycle zips by. Flora said his pictures were "bad but exclusive."

Many threw bottles. These folks looted some full ones.

Amphibian. John Bevin, driving, and Dave Derer hit the waves in their Amphicar.

Amphicar and flood

UPI's Los Angeles picture bureau was a magnet for press agents, who would appear hoping UPI would photograph whatever they were touting and send a photo over the picture network. The standard response was "leave a card, and don't call us; we'll call you."

One fellow showed up with an "Amphicar," in 1961. It was an odd little convertible that would go 70 mph on the highway or 7 mph in the water. German-made, resembling a Crosley, it was the only civilian amphibious passenger vehicle ever mass-produced. He left a card.

Like clockwork, seasonal flooding inundates parts of southwestern Los Angeles, and water flows across one spot on Sepulveda Boulevard to a depth of more than five feet. Assigned to the flood, Carlos Schiebeck remembered the Amphicar and called the PR guy, who was out front with the Amphicar in less than an hour.

They drove to where the road became a river. Cars were lined up on both sides to the water's edge. The little Amphicar passed one line of cars and drove right into the water. They were putting across when Schiebeck heard honking and yelling. Two motorists at the water's edge figured that if that little car could make it, theirs could, and they followed. One car was submerged up to the front windshield, the second up to its hood. The driver of the second car sat atop his car gesturing in an unfriendly way and screaming unprintable things.

The Amphicar duo turned around and helped the young man, a college student, recover his term paper, which had floated out of his car and downstream.

Center divider

Speed. The faster a photographer can get there, get a picture, and get back to the office, the better. A Los Angeles legend was UPI's Carlos Schiebeck, legendary photographer and more legendary driver assigned to a brush fire threatening homes in expensive Orange County, Calif., south of Los Angeles.

The weekday 4 p.m. rush is the worst time to try to get anywhere on a Los Angeles freeway, but Carlos reached the fire scene ten minutes ahead of the half dozen California Highway Patrol officers trying to apprehend him. A CHP officer huffed up. It would take the rest of the day to write all the tickets, he said, but Carlos would be off the hook if he could explain how he beat CHP's finest in hot pursuit.

"Easy," Carlos explained. "There was nobody on the center divider." He had driven 70 and 80 mph along the freeway center divider until he reached a lamppost. He'd signal to join the 5 mph traffic ("who wouldn't let me in?") clear the lamp, pull back up on the divider to do 70 mph to the next lamppost, and so on, to the fire. Awed, the cop wrote no tickets.

Laserphoto Advisory

EDITORS: The White House has refused to release the photos of President Carter warding off the attack of a rabbit with a canoe paddle. Laserphoto will continue to try to obtain the photos from the White House.
(NY46-Aug.29)1979 THE AP

Presidential attack rabbit

In April 1979, President Jimmy Carter, on a holiday in Plains, Ga., was attacked by a "swamp rabbit" while fishing alone. Carter warded off the bunny with a canoe paddle. Not until August did the press learn of the encounter and ask the White House about it. The press secretary said the rabbit was "hissing menacingly, its teeth flashing and nostrils flared and making straight for the president," but refused to release a photo of the encounter made by official White House photographer Bill Fitz-Patrick. AP sent a message (above) to picture clients saying they'd try to get a copy but they never did. But bunny fans, UPI (with the help of the Jimmy Carter Library) presents that photo—27 years later. Checkmate, AP! *Photo by Bill Fitz-Patrick, The White House.*

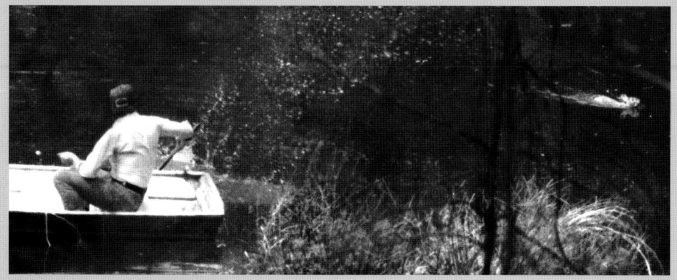

Rabbit transit. Using only his oar, the leader of the free world bats away a bunny. Courtesy Jimmy Carter Library #NLC10342.20

Acknowledgments

This book would not exist but for the generosity of Bill Gates, whose Corbis owns nearly every photograph in it. The Corbis staff in Pennsylvania, where UPI's photos are preserved, made the rest possible, led by the inimitable Ann Hartman, Manager of Library and Records, whose patience and research skills set world standards.

Photo captions have been rewritten and enhanced so today's readers can better understand the yesterdays of ten and twenty years ago and more. Caption details were added in many cases by former UPI staffers who either took the photos or were at the scene. Frank Tremaine, who ran UPI Newspictures, helped keep the history straight, and Gene Foreman, who helped run the *Philadelphia Inquirer,* watched over the text as manuscript consultant and kept the participles undangled.

Authors of two books about UPI, *Down to the Wire* by Gregory Gordon and Ronald E. Cohen (1990) and *Unipress* by Richard M. Harnett and Billy G. Ferguson (2003), were more than generous, offering advice and access to their own material.

Many old chums and colleagues shared stories and helped locate photos and match photos and photographers: Joe Marquette, Darryl Heikes, Carlos Schiebeck, David Kennerly, Dirck Halstead, and Bill Snead.

David Milne, this book's designer, received invaluable support from Susan Soffer and technical wizards Kevin Burkett and Joanne Sosangelis. Philadelphia's Dark Horse Pub provided workspace a respectable distance from the bar. The book's typeface is Milne, named after David; it is a redesign by Matthew Carter of Carter & Cone Type, Inc., of Cambridge, Massachusetts, of the font Carter created for the *Philadelphia Inquirer* in 1971, where Milne, as design director, was winning national design awards.

Dave agreed to apply his design genius to any book I managed to come up with, and ended up alongside me in the shark tank, helping edit thousands of pictures and captions and also helping to organize and balance my creative chaos with his detail discipline.

The Corbis support staff included Vice President Brian Storm in New York and Dina E. Keil, Chris Kubiak, Leslie Gilbert, Sarah Scott, Greg Kellerman in Pennsylvania, and Michelle Young in Seattle, Washington.

A special salute to UPI alums Tom Foty, Ed Hart, Lewis Lord, Allan Papkin, Craig Mailloux, Rod MacIvor, Emil Sevilis, H. Denny Davis, Martin McReynolds, Pat Benic, Patti Yoder, Ann Holloway, Eliot Brenner, Bob Carroll, Joe Galloway, Chris Flora, John Blair, James K.W. Atherton, Vincent E. Mannino, Joe Chapman, Dan Rosenbaum, Vyto Kapocius, Lou Garcia, R.E. Sullivan, Dan Rosenbaum, and Dick Van Nostrand for their contributions. An extra nod to Pye Chamberlayne for his caption editing and tips, and to Marlene Adler of CBS, John G. Morris, and Boots LeBaron. Three classy "other guys" at Associated Press, Hal Buell, Charles Zoeller, and Nick Ut, helped fill in details of AP history.

Thanks to Susan Bennett for the Pulitzer-winner profiles, reprinted by permission, copyright the Newseum, and Claudia Weissberg of the Pulitzer Prizes for pictures of UPI's winning photographers.

Ed Estlow of Lucent Technologies deserves several gold medals for his dogged research into AT&T archives that helped establish circumstances leading to the "dawn" of practical network transmission of photos by wire to multiple points on a network in 1935.

Finally, a big felony hug for Sharon J. Wohmuth, photographer, author, a dear and lifelong friend, who introduced this project to Jill Cohen and Michael Sand of Bulfinch, enlightened editors who realized instantly that the world needed this book.

Thanks, everybody!

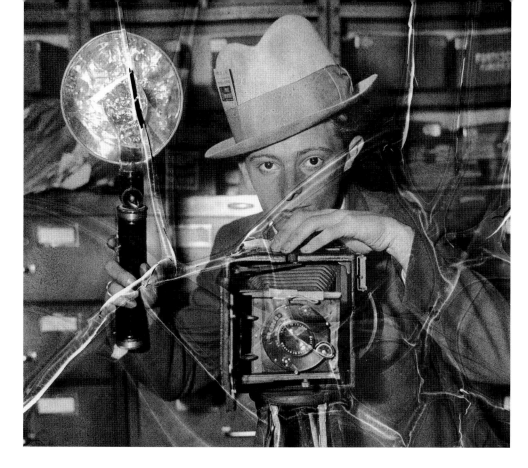

Press photographer, 1932. Complete with a press pass stuck in his hatband, an unidentified Acme photographer holds the workhorse 4 x 5 camera that remained in wide use through the early 1960s. This print, made from the original 4 x 5 acetate negative, shows an advanced state of deterioration, or "vinegar syndrome." A pungent vinegar smell (hence the name) signals chemical deterioration as the film's gelatin emulsion becomes brittle and pulls away from its acetate base, a process accelerated by exposure to heat and humidity.

The UPI Photo Archive

The UPI photo archive is now a buried treasure. Photo historians and photo researchers were alarmed when Bill Gates hired 19 refrigerated trucks and moved the priceless collection he bought in 1995 out of New York (between summer 2001 and March 2002) to a refrigerated cave 220 feet down in a rural Pennsylvania mountain, near Butler, about an hour's drive northeast of Pittsburgh.

The photos might be preserved, critics said, but nobody would ever again have easy access to them. "Far from the reach of historians," huffed the *New York Times*.

Most of those early skeptics now realize that Gates did the right thing. Corbis, which he founded in 1989, has preserved an irreplaceable photographic history while making it more easily accessible to more people than it ever has been.

Corbis worked with Henry Wilhelm, an expert on long-term preservation of photographic materials in subzero cold storage. Wilhelm convinced Corbis that keeping its collection at four degrees below zero Fahrenheit would halt deterioration and leave the photos intact and usable for at least another five thousand years. Wilhelm compared freezing the film to the frozen woolly mammoth found perfectly preserved in Siberian permafrost in 1999. The animal slipped into an ice crevice and froze almost immediately, to be discovered 20,000 years later with all tissues intact.

"It's a real demonstration of how cold storage works," Wilhelm says. "The lessons for film materials are clear. The gelatin layer of film is made from connective tissue of cows, essentially the same as the woolly mammoth. There's just no doubt that this will work for film."

The furor about Corbis "hiding history" has died down. Corbis has both the financial resources and a clear understanding of the importance of the irreplaceable material it is preserving. Corbis and its larger rival, Getty Images, now dominate the photography market.

Gates founded Corbis with the idea of selling photos for display on large-screen wall monitors throughout people's homes. In his Seattle mansion, he can display digital photos or fine art based on occasion or mood. On his tenth wedding anniversary, the monitors displayed the couple's wedding pictures.

Index

Italic page numbers refer to illustrations.

List of Photographs

All numbered photographs are rights managed, copyright UPI/CORBIS, and available at www.corbis.com.